AMERICAN
CHRISTMAS CARDS
1900–1960

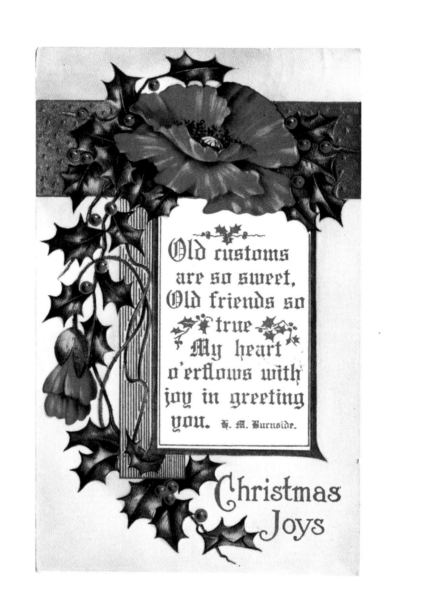

Old customs
are so sweet,
Old friends so
true
My heart
o'erflows with
joy in greeting
you. H. M. Burnside.

Christmas
Joys

AMERICAN CHRISTMAS CARDS
1900–1960

Kenneth L. Ames

with contributions by
Caitlin Dover
Debra Zarlin Edelman
Jeanne Gardner
Kate Goldkamp
Alyssa Greenberg
Mei-Ling Israel
Emma Chandler Jenrette
W. Warren Klein
Cassidy C. Luitjen
Gena Maldonado
Amy Semmig
Sara Spink
Emily Vanderpool
Christie Wilmot

Published by the Bard Graduate Center: Decorative Arts, Design History, Material Culture
Distributed by Yale University Press, New Haven and London

This catalogue is published in conjunction with the exhibition *American Christmas Cards, 1900–1960* held at the Bard Graduate Center: Decorative Arts, Design History, Material Culture on view in the Focus Gallery from September 21, 2011, through December 31, 2011.

Curator of the Exhibition and Editor Kenneth L. Ames
Project Coordinator Ann Marguerite Tartsinis
Coordinator of Catalogue Photography Alexis Mucha
Copy Editor Barbara Burn
Catalogue Design Laura Grey with Helen Dear
Media Team Kimon Keramidas and Han Vu
Exhibition Designer Ian Sullivan

Acting Head of Focus Gallery and Executive Editor of Exhibition Publications, Bard Graduate Center
Nina Stritzler-Levine

Published by the Bard Graduate Center: Decorative Arts, Design History, Material Culture, New York, New York

American Christmas Cards, 1900–1960 is made possible in part with generous support from the Mr. and Mrs. Raymond J. Horowitz Foundation for the Arts and the New York Council for the Humanities.

Exclusive trade distribution by Yale University Press, New Haven and London
ISBN (Yale University Press): 978-0-300-17687-2

Library of Congress Cataloging-in-Publication Data
American Christmas cards, 1900–1960 / Kenneth L. Ames, editor and curator of the Focus Gallery exhibition; with contributions by BGC Graduate Students, Caitlin Dover... [et al.]. p. cm. Published in conjunction with an exhibition held at the Bard Graduate Center: Decorative Arts, Design History, Material Culture, New York, NY, Sept. 27, 2011– Dec. 31, 2011. Includes bibliographical references.
ISBN 978-0-300-17687-2
1. Christmas cards—United States—Exhibitions.
2. Art and society—United States—History—20th century—Exhibitions. I. Ames, Kenneth L. II. Dover, Caitlin. III. Bard Graduate Center: Decorative Arts, Design History, Material Culture.
NC1866.C5A44 2011
394.26630973—dc23
2011025373

Printed by GHP, West Haven, Connecticut

Front cover: French-fold card, 5½ x 5 inches. Black, red, and gray lithography on paper, ca. 1955. Green Tree, Boston, Massachusetts.

Frontispiece: Postcard. Color lithography with gold and embossing on iridescent cardstock. Sent 1915 from Schenectady, New York, to same. Whitney Made, Worcester, Massachusetts. Text signed H. M. Burnside.

CONTENTS

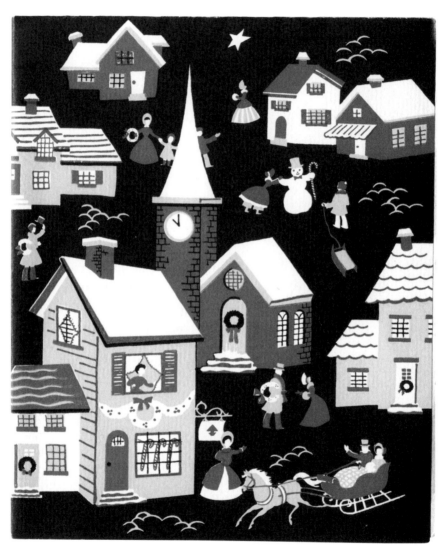

French-fold card
6 x 5 inches
Black and color lithography on paper
ca. 1955
WB (Wallace Brown, New York?),
logo of Allied Printing Trades Council, New York
Made in U.S.A.

FOREWORD

In 1983 Thomas Schlereth, a pioneer in the field of material culture, wrote an important essay examining the historiography and methodology of material-culture studies, in which he quoted Kenneth Ames's characterization of material culture as "a new frontier for scholarship." Thirty years ago material culture was indeed an emerging field that challenged academics to think differently about architecture, objects, and the broader discipline of history. But even now, so many years later, Ken continues to explore new terrain and new aspects of the material world that have been ignored or overlooked despite their potential to illuminate our understanding of American life. This volume, *American Christmas Cards, 1900–1960*, which Ken edited, and the exhibition that it accompanies, for which he served as curator, clearly demonstrate why material culture can be defined today, even more precisely, as a never-ending frontier rather than a new one and why Ken continues to be one of the field's most thoughtful scholars.

Almost immediately after the Focus Gallery was launched at the BGC in 2008, Ken approached me with the idea of curating an exhibition about American Christmas cards, a rather unexpected subject for such treatment. I was intrigued to learn that this omnipresent dimension of American life was actually uncharted terrain, largely absent not only from museum collections but also from the published annals of material culture or the history of graphic design, where one might assume it could be found. Our discussion enabled me to realize that these were the exact qualities that made it an ideal subject for the Focus Gallery, an initiative devoted to faculty-curated exhibitions based on new research and scholarship. As Ken explained to me, Christmas cards were more than the bearers of personal year-end messages; the imagery that embellished the cards, and in many cases seemed too quaint to evoke meaningful narratives, had much to say about American cultural history. Furthermore, this was a prescient moment for consideration of these cards, which were being replaced at a considerable rate by messages created on line and opened in

e-mail inboxes. Like many other forms of communication, Christmas cards that traditionally arrived in the homes and workplaces of their recipients by means of a stamped envelope would soon become largely obsolete.

Ken embarked on this pioneering study of American Christmas cards using the classroom as a forum for engaging graduate students— Caitlin Dover, Debra Zarlin Edelman, Jeanne Gardner, Kate Goldkamp, Alyssa Greenberg, Mei-Ling Israel, Emma Chandler Jenrette, W. Warren Klein, Cassidy C. Luitjen, Gena Maldonado, Amy Semmig, Sara Spink, Emily Vanderpool, and Christie Wilmot—in the research and analysis of the imagery found on hundreds of Christmas cards. Together they created a new classification system for these images, which makes possible for the first time a reading of the multiple meanings these cards have had in American life.

The Focus Gallery idea is grounded in the notion of teamwork, and a core group of BGC staff, including Laura Grey, Kimon Keramidas, Nina Stritzler-Levine, Ian Sullivan, Ann Marguerite Tartsinis, and Han Vu, served as the Christmas cards team, sharing ideas with Ken about how to interpret the content of the project, the display of the exhibition, and the concept and coordination of this publication. They received additional exhibition support from Eric Elder and Olga Valle Tetkowski. Rebecca Allan and Melissa Gerstein worked on the engaging selection of Gallery public programs, and Peter Miller and Elena Pinto Simon helped facilitate the collaboration between the Gallery and Academic Programs.

A creative and skillful team also worked on this publication. Laura Grey, with the assistance of Helen Dear, created the wonderful design, which beautifully captures the spirit of the content. Barbara Burn provided excellent copy editing and support with many editorial details. We also benefited from the proofreading skills of Charmain Devereaux. Bruce White took the lovely photographs of the Christmas cards illustrated in this volume, and Alexis Mucha provided assistance with organizing those images and other aspects of the production.

I want to acknowledge the work of Susan Wall and Brian Keliher in fund-raising for this project and to thank Tim Mulligan and Hollis Barnhart for their efforts on the press campaign.

Last, but by no means least, I want to express the gratitude of the Bard Graduate Center to the Mr. and Mrs. Raymond J. Horowitz Foundation for the Arts and the New York Council for the Humanities for recognizing the scholarly merit of an exhibition about American Christmas cards and for providing financial support for this project.

—Susan Weber, Director

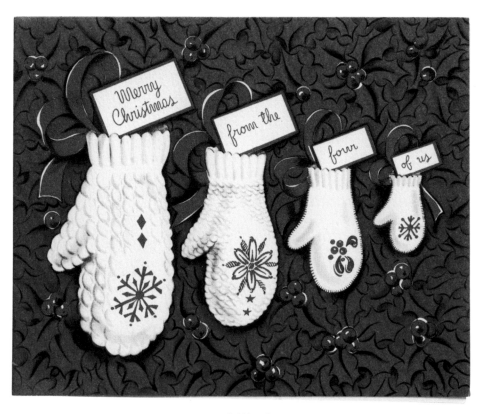

French-fold card
4⅜ x 5½ inches
Black, red, and green lithography on pebbled paper
Sent 1954
National Detroit, logo of Allied Printing
Trades Council, Detroit, Michigan
Printed in U.S.A.

PREFACE

The origin of this project dates to about three years ago, when the Bard Graduate Center initiated a program of small faculty-generated exhibitions. These were to be installed in a newly created, designated space known as the Focus Gallery, a name purposefully both suggestive and slightly ambiguous. The concept called for instructors to offer a class devoted to a topic that could form the basis of a subsequent exhibition. Students were to be involved in the project from the outset and, over the course of a semester or two, they would share in all stages of exhibition creation, from formulation of the governing concept to final installation. Because the Focus Gallery was understood to be experimental, the range of topics or subjects that might form the basis of an exhibition was deliberately left undefined.

This initiative provided an opportunity to design an exhibition-oriented course that combined aspects of museological practice with the fundamentals of material culture inquiry. It was also important for such a course to offer students an opportunity to contribute to some area of scholarship. Three conditions seemed essential for this to happen. First, the objects selected for the course should be relatively unrepresented in the scholarly literature. That they had to possess aesthetic and cultural merit was self-evident, but a limited bibliography was to be considered an asset. The point here was to work with a class of goods free of a dominant paradigm or a governing narrative that could prematurely channel or even shut down inquiry. Well-trodden paths would lessen the possibility of student contribution. Following that line of thought, the selection of little-studied objects would mean that those processes of sorting, sifting, and classifying to which all categories of material are typically subjected either had not yet occurred or, at least, had not been completed. There would, presumably, be no rankings, hierarchies, or structures of value to contend with.

Second, it was essential for the objects to be both intellectually and physically accessible, as found in the world of living people, and not rarified or untouchable. Indeed, a key objective of this exercise would

be to encourage students to learn about goods by looking closely, and then more closely—and by handling them. In other words, this should be a basic exercise in connoisseurship, with conscious attention to the objects' intrinsic properties. This necessarily meant unimpeded and unmediated access to the objects, balanced as appropriate by the requirements of responsible stewardship.

Third, in the tradition of both Aristotelian and material-culture inquiry, our research would begin with the objects and expand outward. In other words, the objects would be our foundation documents, our grounding, our database. Whatever else we achieved, we could at least claim a solid understanding of the physical properties of the goods, and that alone would have some value. On the other hand, starting with presumed cultural or social truths could mean that our objects would become little more than illustrations of foregone conclusions, and that would have little value. Honoring the name of the gallery, then, we would begin with a focus on objects. As much as possible, we would examine them with innocent eyes and open minds, watching for patterns of form or content. If these appeared, we would record them and, perhaps, offer some interpretation. That was all.

Christmas cards seemed well suited to such a venture. Apart from modest seasonal displays, these cards have rarely been the subject of exhibitions, for they suffer from a number of limiting conditions. First, they are too abundant and commonplace to be considered very important. Second, the economic value of most individual cards, whether old or recent, is so insignificant that they command little respect among collectors, a relative handful excepted. Third, the objects are small in size rather than heroic in scale and thus do not lend themselves to grand display. Fourth, they are made from materials of little or no intrinsic worth. Fifth, most Christmas cards were produced as multiples, with scores or even hundreds of identical cards manufactured, each, in a sense, devaluing the next. In short, Christmas cards are not the rare, precious, and unique objects prized by the art world. For these and other reasons, Christmas cards have generally remained beneath

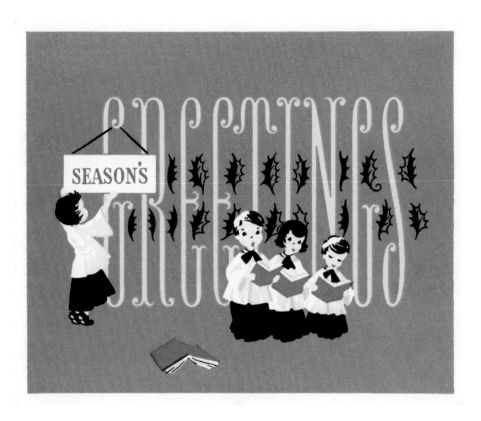

French-fold card
5 x 6 inches
Black and color lithography on paper
ca. 1950
WB (Wallace Brown?), union logo for
Allied Printing Trades Council, New York
Made in U.S.A.

the gaze of the art and academic communities and have been little studied. And that meant that Christmas cards were ideal for our Focus Gallery exploration.

Here, then, is a study of Christmas cards exchanged in the United States of America in the years between about 1900 and 1960. The 1960 cut-off date was chosen to assure that this would be an historical inquiry rather than a study of contemporary culture. Students began by immersing themselves in an accumulation of nearly 6,000 cards, which they gradually sorted, sifted, and arranged. I think it would be accurate to say that there were a few surprises in the early stages of exploration. Although Christmas cards might be examined from any number of perspectives, we decided early on that our own training and inclinations best suited us to visual analysis. Therefore, this study is constructed around the imagery, the pictorial content, of Christmas cards used in this country. Speaking for myself and for all the students who took part in this endeavor, I hope that readers of this volume and visitors to the exhibition will find some value in our attempt to explore and chart this aspect of American material culture. At the very least, we hope that they will agree with us that Christmas cards are worth a second look.

Every project created at the Bard Graduate Center is indebted to Susan Weber, founding director of the institution. I thank her for her willingness to support this admittedly experimental exploration of little-known artifactual terrain. Every project at the BGC also draws on the talents of many colleagues. I am pleased to thank chief curator Nina Stritzler-Levine for her gracious guidance from the outset and for sharing the expertise of her energetic and capable crew, particularly Ann Marguerite Tartsinis, Kimon Keramidas, Han Vu, and Ian Sullivan, all of whom made working on this venture enjoyable and instructive. For the engaging layout of this book thanks are due to art director Laura Grey. I gave her chaos; she transformed it into elegant order.

I owe thanks many times over to the adventurous students who were willing to try something a little different and enroll in the classes

leading up to this book. All are listed on the title page. They may not always recognize their contributions in the final product, for I admit to putting the ingredients into a great pot and stirring vigorously, but I assure them that they are all here in some guise and that I very much appreciate their participation. I hope that they will take pleasure in the outcome of our shared labors. In truth, this project could not have been created without them. Jeanne Gardner was both a student and a course assistant; I am grateful for her valuable assistance and for helping to hold the project together at crucial junctures.

Beyond the BGC, I thank Doug Clouse for his expertise in crafting caption content, acknowledging at the same time that I remain responsible for whatever shortcomings or inaccuracies may be found there. I also recognize David Freund, who shared with me his own extensive collection of graphics, Christmas cards among them. I especially want to thank Anne Stewart O'Donnell for her enthusiastic support of this project and her many suggestions and references. Anne knows more about Christmas cards and their designers and publishers than I ever will; I greatly appreciate her generous encouragement of our fledgling effort. A word of thanks is also due to our unknown outside reviewer, who offered many helpful suggestions for improving this volume. We incorporated them as time and space permitted.

Finally, I am pleased to thank my wife, Nancy Ames, for keeping life good while I wandered around lost in a blizzard of Christmas cards.

—*Kenneth L. Ames*

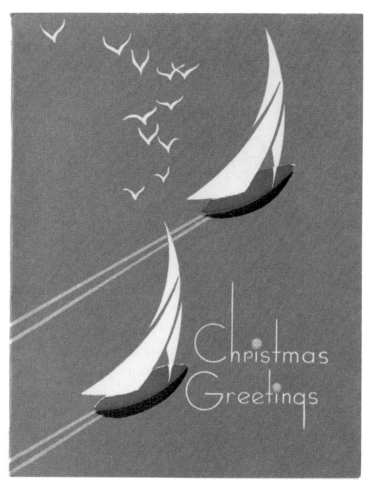

French-fold card
5⁷⁄₁₆ x 4¼ inches
Blue, red, and silver lithography on paper
ca. 1945
Made in U.S.A.

CHRISTMAS CARDS IN AMERICA

This is the first book to explore the images that adorned American Christmas cards of the twentieth century. Not too long ago, Christmas cards could be found everywhere, but in recent years the genre has been visibly in decline, as fewer and fewer people send cards for the holiday season. The chief function of Christmas cards—to make and sustain contact with others—remains as critical as ever, but methods of doing so have superseded traditional ones. It now seems evident that the Christmas card is a culturally specific artifact, a very distinctive and even idiosyncratic way that a fundamental and enduring human gesture could be expressed within the commercial, materialistic, and rapidly changing society that the United States was during the first half of the twentieth century.

Christmas today embraces a rich and complex aggregation of sometimes incongruent beliefs, customs, and activities of multiple and varied origins. Partly religious and partly secular, the modern Christmas engages mind and memory as it celebrates and rewards the senses. The power of Christmas derives in part from the strength and appeal of its repeated rituals and the presumed antiquity of its traditions and in part from its structural flexibility and ability to adapt to changing cultural conditions. Whatever it is that Christmas embodies—and opinions vary—it is clear that the holiday meets deep-seated cultural and psychic needs.

Christmas has become a celebration of many components, among them carols, trees, gift-giving, Santa Claus, stockings, feasting, merriment, eggnog, chestnuts roasting on an open fire, and a good deal more. Much of this has been examined in the considerable scholarly literature on Christmas that has emerged in the last few decades. (We commend the titles in the bibliography to readers interested in learning more.) Since the middle of the nineteenth century, Christmas has also meant Christmas cards, but for some reason these have been nearly invisible in the scholarly literature.

At the most fundamental level, Christmas cards are "little messengers of good will," as one trade catalogue from 1925 put it. But they express more than that simple sentiment, for since their earliest days, Christmas cards have incorporated images as well as texts and usually prominently so. Images are critical components of Christmas cards precisely because they suggest meanings that are both richer and deeper than what words can efficiently convey. This is, indeed, the central premise of this book. A secondary premise is that the study of images on Christmas cards used in the United States from about 1900 to the end of the 1950s enriches our understanding not only of the American Christmas but also of significant aspects of the larger American culture. In short, Christmas cards are a category of American material culture rich in documentary potential. They are also, and this too is consequential, rich in sensory delights.

Christmas cards occur at the intersection of two great cultural traditions—Christmas, on one hand, and tangible expressions of good will, of which greeting cards are modern manifestations, on the other. Each has its own very long history and deep grounding in human culture. Ritual celebrations and systems of exchange are anthropological constants, found in one form or another in most of the world's societies. American Christmas cards are specific formulations of more general human inclinations and may be thought of as layered artifacts, with a shallow and shifting American surface covering but not concealing an enduring and universal ground.

In privileging the images on Christmas cards, we ignore other important aspects of the genre. We do not, for instance, offer a history of the industry or histories of individual firms, entrepreneurs, or designers. We do not examine developments in the printing industry or in the production of papers or inks. The retail trade and matters of distribution, advertising, and display we take for granted, and the complicated matter of gendered labor within the business we leave for others to explore. One important omission we acknowledge involves the important matter of work. Christmas cards do not simply happen,

nor do they sign or send themselves. As with so many other instances of cultural maintenance and performance, the weight of the domestic Christmas card ritual has historically fallen primarily on women. Memories, oral histories, and the evidence of gendered signatures all affirm women's primary role in signing, sending, and, probably, selecting Christmas cards. In houses with servants this may have imposed little burden, but for many housewives, the weight of the Christmas card ritual was added to an already over-heavy holiday season. Surely there are exceptions, but the general pattern of Christmas engagement meant much work for women and relatively little for men.

In addition to the seasonal labor associated with sending cards, there was, for some, the additional effort of maintaining the social account. Christmas cards were not glibly sent to whatever names came to mind but were exchanged as part of a fairly demanding and regulated ritual of social equilibration, a card for a card, so to speak. Many households kept tallies of cards in and cards out. If B sends us a card, we must send a card to B. But what if B did not send one this year? Do we send? How long should we keep B on our list of prospective card recipients? But what if something terrible has happened to B, which is why there is no card? When to send, when not to send? How do we avoid hurt feelings, whether theirs or ours? All a delicate dance of social maintenance and not necessarily enjoyable.

And so it is understandable that some people—some women, perhaps—do not find Christmas cards particularly engaging. The authors of this study, on the other hand, came to the land of Christmas cards as tourists, happy to sample some of the local customs and to see the sights, but outsiders to the society and its inner burdens. But isn't studying historical material culture usually like that? The blessing and the curse of material objects is that they are opaque, regardless of substance. We are captivated by their surface charms and cannot easily see through them to the human conditions from which they emerged or in which they once engaged. In any case, isn't it true that nothing of value is created without effort? Is it not also true that work

is never evenly or even fairly doled out in this world? But perhaps we only attempt to justify the stereotypical male gaze. For what it is worth, also intentionally not studied here are patterns of household card display and the whole matter of preservation. How is it that so many cards still survive?

THE CARDS

Because method shapes outcome, intentionally or otherwise, it may be helpful to explain the processes that shaped this book. The pedagogical objectives, which were fairly abstract, are outlined in the preface. But once those conditions were met, the next requirement was to map out a strategy to meet project-specific objectives. These were three: 1) to examine Christmas cards that circulated in the United States between roughly 1900 and 1960; 2) to determine what, if any, patterns may be evident over the course of those years; and 3) to report our findings. This all appears straightforward on the surface. But what is the best way to examine cards? Far too many were produced, and, in fact, far too many survive to make examination of even a small percentage of extant cards feasible. Some sampling technique would have to suffice.

Our sample consisted of a private accumulation of approximately 6,000 cards, all obtained over a period of a few years through the conventional open market venues—antique and secondhand stores, yard and garage sales, flea markets, and the Internet. Although a few cards were purchased singly, most were bought in lots, sometimes of a few hundred. The lots came from different parts of the country, but the accumulation ended up heavy in cards from New England, New York, and the West Coast, with only a smattering from the South and Midwest.

It is legitimate to wonder how representative our sample actually was, since 6,000 is a statistically insignificant fraction of the millions of cards actually produced. And so we tested our sample against cards that came on the market while our study was under way.

This was made easy by the many vendors on eBay who took time to describe and illustrate their offerings of Christmas cards. Sporadic examinations of vendors' lots of cards from various parts of the country indicated that our sample was indeed representative, but they also revealed another point. In looking at any set of one hundred or so cards, we could see that the cards paralleled our accumulation. The basic themes (about which more later) were the same and in about the same proportion, but in any set of one hundred cards (or any five sets, for that matter), actual duplication of cards was insignificant. In fact, within our own sample, there were not more than twenty duplicate cards, indicating an extraordinary level of design diversity within the genre. But that diversity took place within a framework of relative thematic consistency. In short, we might see in sale lots depictions of travel by coach or the three kings that were new to us, but we did not encounter new categories of imagery. The moral of all this is that we believe the categories of imagery presented here, with the provisos offered later, are representative of the genre at large. If we were to encounter 10,000 more vintage cards, we would surely find thousands of images we had never seen before, but the vast majority would still conform to the basic categorical system we outline here. Examination of period trade and sales catalogues led to the same conclusion.

The chronological emphasis ranges from about 1900 to 1960. At the outset we recognized that cards before 1900 already had a literature. Furthermore, historical societies regularly installed small exhibitions of Victorian-era cards each season, so these cards were already familiar, if only superficially so. On the other hand, including cards after 1960 would have made the study less historical and more contemporary and therefore a different enterprise altogether. The era before 1960 was foreign terrain to the students. None had been there. Concentrating on that period made pedagogical and strategic sense. It also saved us from having to critique, even implicitly, the products of companies still in business, which was not our objective.

The procedures for sorting and classifying cards are not self-evident. Our second project objective was to identify patterns in the cards over time. But which patterns should we emphasize? There were several. For example, the general drift of the cards was from relatively simple to increasingly complex. Early cards with a single printed surface were succeeded by single-fold cards, then by French-fold cards, and finally by augmented French-fold cards. Then there was the matter of style, expressed in design gestures, in color selections, and even in papers used, whether embossed, imitation parchment, or other variations. Many cards from about 1935, for instance, have a quite distinctive look. Size varied over time as well, progressing from smaller to larger. What was constant in the cards, however, was imagery. Once we recognized that the primary function of Christmas cards was expressed through ritual exchange of images, images became the focus of our attention. That means that this study does not embrace the entire artifactual performance of Christmas cards. We focus on a part of the whole but argue that this part is the most important and most culturally articulate feature of the whole.

The categories that appear here are as empirically based as any classification of material culture can be. Most are obvious and, once recognized, surprisingly consistent. Only the category we call "winter" might be described as fabricated, since it combines several different types of imagery. That said, however, three points are worth making. First, the categories described here represent major pictorial concentrations within a broader landscape of lesser themes and various experiments, trials, and alternatives that, for whatever reasons, did not become dominant. Each of the following sections addresses one of these major pictorial themes or types. It should also be noted that throughout the period a few cards bore only text, albeit typically beautified in some way.

Second, our selection here privileges more or less "pure" illustrations of each genre. Understand that many categories can be commingled with others and often were. We have isolated candles and poinsettias,

for instance, but they frequently appear together on cards. We also had to make judgment calls, since it was not always clear how to classify some images. Ships were very straightforward, for the most part, as the images here reveal. The category we call "couples" proved more problematic, since couples sat before open hearths, went visiting, rode in sleighs, made music, and otherwise strayed into other categories. And so you will find couples as a concentration but also couples elsewhere. So too with the three-part compositional device we called a "shrine."

Third, we have omitted a few categories that were distinguishable but either unremarkable or less frequently encountered. Among the first were depictions of holly, which were nearly ubiquitous on cards as seasonal garnish but less often dominant images and less often visually engaging compositions. Among the second were bells, an unlikely subject for depiction, considering the fact that bells are more notable for sound than for their appearance. Over the years, designers repeatedly tried their hands at bells, but the category yielded few cards of distinction.

Although the cards included here document dominant patterns of pictorial emphasis within each category, they are not simply cross-sections of the genre. We have made aesthetic choices. What you see are what people with some degree of visual literacy and sensitivity would consider "better" cards, examples of capable design and competent printing. A few—even many—are quite wonderful.

THE IMAGES

Above all else, Christmas cards are about images. Most cards include words, but images have primacy. With few exceptions, the dominant pattern is image first, then words. Or image large, words small. The hierarchy is clear. Images take ontogenetic priority over words. Any who see can make some meaning of an image but only those who are literate can make meaning of words. But images are vague and imprecise in their meaning, no matter how precise in their details. Although

an image may be static and unambiguous, its meaning is fluctuating, contingent, and personal, constructed and configured by myriad formative and conditional factors. Images may appear simple, but the meanings people make of them may be anything but.

It is worth wondering why the Christmas card industry offered customers so many different categories of imagery. One obvious answer is because the public bought them, but that begs the question. Like many other classes of consumer goods, Christmas cards allowed for the process of mass pseudo-individuation, artifactual reification of the notion that we are all distinct individuals. As with furniture, dishes, silverware, and other household furnishings, diversity in Christmas card imagery allowed people to decide how to represent themselves, whether through ships or three kings, music makers or Christmas trees. The extent to which such decisions were consciously thought through is debatable, but at some level people did make choices, as surviving cards document.

The range of categories exhibited here embodies diversity in intriguing ways. Some subjects are depicted as in the present, but many more Christmas card scenes seem to be set in some vague and distant time and place. This is the process of displacement at work. Displacing a cherished ideal or value to an imaginary location keeps it safe, something people can still believe in. Even if the world is not full of joy and merriment, we can nonetheless depict scenes of joy and merriment taking place somewhere once upon a time. Surely it was once the case, so surely it can be yet again. In this sense, Christmas cards represent the more generous inclinations of the species and allow a glimpse of what it would be pleasant for the world to be like. Christmas cards depict things we would like to believe in, and displacement makes that possible. Archaism is related to displacement in that it too represents some other time, in this case some earlier time. It also serves to suggest historical continuity, albeit often falsely, and is a way of claiming historical depth for what may in fact be a chronologically shallow tradition.

If cards are benign fantasies, however, it is fair to wonder about issues of inclusion and exclusion. Who appears on Christmas cards and who does not? Admittedly, some categories of imagery rarely include people. Candles, poinsettias, ships, and even houses often appear alone, leaving viewers to supply human actors in their imaginations. Otherwise, people depicted are predominantly white, at least until the middle of the twentieth century. Whether this pattern merely indicates the European origins of the modern American Christmas, or is evidence of social blindness or overt racism or some combination thereof, is open for discussion. Avoiding depictions of people sidesteps the issue of inclusion and exclusion entirely, however. Images of cute dogs, cats, and snow people also keep recognition of difference at bay. Some racist cards were produced in the period studied here and still survive. Our sample included only one (but half a dozen stereotypical frugal Scots); we chose not to include it.

All of that said, however, the matter of depicting difference—or, more exactly, not depicting it—is highly complicated. Difference, after all, is often made the rationale for perpetrating great evil in the world. Difference takes many forms. It is not just color but also gender, class, ethnicity, age, education, politics, ideology, worldview, values, or matters such as health, physique, or attractiveness. It could be argued that cards depicting a world without difference are utopian visions of a world without conflict, a world where there are no others to demonize and destroy.

There is also the social reality that, given the choice, most people prefer to be in the company of people like themselves. Different folks may live next door, and in a tolerant society we would expect to greet them with a smile but not necessarily to be close friends. People of a similar age, of a similar background, and with the same values are the ones we prefer to be closest to. (For endless reasons, we leave families out of this discussion.) Presumably, at least some Christmas cards go to close friends, people with whom we really do have a lot in common. In such cases of sameness, there is no point in depicting difference.

Otherwise, however, depicting difference is potentially problematic because once the concept is introduced, there is no controlling the meanings that will be made of it. In Christmas cards, denying difference may be situationally functional. There are other occasions for political statements. In the end, however, it remains true that prejudice, bigotry, and discrimination were widespread in early twentieth-century America and that racial and ethnic slurs could once be heard on every street corner.

The exclusions visible in these cards are instructive reminders of the cultural and geographic origins of the modern Christmas and of Christmas cards. Both were generated in the early nineteenth century in Great Britain, at the time the world's dominant power and most fully modernized nation. If there is a single founding document for today's Christmas, it is Charles Dickens's *Christmas Carol* of 1843. John Callcott Horsley's card of the same year is the prime object from which subsequent cards develop. Both are Anglocentric and oriented to domesticity and family. And although both acknowledge a Christian context, it is clear that their emphasis is on a domestic celebration with some slight religious associations and not the reverse. This has significant ramifications.

In the first place, it helps to account for the relative paucity of cards with explicit Christian references during the first few decades of the twentieth century. In the second, it explains something of the success of Christmas in becoming a national and, in recent years, increasingly international holiday. The American Christmas and the American practice of sending Christmas cards, both products of American WASP culture, were gradually adopted by immigrants to America of varied national backgrounds and were themselves changed in the process. In fact, holiday and cards played critical roles in the process of Americanization. When Jews decided to send Christmas cards, for instance, they did so in an effort to become more fully integrated into American society, not to become Christians. Cards bearing the salutation "Season's Greetings" could be seen as circumlocutions of sorts that allowed

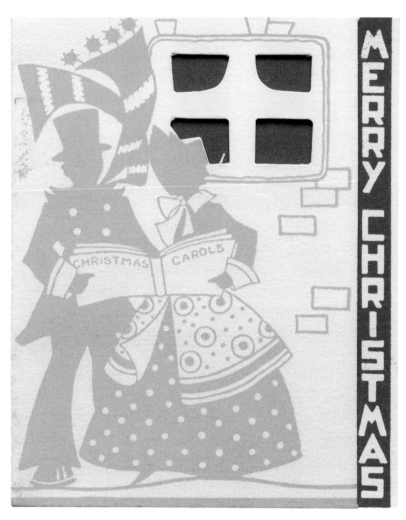

Modified single-fold card
4⅛ x 3⅜ inches
Green and red lithography on cardstock,
die-cut openings at windows, short fold at right
ca. 1935

recognition of the holidays without concession to religion.

Our emphasis on images has both strengths and weaknesses. The strengths, we think, are similar to those of any concentrated or focused study. We see only one thing, but we hope to see it clearly and thoroughly. The weaknesses are typically linked to exclusions and omissions. Christmas cards can be complicated artifacts. Rarely do they consist of image only. Nearly all bear words of some sort, whether printed salutations and greetings or handwritten signatures and notes. Although flat cards are fairly straightforward, with printing and signatures all on one surface, other cards are more multidimensional. Postcards, for instance, offer the generic, from-the-publisher text and image on one side and the personalized address and message on the other. Single-fold cards resemble postcards in content, although they differ in form. French-fold cards may combine images and texts on three surfaces (and on rare occasions, even four) and may be thought of as sequenced performances—and more elaborated artifacts than we mean to engage. Our study is not entirely unlike looking at book covers but not attending to the content within, or perhaps more accurately, looking at gravestone imagery but ignoring the texts cut into the stone.

Exactly how salutations and messages relate to imagery is worth wondering about. The topic is discussed in the trade literature and in handbooks for those who would design Christmas cards. Among scholars, Barry Shank has examined card images and texts within their original social contexts by turning to biography as an interpretive tool, an approach that yields instructive results but is not always feasible. In truth, there are many different exploratory strategies that we could have adopted in our study, but we limited ourselves to one. Perhaps, provoked by what they take to be our shortcomings, others will want to explore these objects from additional perspectives. We hope so, anyway.

Taken as a whole group, the images here may be understood as a lengthy and ongoing artifactual symposium exploring the question

of what Christmas cards should actually look like. Should a Christmas card depend on mimetic imagery or should it invoke stylization? Should a card be an industrially printed reproduction of an oil painting or should it be a short-run original print? Cost was always an important factor in determining how to proceed, but medium and means shape the affective power of the product and its attractiveness to different buying publics. The range of options explored over the period studied here is considerable and constitutes another dimension of the richness of the history of American Christmas cards.

THIS BOOK

This book is conceived as a field guide of sorts, intended to provide an orientation to the most prominent classes of Christmas card imagery. It consists of twenty-five sections, each devoted to a separate category of Christmas cards. The first four sections examine cards of the nineteenth century, postcards, calling cards, and a distinctive period compositional device we have called "shrines." The next twenty sections explore individual themes, starting with winter and ending with humor. A final section looks at business cards, a category defined by sender rather than image.

The organization of each section is much the same, consisting of a selection of representative cards, a short interpretive or exploratory essay, and a timeline. The images and essays are largely self-explanatory, but perhaps a few words should be said about the captions or tombstones for the cards and then about the timelines. Data for the cards appears in the following sequence:

1 Type of card, i.e., flat card, postcard, calling card, single-fold card, French-fold card, or booklet. The terms "modified" or "augmented" may also appear when relevant.
2 Dimensions. Height followed by width, front face of the card only unless otherwise indicated, given in inches to the nearest ¼6.

Because the size of postcards is standardized at approximately 5½ x 3½ inches, measurements for postcards are omitted.

3 Printing process and material (i.e., chromolithography and embossing on cardstock, etc.).

4 Date. Dates preceded by "ca." (circa) are approximations based on stylistic features and/or similarities to dated examples. All other dates are based on postmarks or inscriptions written by senders or recipients and are presumably accurate. In case of mailed postcards, cards with envelopes, and some business cards, the locations of senders and/or recipients are listed.

5 Publisher if known and publisher's city and state. We have standardized some of this data; it does not necessarily appear here as it does on the card. When a card indicates made in U.S.A., we have so noted.

6 Artist or designer if known, with dates, if found.

7 Comment (rarely).

Flat cards are typically printed on heavy paper or cardstock, with an image on one or, less often, both sides. Postcards are variants of flat cards, usually bearing an image on one side and a space for message and address on the other. Calling cards are also usually flat cards, with minimal text and reserved or understated imagery. A single-fold card is made from a sheet of cardstock or heavy paper folded once, usually vertically, so that it opens from right to left, like a book. The one fold creates four surfaces; the major image is generally printed on the first or front surface.

French-fold cards are conventionally printed on paper rather than cardstock. The sheet is folded twice after printing, usually first horizontally and then vertically. This creates eight surfaces, four interior and four exterior. The four exterior surfaces are treated in the same manner as a single-fold card. Booklets are literally small books, characterized by a cover of heavy stock over paper pages within. These usually open in the manner of books; binding is often with ribbon.

In addition to these six types, some cards may be described as either "modified" or "augmented." Most frequently, these terms apply to single-fold or French-fold cards. "Modified" means altered in some way, often by trimming or shaping one or another surface for special effect. "Augmented" refers to cards with something added, generally applied to the front or inserted behind it. The fertile imaginations of designers are matched by the innovative capabilities of printers, so in actual practice the terms "modified" and "augmented" may designate a considerable range of variations on standard formats. On rare occasion, double-fold cards also appear and are described when they do.

On the matter of printing processes and materials, our descriptions should be understood as guides rather than as definitive assessments. Specialists may, in fact, find our terms too primitive. Most cards of the twentieth century were produced by some variation of lithography, although a fair percentage, especially early on or at the upper end of the market, were engraved. It was apparently commonplace within the trade to emulate expensive processes and materials with less costly alternatives. Often, what superficially looks like an engraving or etching is a lithographed evocation thereof. Hand-coloring is also emulated through industrial processes. Thus some Christmas cards misrepresent themselves. Cards marked "original engraving" or something similar may be photo-mechanical reproductions of engravings and not the real thing at all.

We have distinguished between cardstock and paper. Cardstock is thicker and firmer than paper and, although sometimes folded, does not readily bend or flex. Paper, by contrast, is thinner and more flexible and may be easily bent without damage. Both of these paper products were manufactured in considerable and impressive variety, only some slight sense of which can be conveyed in the images included here. Cardstock may be monochromatic in any number of hues, composed of mixed materials that include strands or flecks of contrasting color or surface-printed or laminated for special effect. Papers are equally varied. Some remarkable surfaces appear in the 1930s, apparently

created by rolling or pressing dies onto one face of the paper. This results in intricate and fascinating patterns of swirls, interlace, facets, or crystal-like shapes, which are difficult to photograph and more difficult to describe but important to the visual impact of the card.

Captions list the name of a publisher when that data appears on a card. We have made no attributions or attempts to identify manufacturers of unmarked cards. Interest in labeling cards was evidently uneven within the trade. Some firms, A. M. Davis of Boston, for example, seem to have marked all their products, while others (we don't know which, obviously) marked few or even none of their cards. Even less often does the name of an artist or designer appear on a card. Behind our apparently deadpan listing of a few names and dates—and the more common absence thereof—lies the complicated world of the visual arts in these United States in the earlier half of the twentieth century. Who designed these cards? So often we have no idea. But it is quite clear that people of talent, many men and most likely even more women, worked anonymously within publishing firms or sold their designs to whoever would buy them. Some inkling of how the system worked is suggested in Kate Douglas Wiggin's short novel of 1916, *The Romance of a Christmas Card*. In this charming tale, set in a fictional small town in New Hampshire, everything comes out well in the end because of the male lead's chance encounter with a Christmas card. The card, designed by the central female character in the story, was sent off to a Chicago publisher, who bought, manufactured, and distributed it. How this designer knew of the distant publisher is not entirely clear but designing "on spec" for submission to publishers was probably commonplace in the card industry, paralleling a similar practice in book and magazine publishing.

Many lessons may be derived from a study of these Christmas cards. One that seems particularly clear is that whereas design talent was abundant, opportunities for fame and cultural glory were not. Designing Christmas cards paid the bills but did not lead to recognition or reputation that extended outside the trade. Not only were

people in the industry generally out of sight, but the times were out of joint as well. Between the economic effects of the Great Depression and the incursions of photography, work for design professionals was limited for years during the first half of the twentieth century. It is worth recalling that this period also produced *The Index of American Design*, an overtly make-work project intended to employ out-of-work artists. Christmas cards were probably designed by people who were glad they had the opportunity to do so, as well as by others who would have been much happier working in some other area of design that meant more to them.

Some of the cards included here bear illegible names of designers or initials we were unable to link to known figures. Some names are wholly legible but could not be located in standard printed sources or on the Internet. On the other hand, a number of the designers whose work appears here are very well known—Maxfield Parrish and Rockwell Kent in particular—while others are extensively recorded and by no means obscure. What is also apparent here, however, is the great cultural divide between illustrators and so-called fine artists. Art historian Michele Bogart has traced the development of this two-tier system, which lionizes a few heroic figures, whose work becomes canonized and costly, while generally devaluing any design work that smacks of being done for hire.

Exploring the intricacies of this bizarre cultural system is beyond the scope of this study, but it is worth noting that attempts to exploit the presumed cachet of the fine arts appear within the genre of Christmas cards. Products marketed under the brand of American Artists, Artists and Illustrators, Irene Dash, and occasional others, often with a New York connection, deliberately deviate from the prevailing industry practice of not naming designers by providing sometimes extensive artist documentation, similar to what might be encountered in a museum or gallery. The irony here is that while the image may be based on a drawing, watercolor, or oil painting of some considerable merit, the industrial lithographic reproduction of it is often mediocre at best.

As this little paradox suggests, cultural strands both major and minor intersect in the realm of Christmas cards. The number of ways to approach these objects is considerable; out of all the many possibilities we look only at the images. But that single facet of this multifaceted phenomenon is rich in the extreme.

Finally, readers should note that all cards discussed are authentic; there are no reproductions. All were presumably exchanged by adults, although this cannot always be determined. No names have been changed for any reason. These are real cards sent by real people.

The timelines that accompany most sections serve two purposes. First, they provide information that could not be introduced and developed in short essays without transforming them into long essays. Second, they suggest context for the cards, sometimes narrowly defined and sometimes far broader. Extending the argument that, rather than representing the world, Christmas card imagery engages the world, we felt that it seemed not merely appropriate but necessary to provide references to ongoing activities in the world as they unfolded in the years treated here. The Christmas card, like the Christmas celebration, enters a world already in play. Never assume that what does not appear on Christmas cards does not exist. Christmas cards are selective and purposeful commentaries on, critiques of, and responses to the dynamics of the larger world. Individual senders and recipients interpret card imagery against that backdrop and against the immediate concerns and constraints of their own lives. In some instances, the larger world and personal lives may intersect, and painfully or tragically so. Put otherwise, the timelines identify concurrent events and phenomena, some germane to Christmas cards and others less obviously so but all relevant to the human condition. The twentieth century has had its moments of merriment and mirth, and its occasional admirable episodes of cultural, social, political, scientific, and medical achievement as well. But if it was the best of times for some, it was also the worst of times for others. In the first sixty years of the century, Americans walked through their share of dark passages,

among them World War I, the pandemic of 1918, the Great Depression, and World War II, and were subject to assorted bigotries, discriminations, repressions, witch hunts, and blacklistings, as well as the usual litany of woes that pockmark all lives at some point. The idea behind the divergent entries in the timelines was to prompt thinking beyond the narrow confines of Christmas cards, with their purposefully constrained spectrum of pictorial referents, to the larger messy world against which those images are projected. The entries identify matters large and small, some affecting many, others only a few, some of grave consequence, other of trifling import. All, any, or others unlisted may have helped shape the meanings that one person, several people, or many made of Christmas cards in the past. There was no single meaning for any card here.

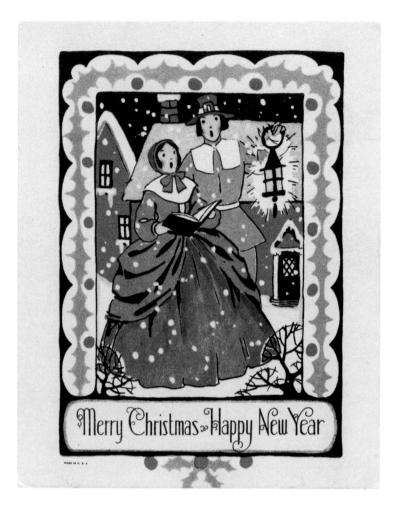

Flat card
4⅞ x 3⅞ inches
Black and color lithography on cardstock
ca. 1925
Made in U.S.A.

THE CARDS

Cards of the Nineteenth Century
Christmas Postcards
Calling Cards
Shrines
Winter
Candles
Poinsettias
Three Kings
Travel by Coach
Ships
Medieval Revels
Houses and Homes
Hearths
Music
Couples
Visiting
Santa and the Children
Christmas Trees
Christian Christmas
Churches
Family Photographs
Warm Places
Cute
Humor
Business

CARDS OF THE NINETEENTH CENTURY

Cards of the nineteenth century have been collected and studied since they first appeared in England in the 1840s. We make no claim to adding anything new to that study. Our purpose in introducing a small selection of nineteenth-century cards here is to provide a benchmark from which to measure continuities and changes in the twentieth century. Both are readily apparent. The chief enabling factor behind Christmas cards of the Victorian era was the newly introduced technology of chromolithography. With this sophisticated process, brilliantly colored printed images became commonplace for the first time. Although our focus here is on Christmas cards, it is important to recognize that these cards emerged as part of a broader international wave of color printing, which included book illustration, magazine covers, posters, advertising, packaging of all sorts, greeting cards for other occasions, various wrappings, certificates, tokens, trade cards, and luxurious and ephemeral paper products beyond number. Many of these are today preserved in scrapbooks, themselves iconic artifacts of the late nineteenth century.

Christmas cards celebrated this new technology of color printing. The typical Christmas card of that era is an elegantly crafted polychrome essay, usually highly naturalistic or mimetic in its rendering of a subject deemed appropriate as a Christmas offering. But Victorian notions of what was appropriate for a Christmas card and twentieth-century notions are quite different. Although nearly any piece of cultural flotsam or jetsam might appear on a Victorian card (and did; see the bibliography for examples), the major subjects were flowers, children, and landscapes. Among flowers, roses predominated. By no means the most exquisite of the images produced, some of the depictions of roses offered here, as well as those of other flowers, are impressive for their verisimilitude, which was exactly the objective. The best of floral chromolithographs rival the best of the still-life paintings they emulated. These impressive bits of gloriously printed paper, these very pretty pictures, were considered wondrous enough to constitute gifts

1843 London, December 17. Charles Dickens's *Christmas Carol* is published; it remains in print ever after.

1843 In London, John Callcott Horsley designs the first Christmas card of the modern era for cultural activist Henry Cole; 2,050 cards are produced for sale.

1845 Boston's Anti-Slavery Office publishes *Narrative of the Life of Frederick Douglass, an American Slave, Written by Himself.*

1850 Louis Prang eludes the Prussian government by fleeing to the U.S.; he later becomes America's leading publisher of chromolithographs.

1852 Harriet Beecher Stowe, whom Abraham Lincoln is said to have called "the author of this great war," publishes her novel *Uncle Tom's Cabin.*

1854 Philadelphia. Timothy Shay Arthur's melodramatic temperance novel, *Ten Nights in a Bar-Room and*

What I Saw There, first appears.

1868 In Boston, Louisa May Alcott publishes volume I of *Little Women*, which is an immediate success.

1868 Horatio Alger issues *Ragged Dick* in book format; the inspirational rags-to-riches story introduces a formula he often repeats.

1869 April 6. The American Museum of Natural History is established in New York City.

in their own right. Seasonal imagery as the twentieth century came to understand it was not a significant focus or requirement of these cards. Depictions of well-dressed and well-scrubbed children involved in any number of activities or merely looking sweet parallel the period interest in childhood, but these too typically avoid specific references to winter or even to Christmas. Much the same is the case for the many images of birds or snippets of landscape that were printed and sent.

Cards of the nineteenth century gradually changed over time and responded to a number of fads and fashions of varying duration and significance. One that is somewhat startling today was the taste for fringed cards that appeared during the 1870s and 1880s. Aberrant though these may seem, they were part of a larger household textiling mania, which involved rugs on top of rugs and the proliferation of lambrequins, parlor throws, and other bits of fabric that were understood to help civilize and soften domestic interiors.

Far more significant for future Christmas card design, however, was the introduction of the picturesque composition, a design strategy that likewise emerged in the 1870s and 1880s. Prompted at least in part by the Europeans' discovery of Japanese design, this new mode was characterized by superimposed or overlapping pictorial fields, often suggesting a print or panel of some sort on top of, in front of, or tucked into an apparently unrelated scene or image. This trompe l'oeil game or playful fusion of illusion and surprise continued into the early twentieth century, where it became, with some modifications, the standard compositional device of Christmas postcards.

The Christmas cards exchanged in nineteenth-century America were manufactured in Britain, Germany, and the United States. Their design vocabulary was international.

1870 April 13. Incorporation of New York's Metropolitan Museum of Art, founded by prominent citizens, among them painter Eastman Johnson.

1873 Neighbors Mark Twain and Charles Dudley Warner in Hartford, Connecticut, collaborate to write *The Gilded Age*; the book subsequently gives its name to an era.

1876 May 10. The Centennial International Exhibition opens in Philadelphia's Fairmount Park and attracts about 10 million visitors.

1878 W. Atlee Burpee & Co. established in Philadelphia and begins selling vegetable and flower seeds by mail.

1879 October. English author and illustrator Kate Greenaway publishes *Under the Window: Pictures and Rhymes for Children* and popularizes a distinctive style of children's dress.

1885 February 18. First American printing of Mark Twain's still controversial *Adventures of Huckleberry Finn*.

1885 Scottish writer Robert Louis Stevenson publishes *Penny Whistles*, better known by its subsequent title, *A Child's Garden of Verses*.

1894 Dublin-born author and aesthete Oscar Wilde publishes *The Importance of Being Earnest*.

1895 Gleeson White issues *Christmas Cards & Their Chief Designers* as a supplement to the British journal *Studio*, documenting the aesthetic achievements of the genre.

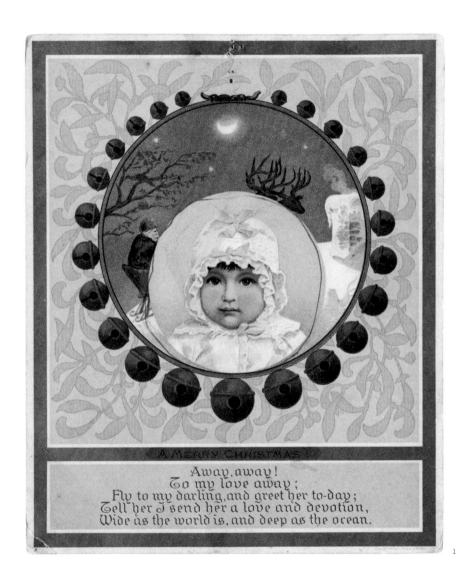

A MERRY CHRISTMAS

Away, away!
To my love away;
Fly to my darling, and greet her to-day;
Tell her I send her a love and devotion,
Wide as the world is, and deep as the ocean.

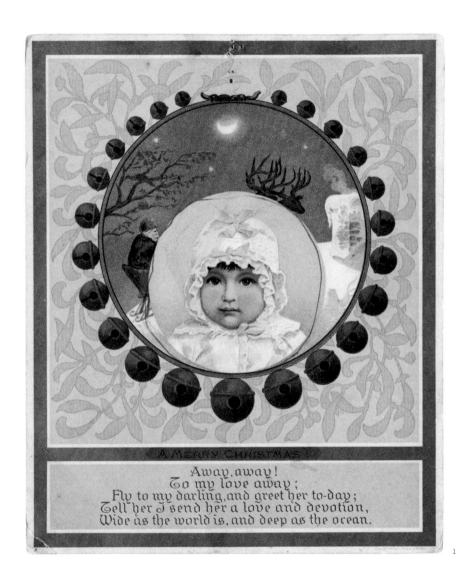

2

3

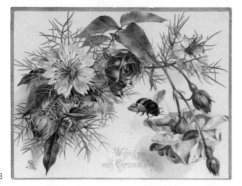

4

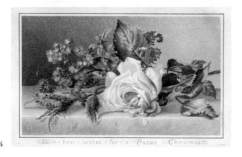

5

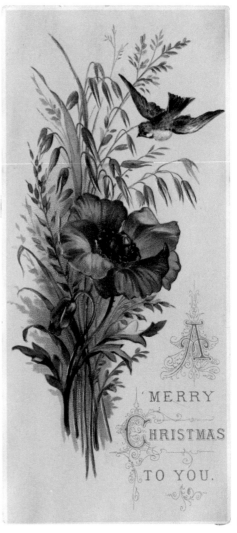

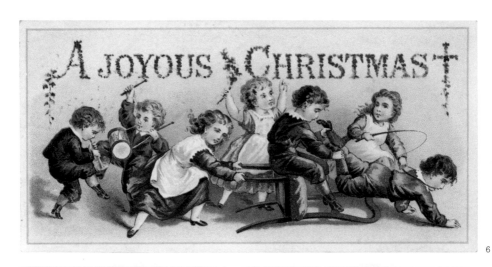

6

BRIGHT BE THY CHRISTMAS.

7

A merry Christmas to you.

8

A Christmas Greeting.

Mirth and music,
Songs and glee—
In your home
This Christmas
be

9

Wishing
you a joyful
Christmas
and a happy
New Year

10

A Joyful Christmas; A long and Happy Life.

11

A merry CHRISTMAS

12

en you
Heaven's
blessing dwell
CHRISTMAS,
and all
times as well!

13 A GLAD NEW YEAR TO YOU.

"Birds of a feather flock together",
So people say.
I wish that we might be together
On Christmas Day.

14

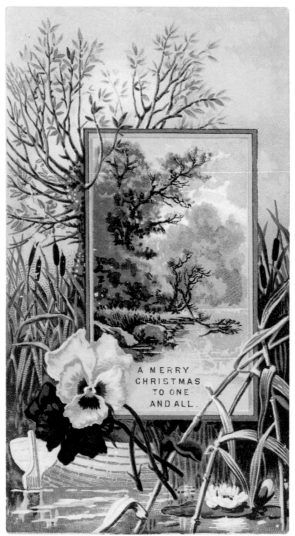

15

CHRISTMAS POSTCARDS

Thousands of Christmas postcards still survive, residue of the postcard mania of the first decade of the twentieth century. The range of pictorial, compositional, and printing strategies employed by postcard designers and publishers was considerable and constitutes far too broad a subject to explore here. Instead we offer a small selection of typical and commonplace Christmas postcards and pass over the quirky or rare. But even commonplace cards are remarkable artifacts in their own right, notable achievements in the history of quality printing for the mass market. And when we see them sandwiched between cards of the nineteenth century and those of the second decade of the twentieth, it becomes apparent that postcards played a pivotal role in the formulation of what later became the traditional American Christmas card.

What postcards derive from their nineteenth-century antecedents is the continued exploitation of chromolithography, now routinely enhanced by embossing and gold and silver inks, and the eccentric composition sometimes known as picturesque or picturesque sentimentalism. This form of design play involves overlapping planes, varied and inconsistent scale, elements of trompe l'oeil, and a fair degree of spatial ambiguity. Some of the later cards in the nineteenth-century section illustrate variations of this mode. In a slightly altered and somewhat more formulaic manner, the same mode appears on more than half of the postcards shown here.

The origins of this eccentric vision seem to lie in the Japanism that swept Western design from the late 1860s onward and, before that, in the playful juxtapositions of eighteenth-century rococo that were revived throughout the nineteenth century. Overtly Japanese or rococo design elements are not apparent on the cards, but their lessons were evidently learned well. This mode of pictorial organization, however, dies with the postcard.

More notable for the future of Christmas cards is the fact that Christmas postcards articulate a distinctive seasonal imagery. This is a new and important development. Embossed evocations

1847 First U.S. postage stamps issued. The five-cent stamp depicts Benjamin Franklin, the ten-cent stamp George Washington.

1873 The U.S. Post Office introduces pre-stamped one-cent postcards.

1874 The Treaty of Bern establishes the General Postal Union, in 1878 renamed the Universal Postal Union

in recognition of its critical role in facilitating worldwide postal service.

1896 The Post Office begins rural free delivery.

1901 The text on the back of U.S. postcards now reads "Post Card" instead of "Private Mailing Card, Authorized by Act of Congress of May 19, 1898."

1907 Postcard backs are now divided into two sections, one for the message and the other for the address.

1909 The Payne-Aldrich Act imposes protectionist tariffs that affect the importation of foreign postcards and printing materials.

of ice and snow, brightly colored sprigs of holly, frosty rural landscapes, and other wintry references now become commonplace. In turn, the generic pretty picture of the nineteenth century has become extinct.

Christmas postcards have their own distinctive properties as well. Many share a certain complexity of mood that distinguishes them from both earlier and later cards. Consider any of the first half dozen cards illustrated here and note text, seasonal garnish, and central image. The text is typically bright (literally) and cheerful, the garnish of holly or poinsettia colorful, but the central image, usually a landscape, is often somber and subdued. These scenes are generally formulaic, depicting a small hamlet with a church or a few rural buildings in a muted winter environment. One or two figures or an occasional flock of sheep may be present, but the scene is quiet and gray in color and mood. Perhaps text and garnish are meant to counter the uninviting landscape. Perhaps all features are meant to be read as parts of an interrelated and complicated seasonal whole. Whatever the case, the affective intricacy and ambiguity of these cards are among their characteristic features.

The Christmas postcard industry was concentrated in Germany, long recognized as the center of the printing world. The cards were made for and sold to an international market, with texts printed in appropriate languages. This explains the European flavor of the landscapes which, while none too particular, are clearly not American. In quick succession, the collapse of the postcard fad, emerging trade restrictions, and war all conspired to shut down the German Christmas postcard export business, leaving the field open to American publishers. The sections that follow record American contributions to the history of the Christmas card over the succeeding half century.

1914 World War I begins. European printing houses and exporters encounter hard times, prompting the development of the U.S. greeting card industry.

1916 To increase the efficiency of letter carriers, the Post Office mandates mail-boxes or mail slots at every address.

1918 November 11. World War I ends. Later, war surplus trucks and airplanes are donated to the Post Office.

1920 The Post Office operates the world's largest fleet of civilian vehicles.

1929 Post Office officials purchase 400 Ford AA trucks for use as a standard vehicle fleet.

1963 The Post Office introduces postal ZIP codes.

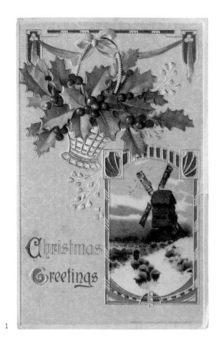

1

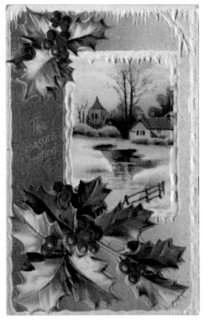

2

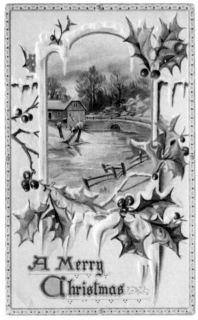

3

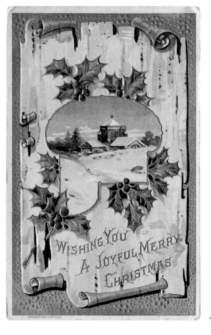

4

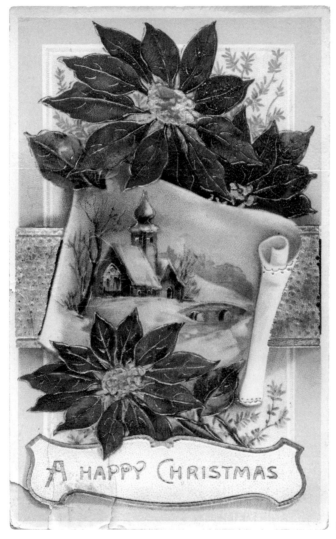

A HAPPY CHRISTMAS

5

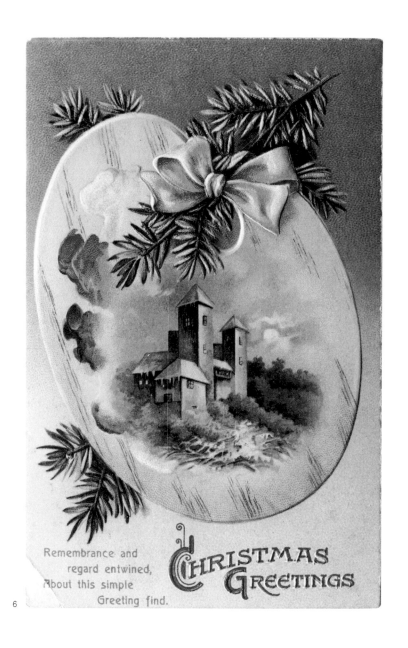

Remembrance and
regard entwined,
About this simple
Greeting find.

CHRISTMAS GREETINGS

6

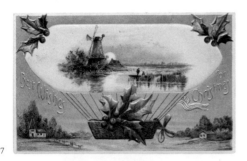

7

8

9

10

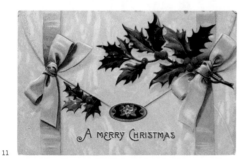

11

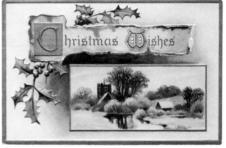

12

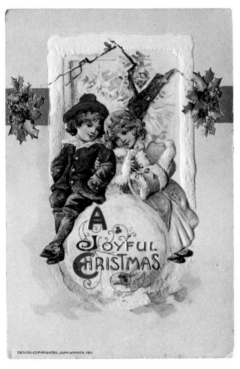

DESIGN COPYRIGHTED, JOHN WINSCH, 1911.

13

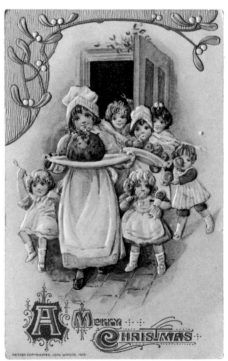

DESIGN COPYRIGHTED, JOHN WINSCH, 1912.

14

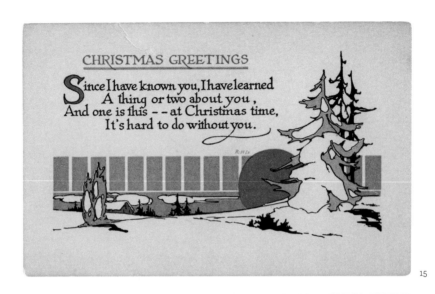

CHRISTMAS GREETINGS

Since I have known you, I have learned
A thing or two about you,
And one is this - - at Christmas time,
It's hard to do without you.

15

Peace and Love

Neath thy soft touch of
Peace and Love
Oh come glad Day
our hearts to move
To truer Friendship - wide Good -
For those who climb will
with us life's hill. H.M.Burnside.

16

CALLING CARDS

Nineteenth-century Christmas cards, and Christmas postcards after them, owe much of their attractiveness to developments in chromolithographic printing. Brilliant color and impressive degrees of naturalism, arranged with a high level of design sophistication, characterize many Victorian cards and often even the cheapest of Christmas postcards. The extraordinary number of surviving Christmas postcards somewhat obscures the fact that the early twentieth century offered an alternative for those who wanted to send something more restrained, more conservative, and, to their eyes, more tasteful. Postcards, after all, were for the mass market. Some people wanted to send Christmas cards of a different sort, cards that were more formal and dignified and conveyed to recipients the impression that the senders were people of status.

Christmas calling cards met this need. Perhaps available from the late nineteenth century onward, they became prominent in the marketplace after the postcard bubble burst and tariffs and World War I intervened to put an end to the German export trade. This genre of Christmas card derived from the engraved cards that had been carried for years by genteel people and those who emulated them. Calling cards were exchanged with social peers according to prescribed rituals, the details of which were described in etiquette books of the day for those new to the practice. Understated elegance and tasteful indication of status were the key concepts. Rather than using chromolithography, which some thought vulgar, calling cards and Christmas calling cards relied on the older technique of engraving. Superseded by newer processes for commercial work, engraving was an archaism, a deliberately conservative choice, and as such was understood as prestigious.

A conventional calling card might carry only a handsomely engraved name printed in black on high-quality white or off-white card stock. With the addition of a Christmas greeting and, perhaps, a discreetly understated pictorial reference to the season, a calling card became a Christmas card. Economist Thorstein Veblen coined the term "conspicuous consumption" to describe the ostentatious spending and display of the very rich. Christmas calling cards were

1899 Thorstein Veblen publishes *The Theory of the Leisure Class.*

1909 Metropolitan Life Insurance Company Tower rises in New York City. Built to the designs of Napoleon Le Brun and Sons and modeled after Venice's Campanile di San Marco, it is the tallest building in the world until surpassed in 1913 by the Woolworth Building, also in New York City.

1913 The Sixteenth Amendment makes federal income tax a permanent feature of the U.S. tax system.

1913 Actress, decorator, and society figure Elsie de Wolfe publishes *The House in Good Taste.*

1915 May 7. Elbert Hubbard and wife, Alice Moore Hubbard, are among

the 1,198 people who perish when a German submarine sinks the *Lusitania* off Kinsale, Ireland.

1917 December 6. Two ships collide and explode in the harbor of Halifax, Nova Scotia, killing some 2,000 people and injuring 9,000 more.

1918 Influenza pandemic kills 50 million people worldwide.

rarely ostentatiously decorated, but they were conspicuous in their use of expensive materials and processes.

Christmas calling cards were fashionable from the first decade of the twentieth century until the 1930s, but the late teens through the 1920s was apparently their greatest era. The examples collected here offer a cross-section, but most embody the idea that a card of high status should be a fine and elegant, beautifully wrought small thing. Indeed, many of the diminutive engraved embellishments or seasonal garnishes are artful achievements in their own right and repay close examination.

These cards could be commissioned by senders from printers, and some of those here probably were. In other cases, images and texts were stock items that could be combined with the name of the sender. In yet other instances, where less formality (or expense) was the point, cards were sold without names and senders inscribed their own, sometimes with considerable flair.

Christmas calling cards vary in distance or difference from the conventional calling card in both their formality and their degree of pretension. Many include only the sender's name and a very brief greeting, embellished with a sprig of holly. Some people simply tucked everyday calling cards inside special holiday folders. At the other end of the spectrum, the image, often highly stylized, became a prominent feature of the card. Some cards have no images at all but instead bear elegantly wrought monograms or initials of the sort applied to stationery and sterling silver. Occasional examples feature heraldic crests; these are sometimes parodied in cards where the details within the crest turn out to be Christmas references. Cards with the image centered above the text seem more formal than those where the image appears at the side. In the latter cases, the image is nearly always on the left. Texts themselves are typically brief, but a few surviving cards from 1918 offer sympathy at Christmas, presumably referring to the devastating influenza pandemic of that year.

1920 January 17. The Eighteenth Amendment takes effect, banning the nationwide sale, manufacture, and transportation of alcohol.

1920 November 2. Station KDKA in Pittsburgh, Pennsylvania, initiates regular radio broadcasts.

1922 Emily Price Post publishes the first edition of *Etiquette in Society, in Business, in Politics, and at Home.*

1925 Howard University professor Alain Locke is author of an essay titled "The New Negro."

1925 Harold Ross begins publication of *The New Yorker*.

1925 F. Scott Fitzgerald publishes *The Great Gatsby.*

1925 In New York City alone, there are estimated to be at least 30,000 speakeasy clubs illegally selling alcohol.

1927 May 20–21. Charles A. Lindbergh flies nonstop from New York to Paris.

1927 August 23. Ferdinando Nicola Sacco and Bartolomeo Vanzetti are executed by electric chair in Boston.

1

Mr. and Mrs. Charles C. Bechtold

WISHING YOU A VERY MERRY CHRISTMAS
AND A HAPPY NEW YEAR.

2

With all good wishes for
Christmas Cheer
and Joy and Health
in the New Year

Lyle E. Atwood

3

With all kind thoughts
and Good Wishes for
Christmas and the Coming Year
Samuel W. Hilt

4

Love and all good wishes for a
Merry Christmas and Happy New Year

5

Heartiest Greetings
for Christmas and the coming Year
1923–1924.
From Carr & Margarette Sherrington

6

With heartiest Christmas Greetings
and wishes for many more happy years

Ralph B. Bennett.

7

Christmas
Greeting

8

With best wishes for your Christmas
and the New Year

Ursula Roston

9

Mr. John B. F. Bacon
wishes you Christmas joy
and all good things for the coming year

10

Sincere greetings and
good wishes for Christmas and
the New Year
Mr. and Mrs. Frank Wesley Smith

11

May your Christmas be filled
with Happiness and the New Year
bring you unbounded Prosperity,
combined with the blessings of
Good Health.

A. C. Callan

12

Christmas Greetings
and all good wishes for your happiness
throughout the Coming Year

Mr. and Mrs. Irwin H. Curt

13

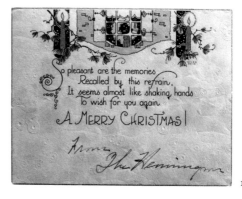

So pleasant are the memories
Recalled by this refrain.
It seems almost like shaking hands
To wish for you again
A MERRY CHRISTMAS!

From
The Kenningon

14

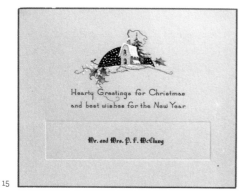

Hearty Greetings for Christmas
and best wishes for the New Year

Mr. and Mrs. P. F. McClung

15

SEASON'S GREETINGS

Mr. Frank Mason Cameron

16

SHRINES

Every component of a graphic design carries meaning. That meaning may not lend itself to verbalization, but variations in materials and composition, as well as in motifs and imagery, affect the feeling a card generates. As the examples in this book reveal, ways of laying out the faces, or fronts, of Christmas cards have been many and diverse. Some layouts, however, have enjoyed considerable popularity and appear often enough to constitute distinct compositional genres. One of these involves the use of a large central design element flanked left and right by identical features to form a more or less symmetrical B-A-B arrangement.

This compositional system has been common in many categories of goods over the centuries. Although the three-part composition sometimes appears on postcards, particularly those in the Arts and Crafts style, the great flowering of the manner on Christmas cards is in the 1920s. The imagery employed is standard for the period—winter landscapes, snow-covered houses, musicians, scenes of coaching or visiting, and, most of all, candles. The latter are occasionally the central motif, but they occur far more frequently as singles, pairs, or sets of three flanking, celebrating, and ceremonializing the central element.

The moods or feelings these cards evoke are varied, from the elegantly subdued to the boisterously animated, with much in between. What all the cards project, however, is the deliberate selection of a given motif as the centerpiece of an imagined holiday altar or shrine. The text of one card makes this explicit: "While Christmas candles glow and shine / To You my heart is turning; / For Memory opens wide a Shrine, / Where all her lights are burning."

Domestic shrine-building is common. Popular sites include mantelpieces, the tops of sideboards or chests of drawers, and dining-room tables. Sometimes an entire side of a room is symmetrically arranged into a shrine-like composition. What are actually enshrined in some of these instances are abstract but significant cultural values. A representative publication of the era, the 1920 *House & Garden Book of Interiors*, provides useful testimony on this point. Text and images throughout this volume indicate that balance, symmetry, order, and formality were all prominent features of the definition of elegance in 1920, at least as understood and expressed by the affluent. Photographs of furnished interiors indicate that the placement of objects—chairs flanking a case piece, for instance—may be based more on the visual impact of such arrangements than on

any actual use. Whether or not someone will in fact sit in these chairs is less important than the emphatic B-A-B rhythm of the composition and the pleasing balance it produces.

Even if not specifically named or recognized as such, shrine-building accelerates during the Christmas season and often involves ingredients depicted in these cards, candles in particular. The extraordinary power of candles as signifiers of the special (see Candles) is amply acknowledged here. Regardless of what the central scene or motif may be, the placement of candles on either side offers it as a subject for contemplation and communion. The same scenes, without the candles, are necessarily experienced in a different way.

Nothing about these cards suggests the merely glimpsed or the accidentally encountered. The flanking elements, be they candles or something else, and the emphatic symmetry speak to awareness, mindfulness, purposefulness. These cards are, in their varied ways, shrines to the season, shrines to the holiday. For Americans of the 1920s they held strong appeal.

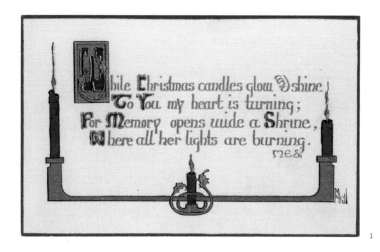

1

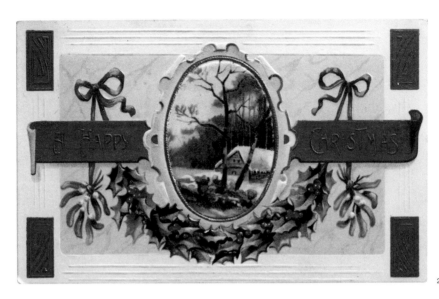

2

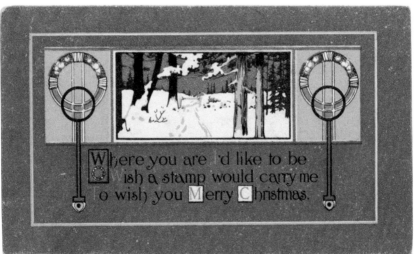

3

With every good wish for Christmas and

your Happiness throughout

the Coming Year

Mr. and Mrs. Charles Stanley Jacob

4

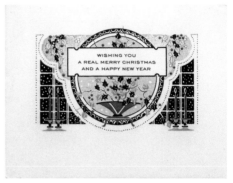

WISHING YOU
A REAL MERRY CHRISTMAS
AND A HAPPY NEW YEAR

5

Greetings! And best wishes
for
Christmas and
the New Year

Dottie & Milton Bacon

6

With best wishes for Christmas and
the New Year

Frankie

7

8

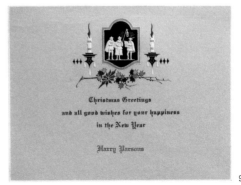

Christmas Greetings
and all good wishes for your happiness
in the New Year

Harry Parsons

9

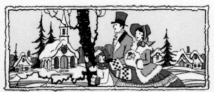

Hearty greetings and best wishes
for a Merry Christmas and a
Happy New Year!

The Fitzers.

10

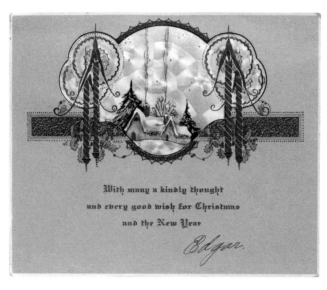

With many a kindly thought
and every good wish for Christmas
and the New Year

Edgar.

11

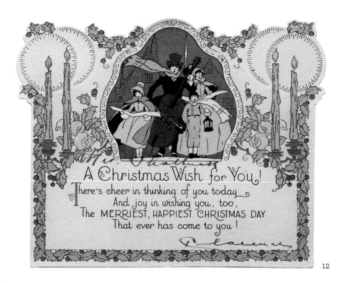

A Christmas Wish for You!

There's cheer in thinking of you today
And joy in wishing you, too,
The MERRIEST, HAPPIEST CHRISTMAS DAY
That ever has come to you!

12

Best *Wishes*

There's a world of GOOD WILL
in saying Hello
And spreading GOOD CHEER
wherever you go;

It's pleasant to pause for
a moment to say
"We wish you GOOD HEALTH
and a glad Holiday"

WITH THANKS for your FRIENDSHIP and
BEST WISHES for your HAPPINESS and PROSPERITY

MELVIN P. PIHL

NORTHWESTERN TRANSFER CO.

PORTLAND, OREGON

13

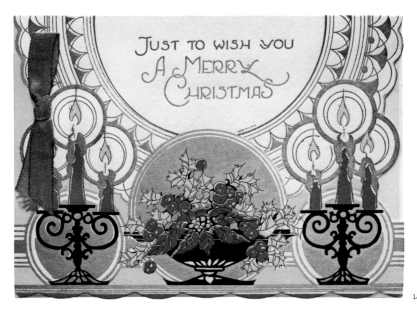

JUST TO WISH YOU
A MERRY CHRISTMAS

14

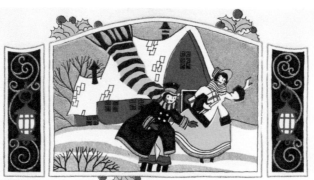

Greetings and Good Wishes
for Christmas and the New Year

Mina

15

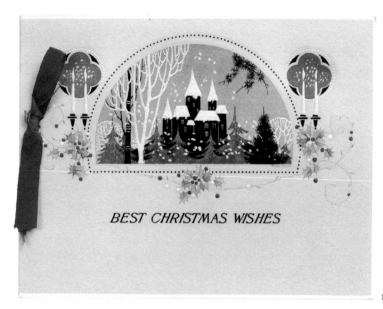

16

17

WINTER

In the beginning, there was winter. Winter and centuries of human responses to it lie at the heart of the celebration now known as Christmas. Many of today's rituals and activities have their roots in the needs of previous societies for expressions of community, communion, and reassurance in the year's most threatening season. Shorter days, declining light, barren or snow-covered landscapes, and potentially lethal cold could be neither denied nor easily avoided. The power of winter was a grim reminder of the tenuous nature of all life. Even today, knowing full well that the year will run its usual course, we sometimes experience the horrifying thought that winter will never end.

Christmas celebrates the realization that winter will indeed someday be over. Spring will come again. After what seems like death, there will once more be life. Temperatures will rise, snow will melt, days will grow longer, plants will come into leaf, and the great cycle will resume. In much of the United States winter is a familiar part of the annual cycle. Although all American Christmas cards implicitly acknowledge winter, a sizeable number make explicit pictorial reference to it. These cards seem to suggest that people should enjoy or at least be fully attentive to winter's distinctive qualities, for they are transitory. Agents of positive outlook in a season that sometimes fosters depression, Christmas cards rarely depict the hardships or dangers of winter, although these may remain implicit. A few images invite reflection or contemplation, but most view the season of snow and cold through more-or-less rosy lenses. Some degree of comfort and security is probably essential for a full appreciation of winter's aesthetic attractions. Because Christmas cards necessarily privilege vision, they offer winter without its howling winds, waist-high drifts, or bitter cold.

Unlike some classes of cards that adhere to narrow pictorial formulas, those bearing winter imagery are diverse. The most somber depict uninhabited winter landscapes and distinctive sights wrought by the season: the intricate patterns of gnarled branches of now leafless deciduous trees, otherwise invisible the rest of the year; the subdued palette of the landscape on a sunless December day; trees bending under a heavy fall of snow. Another pictorial strategy

1850 James Lord Pierpont of Medford, Massachusetts, composes "Jingle Bells."

1866 New England poet John Greenleaf Whittier publishes "Snow-Bound: A Winter Idyl."

1873 Chester Greenwood of Farmington, Maine, invents earmuffs.

1888 January 12. The "Schoolchildren's Blizzard," an unanticipated storm in the west, kills 500, many of them children coming home from school.

1888 March 11–14. The Blizzard of '88 drops up to 50 inches of snow on the Northeast, causing more than 400 deaths and general paralysis.

1889 August 13. Samuel Leeds Allen of Westtown, Pennsylvania, patents the Flexible Flyer sled.

1923 First publication of Robert Frost's poem "Stopping by Woods on a Snowy Evening."

1931 Vermonter W. A. "Snowflake" Bentley and W. J. Humphreys collaborate in publishing *Snow Crystals*.

employs the synecdoche, a small part invoking the larger whole. The most common of these and, thanks to decades of use, now considered particularly evocative of Christmas, is a sprig of holly, whether rendered in naturalistic or stylized form. Bits of mistletoe, pine cones or boughs, and snowflakes are other concise signifiers of the season.

Scenes of human activity within the winter landscape are abundant. Some are based on popular paintings and prints of the same subject. Currier & Ives winter scenes, especially those derived from paintings by George Durrie, have appeared as Christmas cards since the 1930s. For some years after 1946, the innocent memory pictures of Grandma Moses enjoyed favor. The prominence of American Scene Painting during and after the Great Depression contributed to an interest in Christmas cards that reproduced, on a small scale, paintings of wintry life in unpretentious places. New England villages were particularly popular.

An alternative to naturalistic if nostalgic representations of winter activity appears on cards where a more playful, lighthearted, or childlike manner prevails. Related to cartoons and the funny papers on one hand and to "folk art" and modern primitivism on the other, these images take liberties with color, proportion, scale, perspective, and other conventions of naturalistic depiction. Some demonstrate considerable sophistication.

One other major strand of imagery isolates a single iconic winter activity. Travel by sleigh or sledge, a suitably archaic reference by the 1930s, appears often, in at least one uncharacteristic instance actually suggesting the misery of travel on a bitterly cold and snowy night. Scenes of winter play, whether for children or adults, are also common and typically depict sleds, toboggans, ice skates, and the recently introduced sport of skiing. As with most scenes devoted to winter, the retrospective Currier & Ives and Grandma Moses images excepted, these are noteworthy for the absence of displacement. However displacement functioned for other categories, it was not required here. No one had to be convinced of the reality of winter. It made its own case perfectly well.

1932 First Winter Olympics in the U.S. take place at Lake Placid, New York.

1934 Felix Bernard and Richard B. Smith compose "Winter Wonderland."

1937 Irving Berlin writes "I've Got My Love to Keep Me Warm."

1941 December 25. First public performance of Irving Berlin's "White Christmas," on Bing Crosby's *Kraft Music Hall*. Crosby's later recording becomes the best-selling record of all time.

1944 Frank Loesser writes the duet "Baby, It's Cold Outside."

1945 "Let it Snow, Let it Snow, Let it Snow" is composed by Sammy Cahn and Jule Styne and recorded by Vaughn Monroe and the Norton Sisters.

1957 Bobby Helms records "Jingle Bell Rock," written by Joe Beal and Jim Boothe.

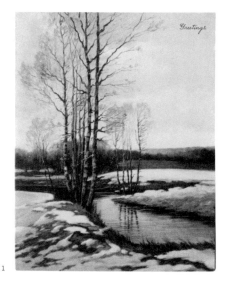

1

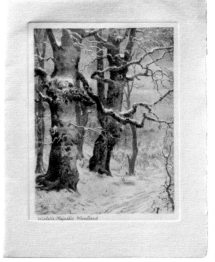

2

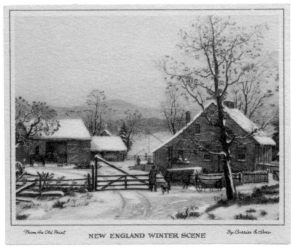

3

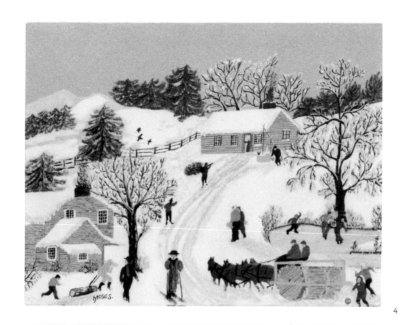

4

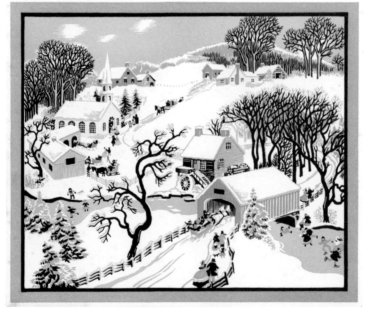

5

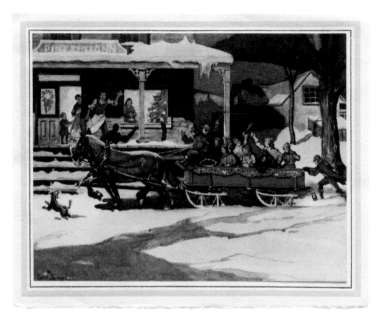

6

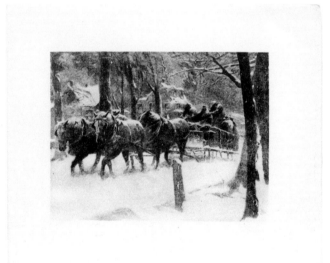

7

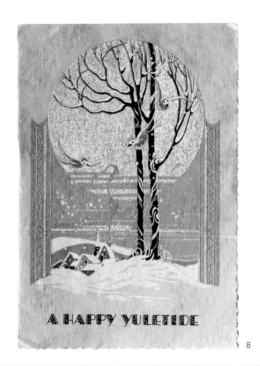

A HAPPY YULETIDE

8

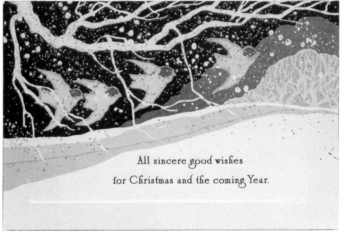

All sincere good wishes
for Christmas and the coming Year.

9

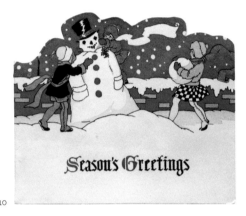

Season's Greetings

10

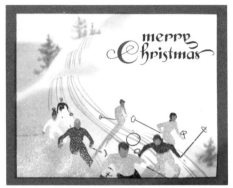

Merry Christmas

11

May you enjoy a Merry Christmas and a Happy New Year!

From the Finch family

12

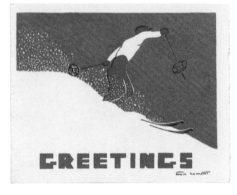

GREETINGS

13

Merry Christmas and a Happy New Year

14

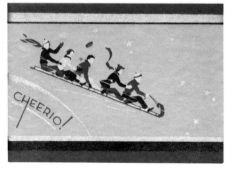

CHEERIO!

15

16

CANDLES

Candles may be the most common Christmas card motif of the first half of the twentieth century. It is therefore noteworthy that candles rarely appear on nineteenth-century cards. The emergence of candles as subject matter apparently correlates with the introduction and spread of electric lighting. By the time most American households were electrified, candles had become staples of Christmas card imagery. In other words, as the utilitarian value of candles declined, their symbolic value rose. Understood as old-fashioned goods, candles fulfilled twentieth-century needs for archaism on Christmas cards. But candles were not merely old-fashioned; they seemed to be timeless as well. After all, who invented candles? When were they introduced? Who even knows? The use of candles was correctly understood to date back centuries, but because the form of candles seemed unchanging, candles were undatable artifacts, unaffected by fad, fashion, or style. And, being undatable, they could be considered timeless, outside of or even transcending ordinary time, in some sense eternal.

This is, on the surface of it, paradoxical, since everyone knows that individual candles are by no means eternal. All are of limited duration and all eventually burn out. But might candles be considered eternal or timeless in some other sense? Consider the following. First, candles are artifacts. They are fashioned by people. Therefore, candles necessarily imply humankind. Second, candles do not spontaneously ignite. A burning candle denotes human presence. Third, while it is true that every candle is eventually extinguished, it is also true that every human life eventually ends. Candles, then, might be thought of as artifactual surrogates for humankind and reminders of the transitory nature of all human life. Perhaps it is the truth evoked by candles that is timeless or eternal.

Even apart from such associations, these simple and slender tapers are powerful evocations of the primal. The flame is both heat and light in its most concise form. The candle stands

1850 The introduction of paraffin leads to the manufacture of inexpensive high-quality candles.

1860 Trade catalogue of Dietz & Co. of New York, manufacturers of lighting devices, illustrates several sets of girandoles, elaborate gilded metal figural candlesticks with glass prisms.

1861 July 9. Frances Appleton Longfellow, wife of the poet, dies of burns received when her dress catches fire while she is melting wax to seal envelopes containing her children's hair.

1865 In *Wonderland*, Alice wonders what it would be like to go out like a candle.

1869 In *The American Woman's Home*, authors Catherine E. Beecher and Harriet Beecher Stowe give directions for making candles but admit that most people now use kerosene lamps.

1879 Thomas A. Edison receives U.S. patent 223,898 for the incandescent light bulb.

1880 Nearly two out of every five fires in New York City are blamed on faulty kerosene lamps.

1892 General Electric is formed from the merger of Edison General Electric of Schenectady, New York, and Thomson-Houston Electric Co. of Lynn, Massachusetts.

1895 Edward F. Caldwell & Co. is established in New York City, prominent designers and manufacturers of electric light fixtures and decorative metalwork.

in one place, yet it grows shorter and the flame dances, flickers, and mesmerizes. The candle is a major agent of enchantment. In ways difficult to verbalize but immediately sensed, candlelight has near-magical powers to transform a setting, whether in a home, restaurant, or church, or for any number of ceremonial occasions. Even a single candle may be an invitation to reflection, contemplation, meditation.

The candle is a simple motif in concept, but it poses significant pictorial challenges. The candle itself is easily enough rendered, but the flame, actually an active and dynamic physical process, cannot be effectively captured in a static image, especially one that is drawn or painted. In previous centuries painters occasionally sidestepped this problem by hiding the candle behind some foreground object and depicting its luminous glow instead, but that stratagem fails when the candle is itself the subject. In most of the cards shown here, designers have adopted the expedient of conventionalizing or abstracting the candle flame, often with aesthetically rewarding results. Variations on the theme of concentric circles are popular, but no two treatments here are identical.

Although candles always signify human presence, people occasionally do appear in these cards, usually either lighting or carrying a candle. Candlesticks or candleholders on Christmas cards may be simple, complex, or absent altogether. Images of candles may be augmented with holly, evergreen boughs, poinsettias, or other seasonal garnishes. Depicted candles number from one to five but rarely more. The motif of the candle in the window, seen from within or without, recurs from time to time. The message is generally understood to mean a warm and welcoming human presence within.

1901 Working for Tiffany Studios, Clara Driscoll designs the Wisteria lamp, which features an elaborate leaded-glass shade over incandescent light bulbs.

1923 Arthur H. Hayward publishes *Colonial Lighting*.

1929 June 5. A light bulb is the centerpiece of a U.S. postage stamp issued to commemorate the 50th anniversary of Edison's invention of the incandescent bulb.

1932 The Rushlight Club is founded, dedicated to the study and preservation of historic lighting.

1946 Nat Simon and Charles Tobias compose "The Old Lamp-Lighter," a hit tune recorded by Sammy Kaye, Kay Kyser, and others.

1958 The song "Sixteen Candles," written by Luther Dixon and Allyson R. Khent, is recorded by the Crests on Coed Records, with lead singer Johnny Maestro.

1958 Film version of *Bell, Book and Candle* appears, based on the Broadway play by John Van Druten and starring James Stewart and Kim Novak.

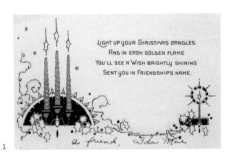

Light up your Christmas candles
And in each golden flame
You'll see a wish brightly shining
Sent you in Friendship's name.

a friend, Ida Mae

1

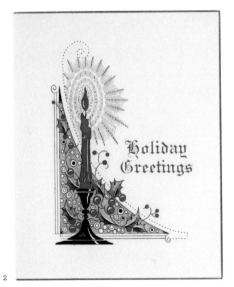

Holiday Greetings

2

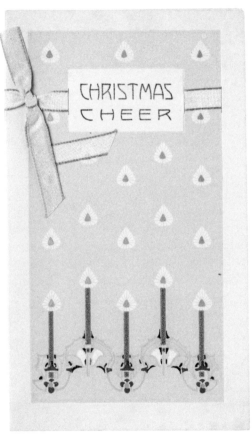

CHRISTMAS CHEER

3

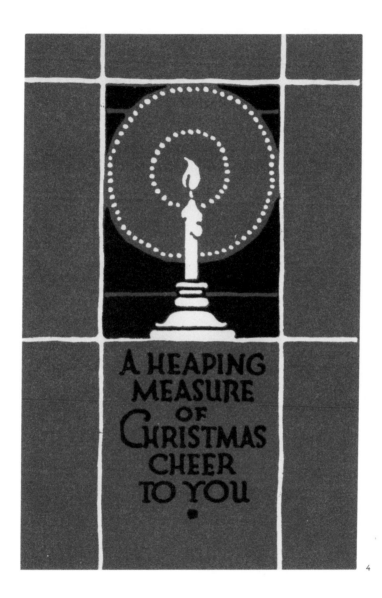

A HEAPING
MEASURE
OF
CHRISTMAS
CHEER
TO YOU

4

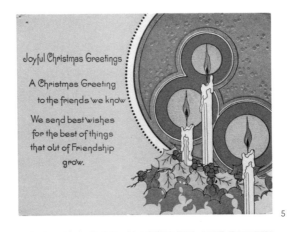

Joyful Christmas Greetings

A Christmas Greeting
to the friends we know

We send best wishes
for the best of things
that out of Friendship
grow.

5

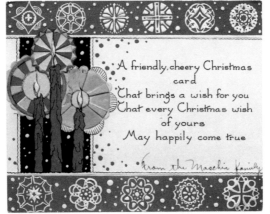

A friendly, cheery Christmas
card
That brings a wish for you
That every Christmas wish
of yours
May happily come true

From the Maschin Family

6

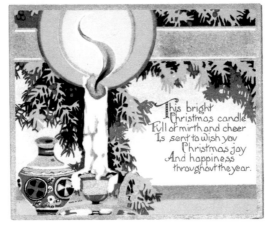

This bright
Christmas candle
Full of mirth and cheer
Is sent to wish you
Christmas joy
And happiness
throughout the year.

7

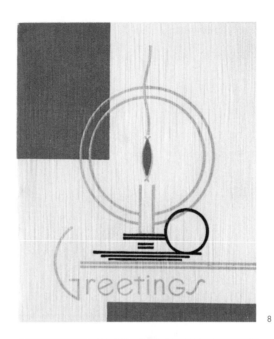

8

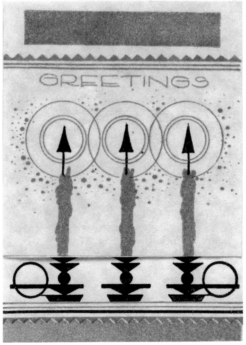

9

10

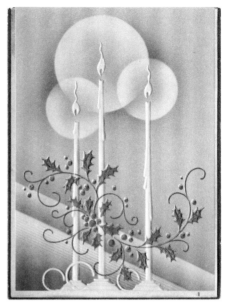

11

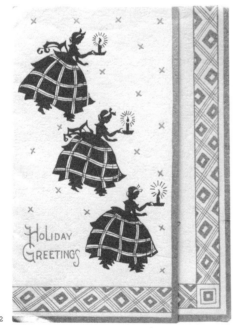

12

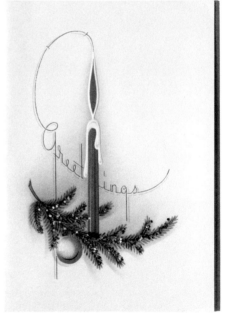

13

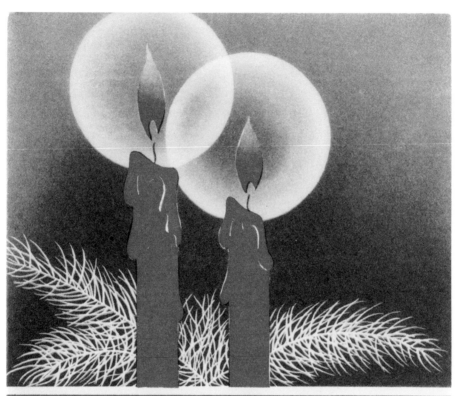

Christmas Greetings

POINSETTIAS

Displays of grouped poinsettias can have a dazzling effect, in life and on paper. That bright red hue and the fact that they flourish in the winter are two attributes that have contributed to their becoming an American holiday staple. It happens that they also have a peculiarly circular story. Brought from another country to the United States, where they were given a new identity and a new look and became a huge commercial success, they eventually returned to their native land, much changed.

Poinsettias (*Euphorbia pulcherrima*) are native to Central America, a fact that has everything to do with the common name they now bear. Joel Roberts Poinsett (1779–1851), pedigreed South Carolinian and career politician, was deployed by President Madison to revolutionary Argentina and Chile to serve, in essence, as the long arm of the United States, and he subsequently played a similar role as the first American ambassador to the Republic of Mexico. While there, he saw the red-leaved plants growing in the wild, and as an amateur botanist, he took an interest in them and sent cuttings home. Historian William H. Prescott, known for his works on Spain and Latin America, is credited with giving the plant the name *poinsettia*.

Poinsett's diplomatic career was busy but checkered; he was, at various times, a member of Congress, a state senator, and the Secretary of War. His time in Mexico included an attempt to broker a commercial treaty between the United States and Mexico that would have required the latter to return fugitive slaves (Mexico refused to ratify the agreement). It is one of history's whimsies that Poinsett is now best remembered as the namesake of a holiday plant.

Once introduced to the United States, and after an appearance at a Philadelphia flower show in 1829, poinsettias rapidly gained popularity. In 1837 the *Horticultural Register and Gardener's Magazine* ran an article stating that the poinsettia was "becoming much in repute." An 1858 edition of another horticultural journal noted that one of *Euphorbia's* benefits is that "it comes into beauty . . . when other plants are out of bloom."

1825 Joel Roberts Poinsett becomes the first American ambassador to the Republic of Mexico.

1829 Poinsettia plants are displayed in Philadelphia at the Pennsylvania Horticulturalists' Society's *First Semi-Annual Exhibition of Fruits, Flowers and Plants.*

1833 German horticulturalist Carl Ludwig Willdenow bestows on the poinsettia its botanical name of *Euphorbia pulcherrima.*

1843 American historian William H. Prescott publishes *The History of the Conquest of Mexico.*

1910 Florists' Telegraph Delivery (FTD) established.

1923 In Encinitas, California, Ecke Ranch nursery field-grows poinsettia plants for shipment to greenhouses throughout the country.

The poinsettia's widespread acceptance at the turn of the century coincided with increased production and consumption of the postcard. Bringing together a new format and a fresh and attractive holiday symbol must have appealed to card designers, as poinsettias run rampant through cards of the period. One such card, by Raphael Tuck and Sons, indicates that they went so far as to create and advertise "The Poinsettia Series" of Christmas cards in 1911. To today's viewers, many of these representations look oddly leggy—more stem, less densely clustered leaves. Plants at the time were not as lush as they are today and were often sold as cut flowers.

As poinsettias continued their triumphal march through the visual landscape, their portrayal became more stylized. Unless the plant was shown in a basket or other container, signaling its function as a holiday gift, the poinsettia's floral shape was often a springboard for design experimentation. Cards from the 1940s and early 1950s feature three-dimensional folded poinsettias; pale, abstracted poinsettias set off with printed foil (evocative of the material used by florists to wrap their pots); and velvety, flocked poinsettias in improbable colors. The very showiness of the plant seems to have brought out the impresario in card makers.

Aside from their decorative virtues, the poinsettias on these cards represented a fusion of American traditions from different parts of the nation. The southern states and California offer a more hospitable horticultural environment than New England, where some of these cards were purchased. The plants they depict were once raised primarily in California, where a family named Ecke, descendants of a German immigrant farmer, has been producing a sizable percentage of the world's poinsettias since the 1920s. (The Eckes also bred the plants for the now-ubiquitous bushy effect.) But as the world goes, so goes the poinsettia. The Eckes now grow many of their plants in Guatemala to save costs. Global economics have brought the poinsettia back to Central America.

1936 Boston florist Henry Penn creates the slogan "Say It with Flowers," which becomes part of the FTD trademark.

1936 Georgia O'Keeffe paints *Mule's Skull with Pink Poinsettias.*

1948 A small gift-fruit shipper in Vero Beach, Florida, takes the name Poinsettia Groves, which it still retains.

1964 November 9. In Bethlehem, Pennsylvania, the U.S. Post Office issues a set of four five-cent Christmas stamps, each depicting a different plant associated with the season: holly, mistletoe, a conifer sprig, and poinsettia.

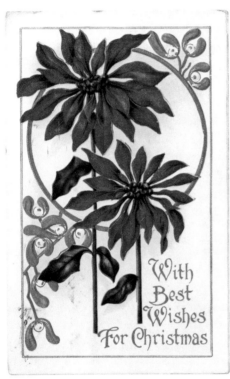

1

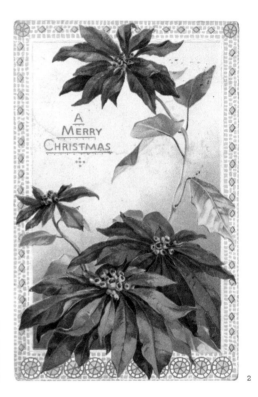

2

3

With very best wishes
for your happiness at Christmas
and the New Year

Ida + Del Day.

4

A Merry Christmas

5

Here's to a Real Sure Enough
Honest to Goodness
MERRY CHRISTMAS
and HAPPY NEW YEAR!

To Bill, Dorothy,
from Marga, Emley, & Bobby

6

A Merry Christmas

7

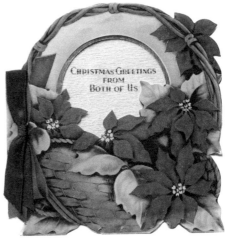

8

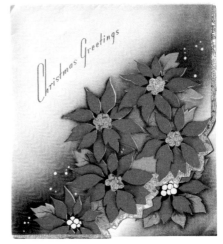

9

10

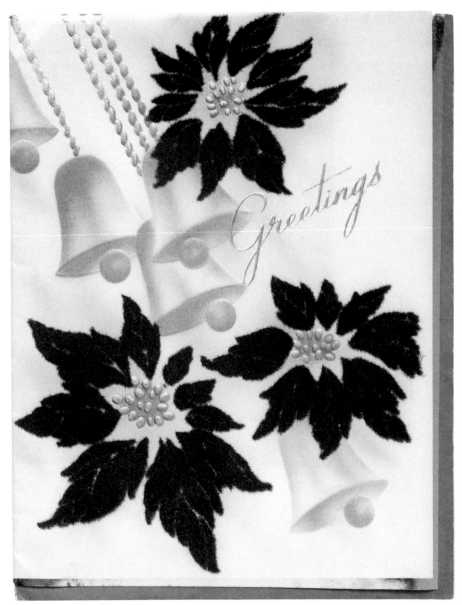

Greetings

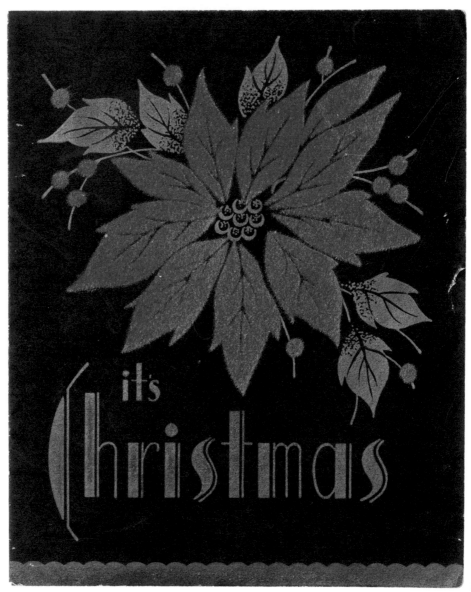

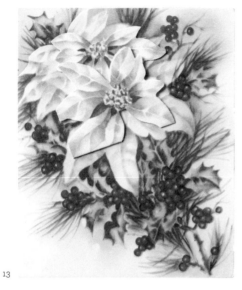

13

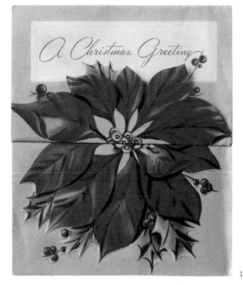

14

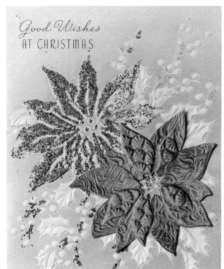

15

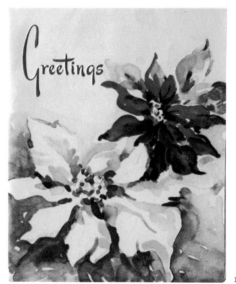

16

THREE KINGS

Christmas cards bearing images of the three kings or the three wise men on their way to Bethlehem stand apart from the larger category we have called Christian Christmas on the basis of their sheer numbers and the relative consistency of their imagery. Although numerous variations on this theme can also be seen, the majority of these cards depict three men in some version of Middle Eastern attire riding camels through the desert in the direction of a small town with a bright star above it. The texts in these cards may or may not make an overt biblical reference; many simply bear a generic Christmas or holiday greeting.

The visual language of the three kings is an early medieval construction gradually built upon the decidedly scanty textual description in the Gospel of Matthew. Over time, the status of the ambiguously labeled "wise men" of indeterminate number became inflated. They were depicted as three powerful rulers, not just the bearers of significant gifts but actual kings, bowing before the infant Jesus and legitimizing the miracle of his birth and his divine status. Furthermore, over time the "kings" were named and became differentiated in age and in origin, thereby emphasizing the sovereignty of Christ and visually signaling his rule over the whole world and all ages of humankind. By the fifteenth century, an elaborate iconography had developed around the three kings, who were depicted in the many Adoration of the Magi paintings that survive from that era and after. As familiar as these paintings are today and as central as many are to the Renaissance canon of painting, they do not appear to have served as models for images of the kings on American Christmas cards of the early twentieth century. Why they did not is unclear.

Christmas cards bearing images of the three kings cluster in date from the second decade of the twentieth century into the 1940s and, with some modifications, beyond. In these decades America underwent rapid modernization accompanied by often highly disruptive and unset-

1848 New York architect Leopold Eidlitz designs an Islamic-style mansion in Bridgeport, Connecticut, for P. T. Barnum, who names the place Iranistan.

1850 The Order of the Eastern Star, a Masonic organization open to both men and women, is founded.

1857 Episcopal priest John Henry Hopkins writes "We Three Kings of Orient Are," possibly for a Christmas pageant at General Theological Seminary in New York City.

1861 The 5th New York Volunteer Infantry adopts Zouave uniforms, based on the attire of Algerian military of the 1830s.

1870 Ancient Arabic Order of the Nobles of the Mystic Shrine (a.k.a. the Shriners) is founded in New York City.

1870 Architect Calvert Vaux collaborates with painter Frederic Church in designing the latter's quasi-Islamic residence Olana near Hudson, New York.

1881 So-called Cleopatra's Needle, an Egyptian obelisk dating from about 1450 B.C., is set up in New York City's Central Park.

1893 Farida Mazar Spyropoulos (a.k.a. Little Egypt) dances at the "Street in Cairo" installation at the World's Columbian Exposition in Chicago.

1895 Henry Van Dyck publishes a Christmas tale entitled *The Story of the Other Wise Man.*

tling change. It was an age of anxieties. Anti-modern sentiments, fears of the dissolution of community, weakening of emotional bonds, and the lessening of meaning in modern life were expressed in yearnings for "authentic" experience. That notion was open to multiple interpretations, but for some it meant being attracted to "Oriental" or other "primitive" cultures. In any event, it suggested something other than the modern, mobile, industrial world.

It was perhaps this impulse that led to the considerable popularity in 1904 of a book by Robert Smythe Hichens entitled *The Garden of Allah*, an ethnographic novel of passion, danger, and sensuality set in the oases of the Algerian desert. The book inspired a Broadway play and no fewer than three film interpretations, and it helped fuel the craze for Islamic-influenced fashion and décor. In this last phenomenon we can see another aspect of American society of the early twentieth century that troubled anti-modernists of the time and continues to cause much hand-wringing in discussions of Christmas today—the pervasiveness of materialism. The imagery of the three kings on these Christmas cards of the early twentieth century bears an uncanny resemblance to that used in period advertisements for Oriental (Islamic) rugs; the gifts of the kings signaling Christ's triple role as king, priest, and martyr are subsumed under the general trend toward material indulgence and luxurious Christmas giving.

Whatever the explanation, both time and place in cards depicting the three kings are ambiguous, although the many domes and minarets depicted have a decidedly Islamic and therefore anachronistic cast to them. Perhaps what we are seeing is yet another instance to the fabled syncretism of Christmas: the three kings have met up with the Shriners and Camel cigarettes.

1904 Robert Smythe Hichens publishes *The Garden of Allah*, a sensationalistic novel set in Algeria that becomes wildly popular.

1906 O. Henry publishes "The Gift of the Magi."

1908 A British company strikes oil in Persia, today's Iran, setting off expanded oil exploration in the region; the company continues today as BP.

1909 Maxfield Parrish illustrates *Arabian Nights: Their Best Known Tales*,

edited by Kate Douglas Wiggin and Nora A. Smith.

1913 R. J. Reynolds Tobacco introduces Camel brand cigarettes.

1921 Rudolph Valentino stars in *The Sheik*. The popularity of the film and Valentino's sexual potency are used to sell Sheik brand condoms in the 1920s.

1921 The song "The Sheik of Araby" is a Tin Pan Alley hit and later becomes a jazz standard.

1922 English archaeologist and Egyptologist Howard Carter discovers the tomb of Pharaoh Tutankhamen and sets off Egyptomania.

1922 Graumann's Egyptian Theater is constructed in Hollywood, decorated with columns and hieroglyphs and staffed with employees dressed as Bedouins and carrying spears.

1937 Duke Ellington records "Caravan," composed by trombonist Juan Tizol.

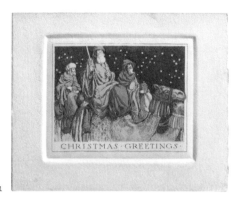

1

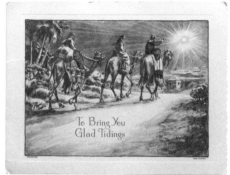

To Bring You
Glad Tidings

2

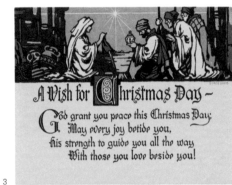

A Wish for Christmas Day ~

God grant you peace this Christmas Day,
May every joy betide you,
His strength to guide you all the way
With those you love beside you!

3

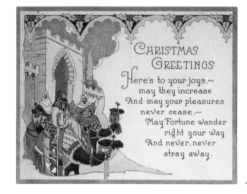

CHRISTMAS
GREETINGS

Here's to your joys,~
may they increase
And may your pleasures
never cease.~
May Fortune wander
right your way
And never, never
stray away.

4

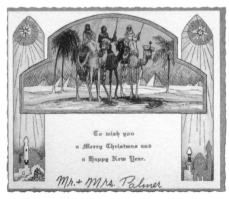

To wish you
a Merry Christmas and
a Happy New Year.

Mr. + Mrs. Palmer

5

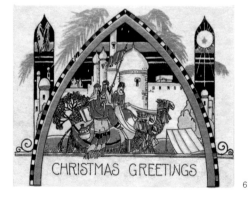

CHRISTMAS GREETINGS

6

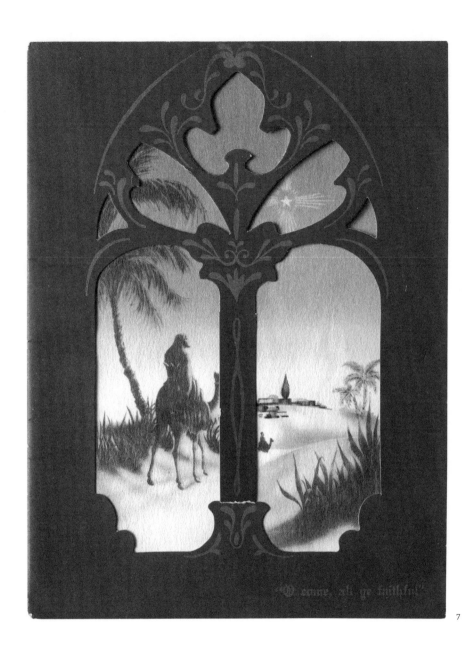

"O come, all ye faithful"

7

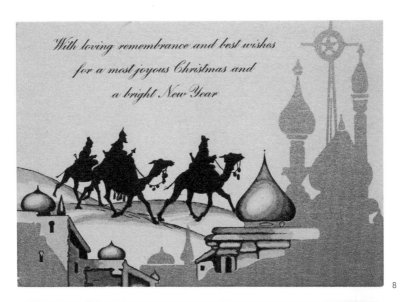

With loving remembrance and best wishes

for a most joyous Christmas and

a bright New Year

8

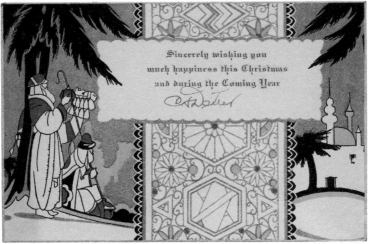

Sincerely wishing you
much happiness this Christmas
and during the Coming Year

9

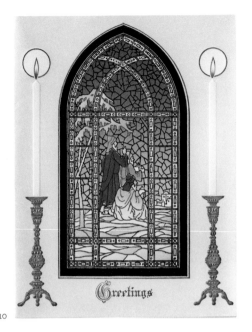

Greetings

10

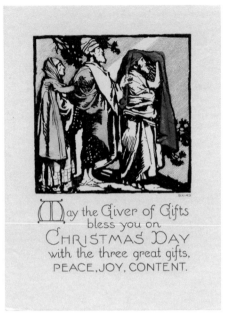

May the Giver of Gifts
bless you on
CHRISTMAS DAY
with the three great gifts,
PEACE, JOY, CONTENT.

11

May He who was in Bethlehem born,
On that first welcome Christmas morn,
Grant you His peace and amply bless
You and yours with happiness.

Adelina M. Barili

12

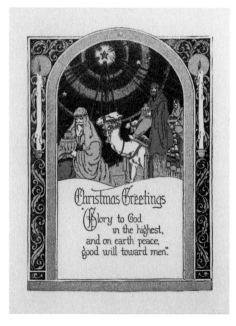

Christmas Greetings
"Glory to God
in the highest,
and on earth peace,
good will toward men."

13

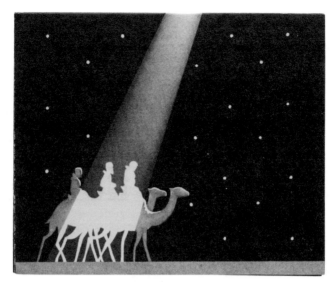

14

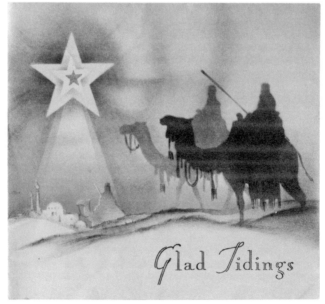

Glad Tidings

15

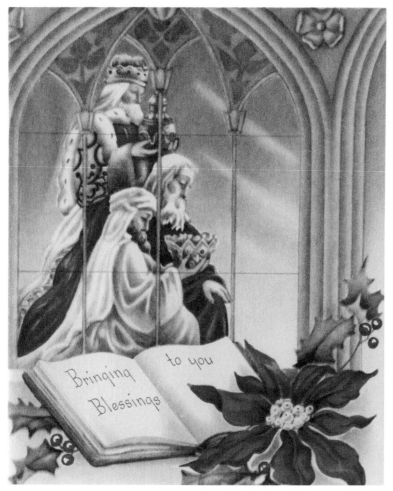

Bringing
Blessings to you

16

TRAVEL BY COACH

"A curious little green box on four wheels, with a low place like a wine-bin for two behind, and an elevated perch for one in front, drawn by an immense brown horse displaying great symmetry of bone." Thus did Charles Dickens's *Pickwick Papers* (first published in serial form in 1836–37) describe the late Georgian-era coach, which survived into the age of the automobile as a nostalgic image that turned up with notable frequency on Christmas cards. That the very large group of surviving coaching cards displays a highly consistent visual language of cheerful travelers rolling through wintry landscapes and alighting at picturesque country inns complete with bright fires and wreaths and holly is rather strange, when one stops to consider that today's quintessential vision of the American stagecoach is set in the West. Nonetheless, the imagery that prevails on Christmas cards was conjured from stories by Dickens and Washington Irving, tales from the early nineteenth century set in England and peopled with top-hatted men and hoop-skirted women.

Dickens, especially, provided Christmas vignettes of jolly coachmen and singing travelers, of a stage loaded down with food and bundles, and of the accommodating country inn. In *The Pickwick Papers*, Dickens created an atmosphere of hilarity by prefacing his characters' journey with a scene in which they try to wedge a large fish into the coach. Yet he also evoked the physical aspect of travel, describing in words what the cards show in pictures: "They have rumbled over the streets and jolted over the stones, and at length reach the wide and open country. The wheels skim over the hard and frosty ground.... Another crack of the whip and on they speed at a smart gallop; the horses tossing their heads and rattling the harness, as if in exhilaration at the rapidity of motion."

But Dickens also treated the Christmas journey with reverence. For him Christmas had a ritual quality that collapsed time and space, "mitigating the pains that separations had brought,"

1826 The Mohawk & Hudson Railroad, connecting the cities of Schenectady and Albany, is the first railroad chartered in the state of New York.

1827 The Abbott Downing Company of Concord, New Hampshire, manufactures its first stagecoaches.

1832 The New York and Harlem Railroad introduces horse-drawn streetcars to New York City.

1852 Henry Wells and William Fargo found Wells Fargo & Co; in 1857 the

firm joins others to establish the Overland Mail Co., providing regular service between St. Louis and San Francisco.

1869 May 10. At Promontory Summit in Utah Territory, Leland Stanford hammers in the Golden Spike, celebrating the completion of the transcontinental railroad.

1871 Eastman Johnson paints *The Old Stagecoach*, now in the collection of the Milwaukee Art Museum.

1872 Mark Twain publishes *Roughing It*, a semi-autobiographical account of travels by stagecoach through the American West.

1900 Alice Morse Earle publishes *Stage-Coach and Tavern Days*.

1908 Henry Ford offers the Model T for sale at $825.

1910 The state of New York issues the first automobile driver's licenses in America (to professional chauffeurs).

able to "recall to the old man the pleasures of his youth; and transport the sailor and traveler, thousands of miles away, back to his own fireside and his quiet home!" For home and the yearly gathering of family members were central to Dickens's conception of Christmas. He asked his readers, "How many families whose members have been dispersed and scattered . . . meet once again in that happy state of companionship and mutual good-will?" In America, the answer varied year by year. During World War I and the Great Depression, for example, circumstances prevented many people from spending Christmas with loved ones. We know this from the large number of cards with handwritten notes that express longing for an absent friend or relative, or complain of the distance and amount of time that separate the card sender and recipient. Perhaps the Dickensian Christmas coach was a pictorial means of expressing such a sentiment, though with the requisite gloss of holiday cheer. Certainly there are many coaching cards that contain printed verses or greetings that refer to fond memories, the crossroads of life, and carrying people in one's heart.

That coaching cards emerged around 1920 as the automobile was starting to permeate American society is surely not a coincidence. That the imagery mostly disappeared during the post-World War II craze for Westerns in movies, comic books, and television is probably not surprising either. It appears that the affect of the Christmas coach, whether traveling through New England or Merrie Olde England, was not transferable to the coaches of the wild frontier. Automobiles themselves were featured on a few cards, most of them with a self-consciously modern flavor and occasionally a touch of humor. It is plain that these cards lacked the emotional resonance of the coaching cards, which probably explains their relative lack of popularity. Scenes of coaching, by contrast, are abundant in the extreme and constitute some of the most engaging and accomplished Christmas card images of the era.

1913 New Jersey becomes the first state to require licenses for all drivers.

1915 Clifton Johnson's *Highways and Byways of New England* and L. H. Baker's *The Favorite Motor Ways of New England* both offer guidance to those touring the region by car.

1916 Kate Douglas Wiggin publishes *The Romance of a Christmas Card*, in which a Christmas card and traveling both figure prominently.

1917 The Bleecker Street line closes, ending the era of horse-drawn streetcars in New York City.

1918 In this year, half of all cars on American roads are Model T Fords.

1919 The Abbott-Downing Co. of Concord, New Hampshire, closes.

1923 August 20. In Niagara Falls, New York, the opening of the Red Coach Inn, an imposing hostelry in the English Tudor half-timbered style.

1925 Antiquarian and photographer Mary Harrod Northend publishes *We Visit Old Inns*.

1927 The first Bracebridge Dinner is held at Ahwanee Hotel in Yosemite

National Park, based on an episode recounted in Washington Irving's *Sketch Book*.

1933 April 7. The Budweiser Clydesdales make their debut in a parade held to celebrate the end of Prohibition.

1935 The carriage horses return to New York City's Central Park.

1935 Or thereabouts. The Red Coach Grill welcomes diners in Wayland, Massachusetts; franchises later replicate the restaurant in other parts of the country.

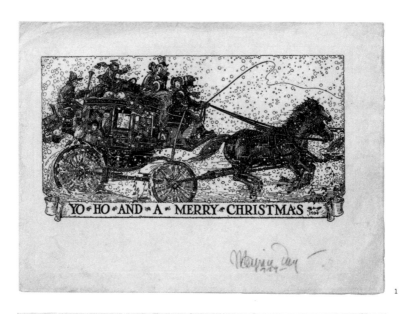

YO HO AND A MERRY CHRISTMAS

1

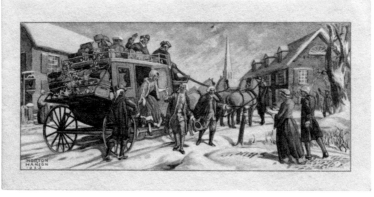

2

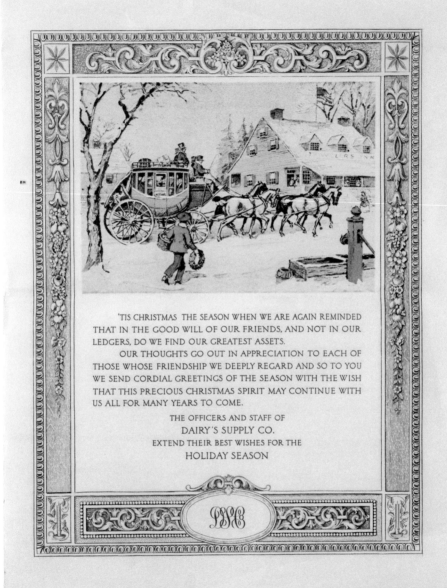

'TIS CHRISTMAS THE SEASON WHEN WE ARE AGAIN REMINDED THAT IN THE GOOD WILL OF OUR FRIENDS, AND NOT IN OUR LEDGERS, DO WE FIND OUR GREATEST ASSETS.

OUR THOUGHTS GO OUT IN APPRECIATION TO EACH OF THOSE WHOSE FRIENDSHIP WE DEEPLY REGARD AND SO TO YOU WE SEND CORDIAL GREETINGS OF THE SEASON WITH THE WISH THAT THIS PRECIOUS CHRISTMAS SPIRIT MAY CONTINUE WITH US ALL FOR MANY YEARS TO COME.

THE OFFICERS AND STAFF OF
DAIRY'S SUPPLY CO.
EXTEND THEIR BEST WISHES FOR THE
HOLIDAY SEASON

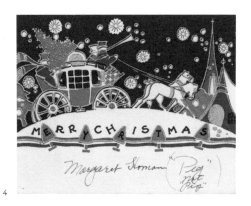

4

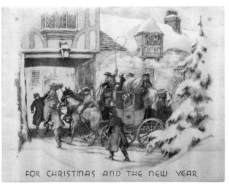

FOR CHRISTMAS AND THE NEW YEAR

5

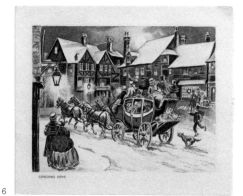

6

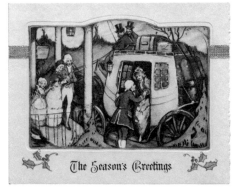

The Season's Greetings

7

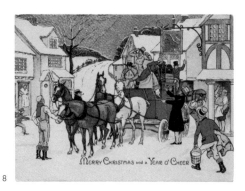

8

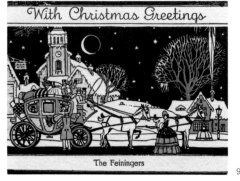

9

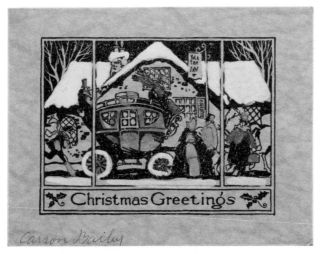

Carson Bailey

10

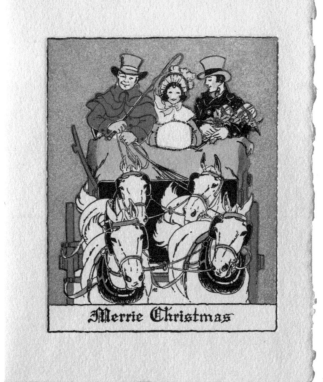

Merrie Christmas

11

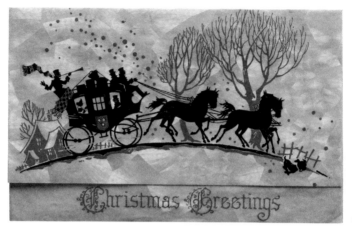

12

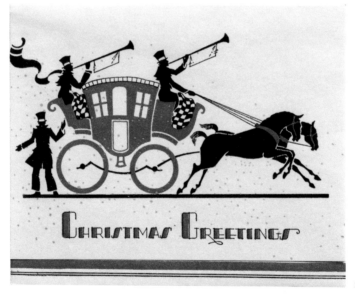

13

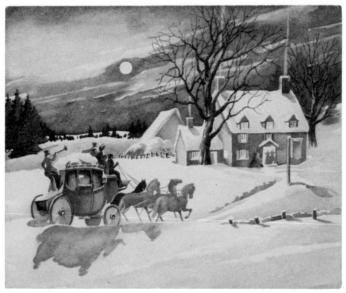

14

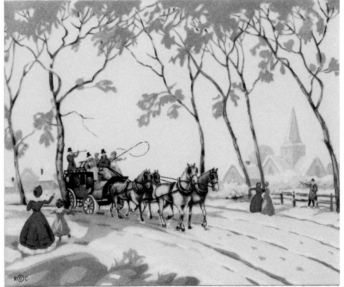

15

SHIPS

Ships are majestic testimony to the ability of humans to overcome obstacles. Ships solve the problem of carrying people and cargo over water. Ships of many kinds have figured prominently throughout history, but they have never been explicitly linked to the celebration of Christmas in the United States. Why, therefore, do images of ships appear on American Christmas cards? The answer is not obvious. Occasional references to "ship of good cheer" or "cargo of good wishes" hardly offer a compelling explanation. Yet ship imagery abounds, particularly during the 1920s and 1930s, and it is remarkably consistent at that.

One way to approach ship imagery is to think about it as a component of the larger category of travel, which also embraces the three kings and coaching, as well as the occasional train, automobile, or plane. But unlike the majority of those images, where people are usually at the center of activity, humankind is often completely invisible on ship cards, so something else must be operative here. Perhaps some clue lies in the form of the ships depicted. Nearly all are archaic and obsolete sailing craft, three-masted schooners. The ships are often quite accurately drawn; the number and location of sails and overall proportions of the vessels are generally correct and closely resemble the images of ships printed in books and on maps of the sixteenth and, especially, seventeenth century. The garish colors on some of the cards recall the hand-colored images on many of those publications.

Cards bearing images of archaic commercial sailing craft may be particularly eloquent instances of the practice of displacement that recurs with such frequency on Christmas cards. Perhaps, in most concentrated terms, images of ancient ships are actually about contemporary ships and more generally about shipping, commerce, and growing American presence in international trade. The images themselves reference ships of the Dutch Golden Age, when international commerce over the seas made that country the richest in Europe. Relying on ship-

1830 September 16. Oliver Wendell Holmes's poem "Old Ironsides" is printed in the *Boston Daily Advertiser* and generates enthusiasm for preserving the venerable warship.

1833 "I Saw Three Ships" is included in *Carols Ancient and Modern*, published by English antiquarian William B. Sandys.

1838 The British steamship *SS Great Western*, designed by Isambard Kingdom Brunel, begins regular transatlantic crossings.

1841 January 3. American novelist Herman Melville sails from New Bedford, Massachusetts, on the whaler *Acushnet*, bound for the south Pacific; *Moby-Dick; or, the Whale* appears in 1851.

1844 A group of gentlemen establish the New York Yacht Club, an exclusive association dedicated to racing sailing craft.

1878 May 25. Gilbert and Sullivan's comic opera *H.M.S. Pinafore; or, The Lass that Loved a Sailor* opens in London.

1883 Previously serialized, Robert Louis Stevenson's *Treasure Island* appears in book format; N. C. Wyeth's memorable illustrations enhance the 1911 edition.

1901 The grandly imposing clubhouse of the New York Yacht Club at 37 West 44th Street in Manhattan is completed; architects are Warren and Wetmore.

ping, the Dutch and then the British after them were able to dominate commodities markets and consolidate their positions as world powers. The enduring emblem of that era remains the three-masted East Indiaman, repeatedly evoked on these cards.

By the 1920s the United States was undergoing a shift in its own global status, becoming one of the richest and most powerful nations in the world after wartime devastation of its former European rivals. These images of early sailing ships may be oblique references to America's emerging dominance. It is reasonable to imagine that successful American businessmen might have been drawn to an image suggestive of the Dutch Golden Age when choosing a Christmas card. The energy, movement, and confidence conveyed by these cards and the winking reference to global domination come together to create a perfect Christmas card for elite Jazz Age Americans.

Of course, the people who bought these cards might simply have preferred boats to images of three kings, candles, or snowy landscapes. The celebration of Christmas and the images that accompany that celebration are dynamic and adaptive; it sometimes seems that there are few inappropriate ways to mark a holiday that was once pagan and then was Christian and is now mostly secular. These cards represent a flash of popular interest in ships at a period when the United States was relatively affluent and powerful. The materials used to produce the cards suggest that the buyers of ship cards were relatively affluent as well. By circulating Christmas greetings via cards with ships, the senders could align themselves with imperial power of the past and confirm their position within an elite subgroup in a country that was well on its way to becoming the imperial power of tomorrow. Or perhaps they mean something else altogether.

1909 September 25. Initial ceremonies of the Hudson-Fulton Celebration, an event commemorating two figures critical to the commercial development of New York.

1914 After 10 years and thousands of deaths, the Panama Canal is completed, dramatically reducing the time of ship travel between the Atlantic and Pacific Oceans.

1926 Douglas Fairbanks stars in the silent film thriller *The Black Pirate*.

1929 December 29. Incorporation of the Maritime Historical Association, dedicated to preserving maritime culture; today known as Mystic Seaport in Mystic, Connecticut.

1934 Debut of Cole Porter's *Anything Goes*, a light-hearted musical set on a transatlantic ocean liner.

1935 Errol Flynn, Olivia de Havilland, and Basil Rathbone star in the film version of *Captain Blood*, based on Raphael Sabatini's novel of 1922.

1935 Film version of *Mutiny on the Bounty*, with Charles Laughton and Clark Gable, wins the Academy Award for Best Picture.

1937 An English author writing under the pen name C. S. Forester begins a series of novels featuring the fictional Royal Navy officer Horatio Hornblower.

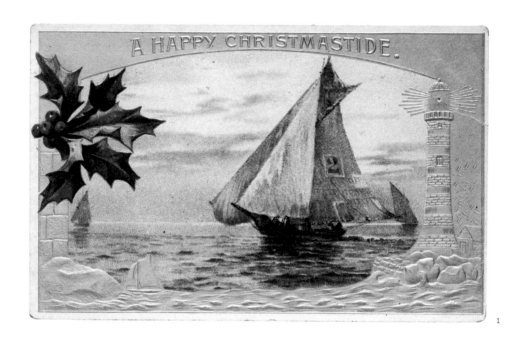

1

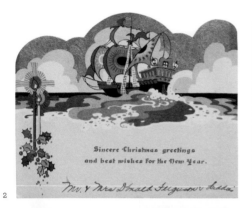

Sincere Christmas greetings
and best wishes for the New Year.

Mr. & Mrs. Donald Ferguson Addai

2

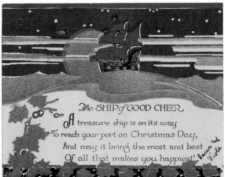

The SHIP of GOOD CHEER
A treasure ship is on its way
To reach your port on Christmas Day,
And may it bring the most and best
Of all that makes you happiest!

3

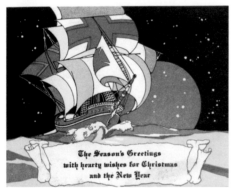

The Season's Greetings
with hearty wishes for Christmas
and the New Year

4

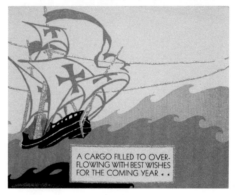

A CARGO FILLED TO OVER-
FLOWING WITH BEST WISHES
FOR THE COMING YEAR · ·

5

MERRY CHRISTMAS TO YOU, HAPPY NEW YEAR, TOO!

Mr. and Mrs. Charles Gray

6

The best of wishes for a merry Christmas
and a happy New Year

Miss Isabel Colman Shattuck

7

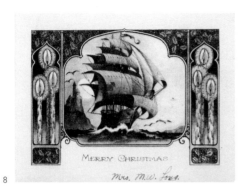

8

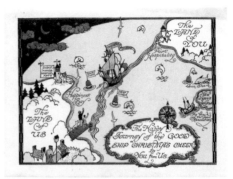

9

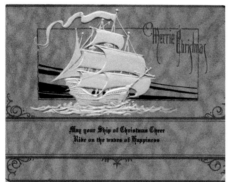

10

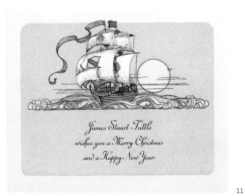

11

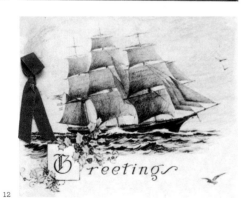

12

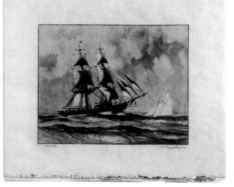

13

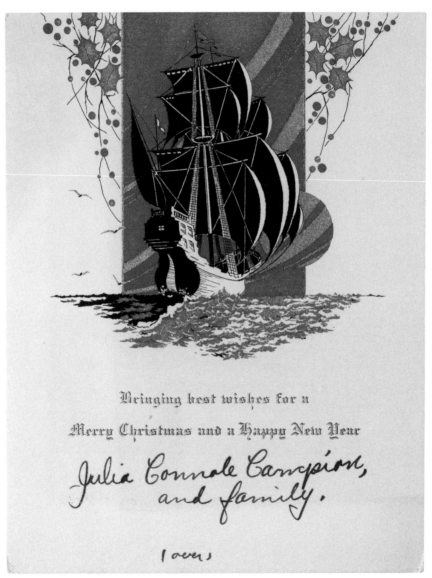

Bringing best wishes for a

Merry Christmas and a Happy New Year

Julia Connale Campion,
and family.

(over)

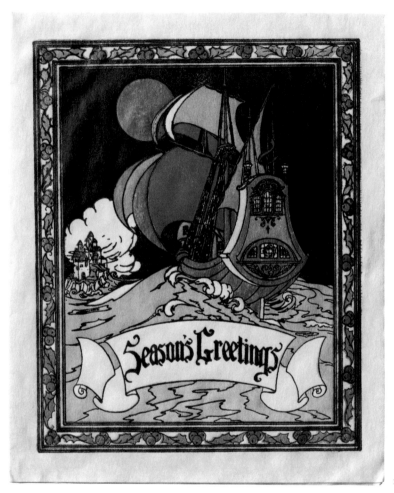

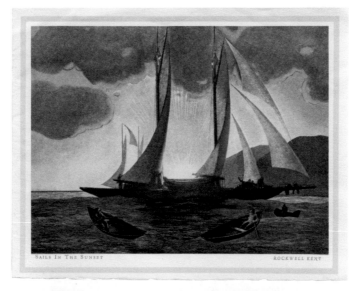

SAILS IN THE SUNSET ROCKWELL KENT

16

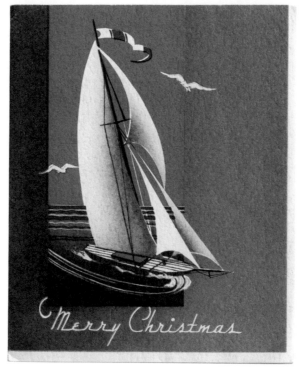

Merry Christmas

17

MEDIEVAL REVELS

The so-called Middle Ages were discovered once again in the nineteenth century and found worthy of selective celebration and emulation. Within the developing discipline of art history, emphasis was on the artful products of the Christian church, which were sorted, classified, and ranked to create a canon that still endures. Designers of American Christmas cards of the twentieth century took little interest in medieval Christian imagery, however, with the occasional exception of references to the tradition of the illuminated manuscript. Cards produced both early and late offered either replications of or free variations on the hand-lettered and ornamented pages of these texts, usually showing a marked preference for Gothic-style prototypes.

Much more appealing to designers and the purchasing public alike were wholly secular scenes of feasting and revelry. The major themes of these images included music both sung and played on various instruments; processions of splendidly (and imaginatively) attired people on their way to a sumptuous meal; and depictions of figures bringing in the Yule log. Although medieval music scenes sometimes overlap with those presented here under the rubric of music (see Music), there are both differences and links. The medieval music-makers are distinguished by their often elaborate and intentionally unfamiliar attire and by the generally undatable architecture around them; fairy-tale castles are popular backdrops.

These scenes of male musicians performing or moving through a wintry night appear to reference the various traditions of mumming that were parts of European seasonal rituals and were later transferred to this country. Mummers typically made informal house visits to spread wishes of good will, good fortune, and prosperity, often accompanied by play acting, music, or other types of performance and frequently culminating in a communal meal or drink. Mummery shares an origin with the New Year's carnival and sometimes devolved into similarly boisterous behavior. However, mumming also offers an opportunity to act and dress in opposi-

1836 In London, Augustus Welby Northmore Pugin publishes *Contrasts*, intending to show how life in the Christian Middle Ages was superior to that of the modern secular age.

1859 Alfred Lord Tennyson publishes *Idylls of the King*, his reworking of the Arthurian legend; sales reach 10,000 in the first week.

1871 Construction begins on the Connecticut State Capitol building in Hartford, designed by Richard M. Upjohn and James Batterson; a

Gothic-style dome is among its prominent features.

1889 Mark Twain's *A Connecticut Yankee in King Arthur's Court* satirizes romanticized views of the Middle Ages.

1896 William Morris's Kelmscott Press produces *The Works of Geoffrey Chaucer*, considered a major monument in the history of book design.

1901 January 1. The first official Mummers Parade takes place in Philadelphia.

1905 Boar's Head Provisions Co. begins in Brooklyn, New York.

1910 Frank Woolworth commissions architect Cass Gilbert to design the neo-Gothic Woolworth Building in New York City; this "cathedral of commerce" is the tallest building in the world when completed in 1913.

1919 Dutch historian Johan Huizinga publishes *The Waning of the Middle Ages*.

1921 In New Haven, Connecticut, Harkness Tower is completed, the

tion to social conventions, for its underlying motivation is community socializing and bonding. Philadelphia's annual Mummers Parade, which takes place not on Christmas but on New Year's Day, conserves, with endless and ongoing changes, the spirit of medieval winter mumming.

Court pageantry and holiday feasting on a grand scale also constitute a notable component of medievalizing imagery. While serving as extravagant entertainment, these processional rituals and communal meals similarly served to underscore jovial fellowship and cement social relationships. The jesterlike figure known as the Lord of Misrule often presided over courtly festivities and even became an important royal official at the height of the court masque. Similar figures also led bands of riotous mummers.

The pageants and processions seen on the cards here are elaborated and formalized by blaring trumpets, billowing banners, figures dressed in lavishly intricate and flowing robes, and the ceremonial presentation of a boar's head, plum pudding, or other festive fare. The curious part of these celebrations of feasting, however, is how very infrequently they actually appear on American Christmas cards. Readers familiar with Dickens's *Christmas Carol* may recall that the most sustained descriptive passage in the book is the sensuous and powerfully evocative enumeration of the glorious range of foodstuffs for sale in London shops at Christmas. In the same spirit, the central scene of Horsley's 1843 Christmas card for Henry Cole depicts a multigenerational family obviously enjoying a satisfying holiday tipple. Somewhere along the line, something in later American culture conspired to suppress representation of the full Epicurean potential of Christmas. Too bad.

most prominent of numerous Collegiate Gothic structures designed by architect James Gamble Rogers for Yale University.

1922 The silent film *Robin Hood* is released, with Douglas Fairbanks in the leading role.

1922 New York architects Howells and Hood win the competition to design the new headquarters of the *Chicago Tribune* with a Gothic skyscraper in the "American perpendicular" style.

1922 Scribner's reprints Sidney Lanier's *The Boy's King Arthur* with new illustrations by N. C. Wyeth.

1924 December 2. Sigmund Romberg's operetta *The Student Prince* opens in New York and features the rousing "Drinking Song," which is particularly popular during Prohibition.

1929 Milton Ager and Jack Yellen copyright the song "Happy Days Are Here Again," later associated with

the election of Franklin D. Roosevelt and the repeal of Prohibition.

1937 February 13. Hal Foster's comic strip *Prince Valiant* makes its debut.

1940 The Boar's Head and Yule Log Festival is initiated at Christ Church Cathedral in Cincinnati, Ohio.

May the meaning of Christmas be deeper Its friendship stronger and its hopes brighter As it comes to you this year

1

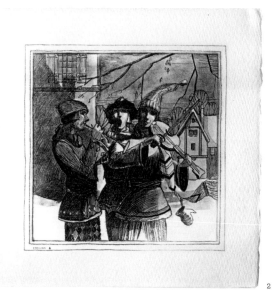

2

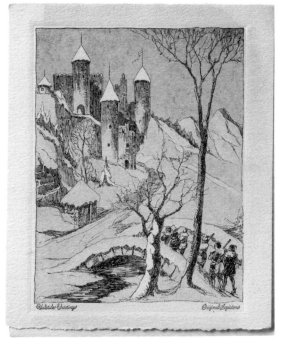

3

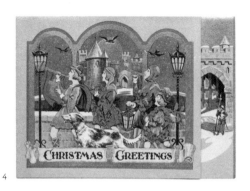

4

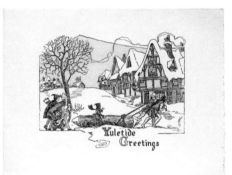

5

6

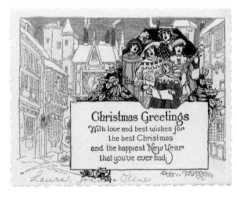

7

8

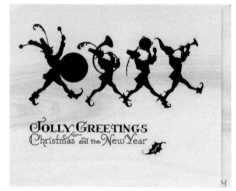

9

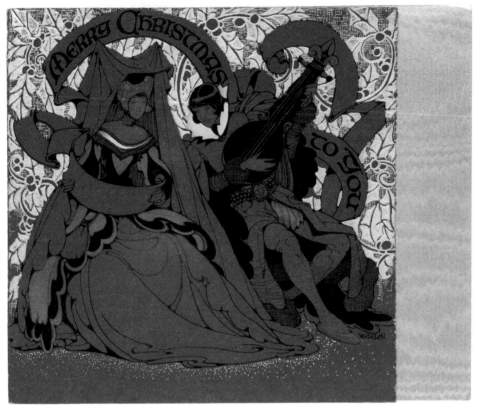

10

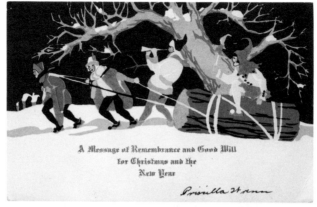

11

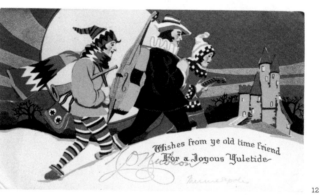

12

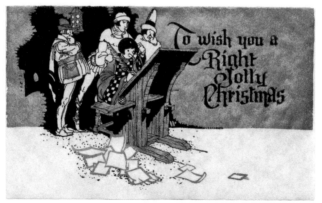

13

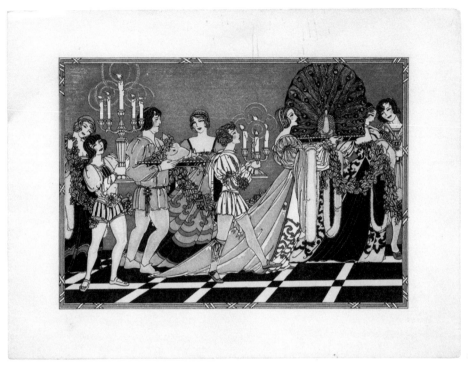

HOUSES AND HOMES

Against the many oft-repeated motifs of the Christmas card landscape, the image of a house, with trees, with snow, most often in a rural setting, stands for primal human shelter. Refuge, coziness, belonging, place—the sparest of depictions conjures the deepest meanings of home, which now come to symbolize Christmas at its essence. On the whole, holiday cards featuring houses are unusually subdued, communicating a restfulness on the quietest end of the season's emotional spectrum. Indeed, whether fairy-tale home, smoky farmhouse, or ancient half-timbered abode, these are dream houses, not real ones. Visions of imaginary residences provide, in the words of French philosopher Gaston Bachelard, "the psychological elasticity of an image that moves us at an unimaginable depth." He goes on to say that "the house shelters day-dreaming, the house protects the dreamer, the house allows one to dream in peace." Christmas card dream houses are rooted in two deeply embedded American cultural constructions: the aspiration to own a free-standing, single-family home and the romance of an invented rural New England past. References to both abound in these images.

According to anthropologist Grant McCracken, key physical attributes, such as natural materials and traditional styles, universally embody the feeling of homeyness. The creation of this sensation depends on visual cues that communicate enclosure and therefore safety. It is no accident, then, that the repetition of vaguely New England countryside vistas on Christmas cards—the profile of a steep roofline against rounded hillsides or protected by a grove of snow-covered trees—fulfills these criteria perfectly. Adding to this equation is the potency of rural New England as the romantically reconstructed national past. Titles like "The Old Homestead" appealed to generations jarred by industrialization and migration who longed for an apparently simpler time when a plot of land might have guaranteed an inheritance as well as a place of rootedness.

1821–22 The term "Cape Cod House" first appears in Timothy Dwight's posthumously published *Travels in New England and New York.*

1823 "Home! Sweet Home!" Is sung as an aria in John Howard Payne's otherwise forgotten opera *Clari, Maid of Milan.*

1830 May 26. President Andrew Jackson signs the Indian Removal Act, prompting the "Trail of Tears" and forced westward emigration of Native Americans.

1850 *The Architecture of Country Houses* by America's first tastemaker, Andrew Jackson Downing, promotes rural living for all classes.

1851 Sometime resident of Concord, Massachusetts, Nathaniel Hawthorne, publishes *The House of the Seven Gables.*

1862 President Abraham Lincoln signs the Homestead Act, which grants up to 160 acres of Western federally owned land freehold to settlers who will improve it.

1883 February 16. The first issue of *Ladies' Home Journal* appears, with Louisa Knapp Curtis as editor.

1890 Jacob A. Riis's *How the Other Half Lives* exposes the poverty of tenement life in New York City's Lower East Side.

1899 New Hampshire Governor Frank West Rollins initiates "Old Home Week;" similar festivals spread across New England.

1922 Edwin Meredith, former Secretary of Agriculture under Woodrow Wilson, establishes the magazine *Better Homes and Gardens.*

1922 Vice President Calvin Coolidge calls for America to become "a nation of home owners."

While cities were swelling in population, these images painted a wish for the American ideal of the single-family, free-standing home in a small town or village or comfortably set off by itself. In architectural style, aside from a fleeting taste for various fantasy and enchanted forms, the occasional log cabin, or that even rarer urban residence, the simple, snug form of the Cape Cod house, predominates. In the Cape Cod house, the center-chimney design bespeaks warmth and nurture, and the low profile suggests the modest and unpretentious. The isolated front door of a house sometimes also appears as a motif, a commonplace but expressive artifact that serves to separate in from out, warm from cold, society from nature. House images rarely include people, nor do they need to. The house itself is sufficiently evocative.

What is particularly striking about so many of the houses depicted on cards of the second quarter of the century is that they are so insistently vernacular. Big houses occasionally appear, often associated with some historical worthy, but the undatable house in a vaguely old-timey style predominates, standing apart from the fashionable and of-the-moment on one side and the ostentatious and costly on the other. And, odd as it may seem, although these cards usually depict exteriors, they evoke thoughts and feelings associated with interiors, both domestic and psychic.

Taken by itself, the message "Greetings from our house to your house" is terse and even banal. Connected to images such as these, however, it becomes an invitation to shared sympathies and sentiments of great complexity and depth, indicating once again why images play such primary roles on Christmas cards.

1925 Edward Hopper paints *House by the Railroad*, now in the collection of the Museum of Modern Art.

1932 Ted Lewis and his band have a hit with "In a Shanty in Old Shanty Town," a song written by Ira Schuster, Jack Little, and Joe Young.

1935 Laura Ingalls Wilder publishes *Little House on the Prairie*.

1936 March 10. Dorothea Lange's photograph of Florence Owens Thompson, better known as *Migrant Mother* and considered a canonical image of Depression-era America, appears in the *San Francisco News*.

1939 John Steinbeck publishes *The Grapes of Wrath*, which wins the Pulitzer Prize in 1940; Steinbeck himself wins the Nobel Prize for Literature in 1962.

1941 James Agee and Walker Evans collaborate on *Let Us Now Praise Famous Men*, documenting the lives of Alabama sharecroppers.

1942 February 19. President Franklin D. Roosevelt signs Executive Order 9066, which leads to the internment of Japanese-Americans for the duration of World War II.

1942 In *The Little House*, a children's book by Virginia Lee Burton, a rural family home is gradually swallowed up by a big city.

1947 Levitt & Sons begins construction of the first Levittown in Hempstead, Long Island.

1948 The film version of *Mr. Blandings Builds His Dream House* appears, based on the 1946 novel by Eric Hodgins.

1956 *The Crack in the Picture Window*, written by John Keats, critiques suburban sprawl.

Merry Christmas 1927
M. C. and W. T. Meenam

1

CHRISTMAS GREETINGS
From our own home to your own home
The best of greetings go.
Because the family with this wish
Would voice a glad Hello!
The Weavers

2

Best Wishes
for the Season's Cheer
and Many Happy Days

3

The Season's Greetings and the
Best of Wishes
for your Christmas and the New Year
Mr. and Mrs. Harold M. Hayes

4

CHRISTMAS
GREETINGS

Just a card with friendly greetings
And a little word of cheer
To wish you Merry Christmas
And a prosperous New Year

Anna Witt.

5

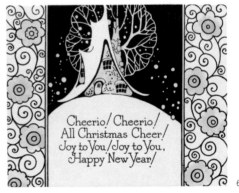

Cheerio! Cheerio!
All Christmas Cheer!
Joy to You! Joy to You,
Happy New Year!

6

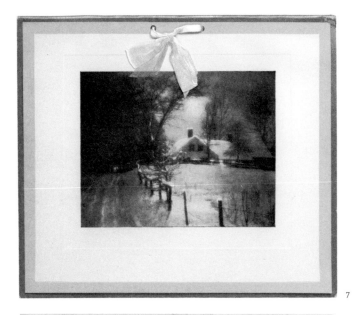

7

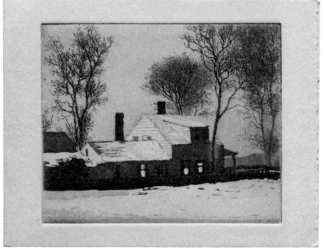

8

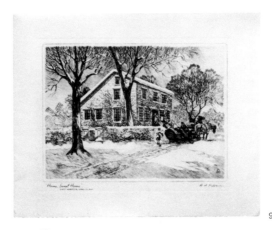

9

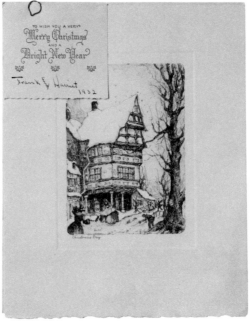

10

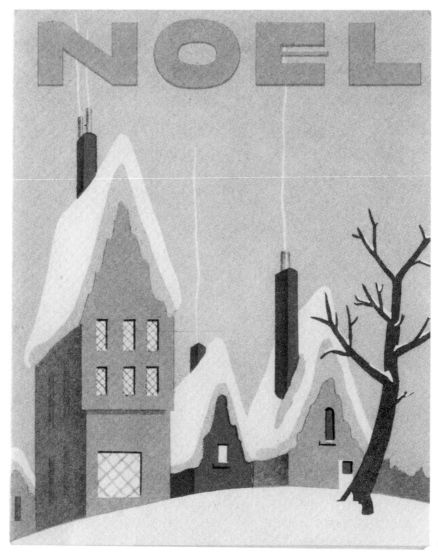

11

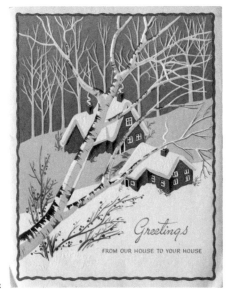

12

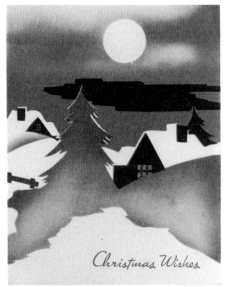

13

14

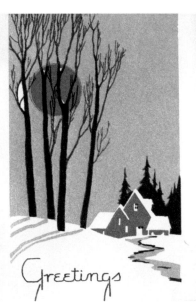

15

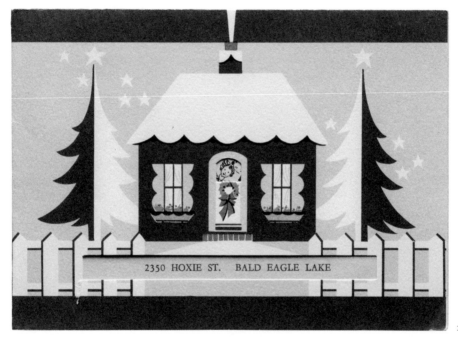

16

HEARTHS

There is much that is primal in American Christmas card imagery, the biological couple for one thing, the brute fact of winter for another. Then there is fire. Fire condensed to a single flame appears as the candle, but fire as a source of heat and nurture is represented by the hearth or the fireplace. In Latin the word for hearth is *focus*, an ancient recognition of fire's ability to command our attention. Survival is at the heart of the domestic fire. What Gaston Bachelard calls fire's "intense gentleness" suits the heightened intensity of Christmas, as well as the hearth's synonymous meanings of home/family, the central tenet of the secularized season. Warm, inviting, cheerful, the earliest visions of fireplaces on cards evoke comfort and friendship. Less expected is what these cards assert about changing social roles, with the hearth as the stage on which the drama unfolds. By the middle of the twentieth century, in the same rooms, conviviality cools, replaced by exclusivity and introversion.

Starting with the diminutive emblems on cards of the 1920s, images of hearths are mini-shrines, delicate beautifications of greeting. Bathed in the nostalgic glow of the Colonial Revival, still-life tableaus systematically feature kettle, tongs, andirons, bed warmer, and other period props. Although all the material culture in the scene implies human presence, many of these images are uninhabited. In other images, these same iconic and evocative artifacts set the stage for old-fashioned fireside activities, such as making popcorn, smoking pipes, conversing, and reading, sometimes accompanied by the requisite woman at a spinning or walking wheel. The effort to preserve an imagined preindustrial past coincided with the utilitarian obsolescence of the fireplace, although not the psychological need for it. Newly built houses then as now still retained the fireplace as the ceremonial focus. Eschewing unromantic coal, whether Pilgrim Century great room or modern living room, all the fireplaces on these Christmas cards burn wood.

1741 Benjamin Franklin invents the Franklin Stove, a metal-lined fireplace that generates more heat and less smoke than conventional masonry fireplaces of the era.

1835 Cast-iron parlor stoves increasingly replace fireplaces for home heating; many stoves are manufactured in Troy and Albany, New York.

1864 An "old New England kitchen" is installed at the Brooklyn Sanitary Fair, serving old-time New England fare to visitors to this Civil War fund-raiser.

1876 "The New England Kitchen" is a popular attraction at the Philadelphia Centennial Exhibition.

1886 John Pickering Putnam publishes *The Open Fireplace in All Ages*.

1890 American artist John Haberle paints his eight-foot-high masterpiece *Grandma's Hearthstone*, now in the Detroit Institute of Arts.

1893 Fireside Industries for the revival of traditional crafts founded at Berea College in Kentucky.

The ambiguous motif of the empty red chair emerges about 1930, when it become part of the furnishings of a contemporary interior with neo-Colonial overtones. This device may speak to an absence or serve as an evocation of Depression-era compensatory abundance. "Always a Chair for You" may point to anxieties of changing gender roles; economic insecurity in the 1930s hit men harder than women, while print advertising of the period portrayed women as aloof, hard-to-please creatures. Perhaps to mediate such perceptions, couples emerge as consistent hearthside presences (see also Couples), but attired in a contemporary manner rather than the imaginary antique mode so often represented in other categories of imagery.

One of the most notable differences between early populated hearth scenes and those of later years is the orientation of the figures depicted. In the earlier cards, not incidentally set in the imagined past, figures are arranged either more or less parallel to the picture plane; more frequently, they form a loose, outward-looking semicircle that embraces viewers. In the later cards, set in schematized contemporary settings, husband and wife sit on a sofa or in matching his and hers armchairs facing away from viewer. The scene is cozy and intimate, but we are not part of it. The invitation to enter the scene of physical and social warmth has been replaced by exclusion and isolation. Physical warmth is still present but social warmth has apparently become rationed. These are curious and somewhat unsettling images.

1904 Wallace Nutting Art Prints Studio opens on East 23rd Street in New York City, selling hand-colored photographs of, among other things, colonial interiors with fireplaces.

1910 Camp Fire Girls of America founded in Thetford, Vermont.

1914 Wartime song "Keep the Home-Fires Burning" published in London, recorded by John McCormack and others.

1933 March 12. President Franklin D. Roosevelt gives the first of a series of informal radio broadcasts known as the Fireside Chats.

1941 In *Winter in Vermont*, author Charles Edward Crane discusses the merits of various trees as fuel and the comparative advantages of burning seasoned and green wood.

1944 Mel Tormé and Bob Wells compose "The Christmas Song," which begins with the line "Chestnuts roasting on an open fire."

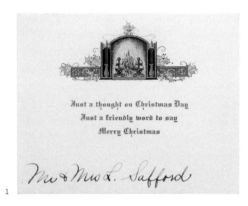

Just a thought on Christmas Day
Just a friendly word to say
Merry Christmas

Mr & Mrs L. Safford

1

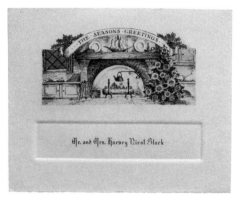

THE·SEASONS·GREETINGS

Mr. and Mrs. Harvey Nirol Black

2

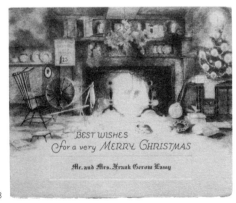

BEST WISHES
for a very MERRY CHRISTMAS

Mr. and Mrs. Frank Gerow Lamy

3

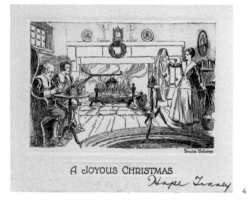

A JOYOUS CHRISTMAS
Hope Tinney

4

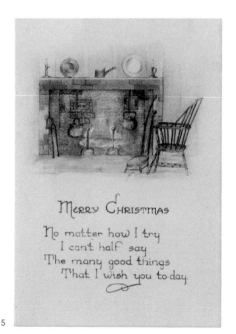

MERRY CHRISTMAS

No matter how I try
I can't half say
The many good things
That I wish you to-day.

5

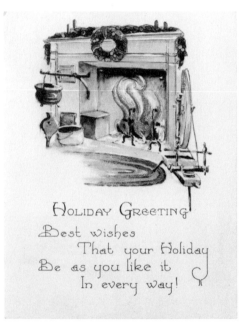

HOLIDAY GREETING

Best wishes
 That your Holiday
Be as you like it
 In every way!

6

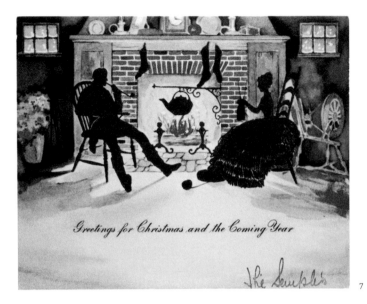

Greetings for Christmas and the Coming Year

The Semples

7

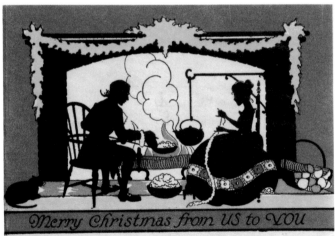

Merry Christmas from US to YOU

8

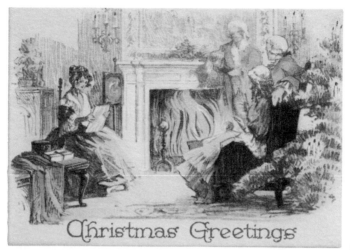

9

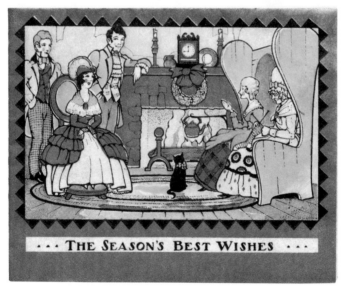

10

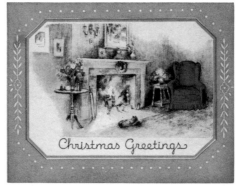

11

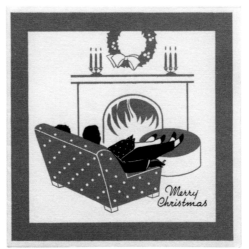

12

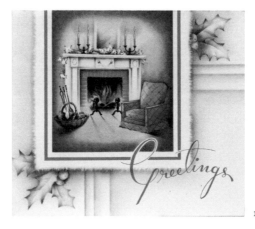

13

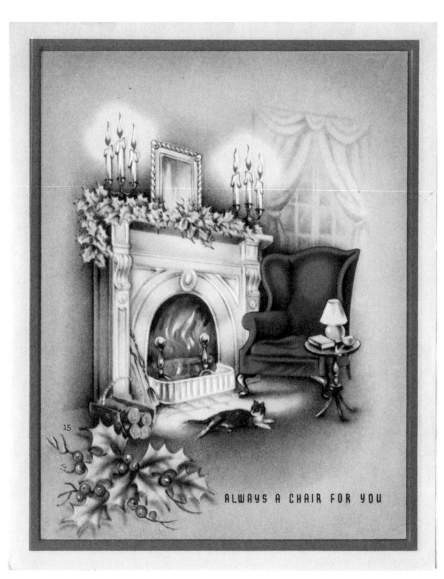

15

ALWAYS A CHAIR FOR YOU

14

Hearths 137

MUSIC

Recorded music shapes today's experience of Christmas, so much so that complaining about its pervasiveness has become a holiday tradition itself. As much of the technology for recording and broadcasting music came into use during the period of the cards shown here—the early 1900s through the early 1950s—many who sent and received cards had a similar (if not quite so intensive) relationship with Christmas music. Yet with few exceptions most of these cards show one thing: people making music. It is the experience of hearing people play and sing that lives in these images.

Caroling is well represented here, especially on cards from the 1920s and 1930s, where carolers are shown in two guises, as medieval revelers or as hoop-skirted and top-hatted Victorians. Both do their singing among the half-timbered houses of a European village (or maybe a neighborhood in Westchester County, New York). The medieval garb on some (see also Medieval Revels) points to the roots of the genre. Christmas carols existed in recognizable form in Western Europe in the early eleventh century, and the practice of singing outdoors in groups had become part of the European Christmas by the sixteenth century. Caroling was initially as much about feasting and drinking as singing. One early song states repeatedly that the singers want no food or beverage other than ale. Should you bring them something else, "Thow shalt have crysts curse and myne."

Early Christmas carols were much collected by European nineteenth-century antiquarians with an interest in folklore. Notable among these was William Sandys, a solicitor in Cornwall, whose 1833 book *Christmas Carols Ancient and Modern* helped popularize the form. (Charles Dickens, who chose to frame his own Christmas story as a carol, must have been aware of the book, as he and Sandys corresponded at least once.)

Many carols considered classic today were created in the nineteenth century in England and America, but in later years historians and collectors of older songs often had a low opinion of the new carols. The author of an article in the December 1914 issue of *The Musical Times* wrote,

1742 April 13. Handel's *Messiah* premieres at the Music Hall in Dublin, Ireland.

1818 In Obendorf, Austria, first performance of "Stille Nacht (Silent Night)," words by Joseph Mohr with melody by Franz Gruber.

1833 In London, William Sandys publishes *Christmas Carols Ancient and Modern*.

1849 In Lancaster, Massachusetts, Unitarian minister Edward Hamilton

Sears writes the lyrics for "It Came upon a Midnight Clear."

1853 English cleric John Mason Neale publishes his original composition "Good King Wenceslas" in *Carols for Christmas-tide*.

1877 Thomas A. Edison demonstrates the use of the phonograph.

1892 December 18. Tchaikovsky's two-act ballet *The Nutcracker* premiers at the Mariinsky Theatre in St. Petersburg, Russia.

1903 November 22. Italian tenor Enrico Caruso makes his first appearance with New York's Metropolitan Opera in a new production of Giuseppe Verdi's *Rigoletto*.

1923 The Charleston, a dance named after the city of Charleston, South Carolina, is popularized in the Broadway show *Runnin' Wild*.

1934 Huddie "Lead Belly" Ledbetter records the old song "Goodnight, Irene"; the Weavers record an altered version in 1950.

"Two things stand clear: a man can no more make a carol than a Christmas tree. Such things only grow in the ages. The other is—How easily we can do without German carols, if we try!"

The appearance of carolers on cards from the 1920s and 1930s is no coincidence. Caroling was introduced to the country in the late nineteenth century and slowly gained popularity as a Christmas Eve activity in the decades that followed. The National Bureau for the Advancement of Music actively promoted caroling across the country. In a 1924 report on the encouraging results of their efforts, the organization noted that whereas 30 American cities hosted caroling in 1918, as many as 1,285 did so in 1923.

In giving carolers Victorian outfits, illustrators were evoking what appeared to be a fully formed, unbroken European tradition. It would be closer to the truth to describe their efforts as a revival of a revival, but it belittles both the Victorians and their American emulators to attribute the idealization of caroling entirely to nostalgia. Human voices lifted against the dark and cold and the contrast between the warm interior of a house and chilled but persevering singers—these have much to do with what it means to be human in winter.

That said, caroling thrived in the early twentieth century, even indoors. In the 1910s and 1920s, Wanamaker's department store in Philadelphia hosted carol singing and printed its own book of carols for shoppers. The relationship between commerce and Christmas music, direct and indirect, only solidified in subsequent years, as exemplified by the 1952 Billboard hit "I Saw Mommy Kissing Santa Claus," which was inspired by an advertisement for the Neiman Marcus department store.

The mid-century association of Christmas with saccharine adorability (see Cute) is manifest here in the outbreak of choirboys on cards from the late 1940s and early 1950s. Perhaps illustrators were thinking of the Vienna Boys' Choir, which made an extensive tour of the United States in 1948 after ten years of Nazi persecution. The Harlem Boys Choir, created more than a decade later, would take its raison d'être—children's voices raised in song—and turn it into a new American tradition.

Other cards depict music in the home, where couples and families gather around an instrument. These cards, created on the cusp of the Depression, may have offered comfort. Even if no carolers came calling, one could feel fortunate to be able to sing carols oneself or listen to them on the phonograph.

1941 February 15. Duke Ellington's band makes the first commercial recording of Billy Strayhorn's "Take the 'A' Train."

1941 Pianist Katherine K. Davis composes "The Carol of the Drum," later known as "The Little Drummer Boy."

1948 July. The Orioles record "It's Too Soon to Know," which quickly rises to #1 on the Rhythm and Blues chart.

1949 April 17. Rogers and Ham-merstein's *South Pacific* opens at New York's Majestic Theatre, with Mary Martin and Ezio Pinza in the leading roles.

1954 Dylan Thomas publishes *A Child's Christmas in Wales*, in which he recalls singing "Good King Wenceslas."

1955 The Weavers, blacklisted in 1953, perform at a sold-out reunion concert at Carnegie Hall.

1957 Elvis Presley's *Elvis' Christmas Album*, the first holiday album for the singer, becomes a runaway hit; songs include the classic "Blue Christmas."

1959 February 3. A small plane crashes near Clear Lake, Iowa, killing Buddy Holly, Ritchie Valens, and J. P. Richardson ("The Big Bopper").

1959 The Dave Brubeck Quartet records the album *Time Out*, which includes the iconic "Take Five," composed by the band's saxophonist Paul Desmond.

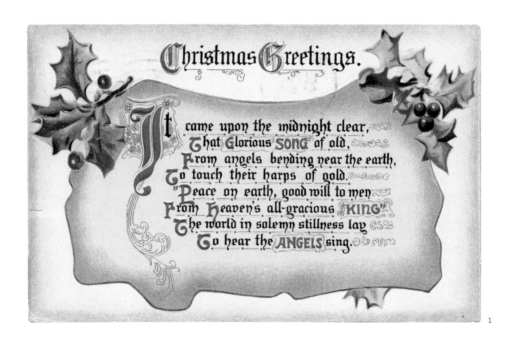

Christmas Greetings.

It came upon the midnight clear,
That Glorious SONG of old,
From angels bending near the earth,
To touch their harps of gold.
"Peace on earth, good will to men
From Heaven's all-gracious KING."
The world in solemn stillness lay
To hear the ANGELS sing.

1

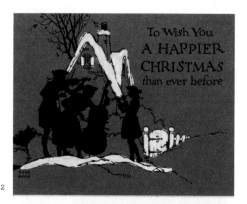

To Wish You
A HAPPIER
CHRISTMAS
than ever before

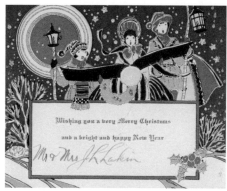

Wishing you a very Merry Christmas
and a bright and happy New Year

Mr & Mrs J.R. Lakin

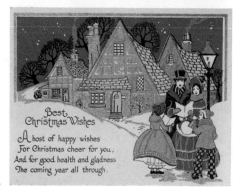

Best
Christmas Wishes

A host of happy wishes
For Christmas cheer for you,
And for good health and gladness
The coming year all through.

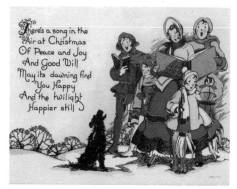

There's a song in the
Air at Christmas
Of Peace and Joy
And Good Will
May its dawning find
You Happy
And the twilight
Happier still

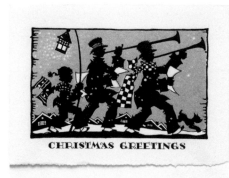

CHRISTMAS GREETINGS

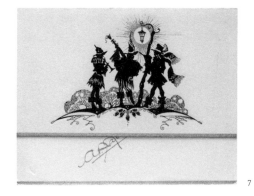

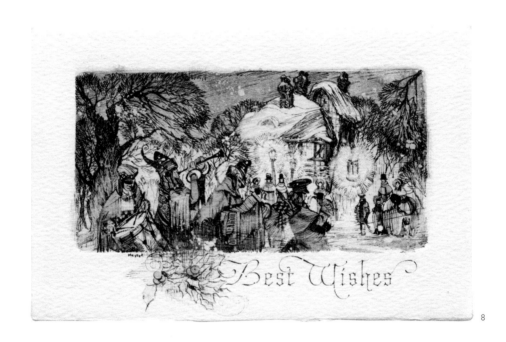

Best Wishes

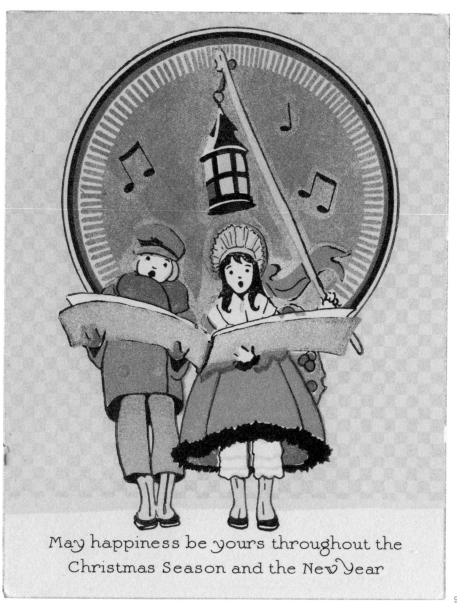

May happiness be yours throughout the
Christmas Season and the New Year

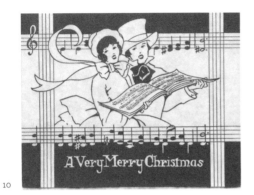

10

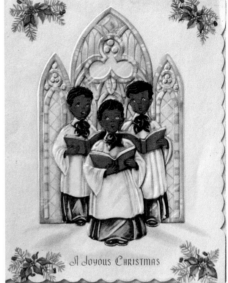

11

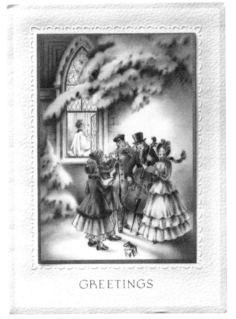

12

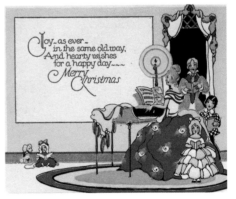

13

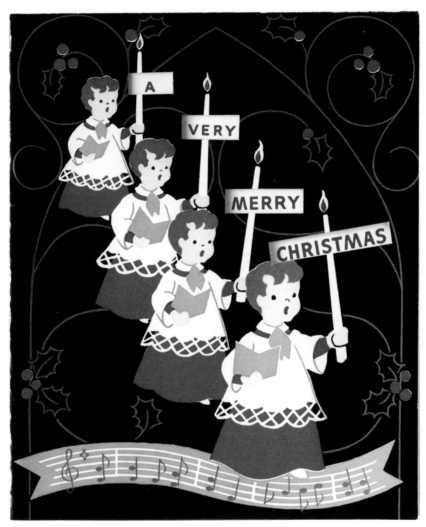

14

COUPLES

Should couples be recognized as a separate category of Christmas card imagery? At the outset of the project, we thought yes. After further examination and reflection, however, we changed our minds, noting that the majority of the couples depicted on cards seemed to be visiting, and so it made more sense to simply fold couples into that category. But after even more pondering, we reversed ourselves yet again. The problem with the couples cards was that there were simply too many to ignore, or even to confine, for that matter. Couples appear here and there in other categories—hearths, for example—but we decided to leave them there. Couples are also implicit in every card signed "Mr. and Mrs." or with the familiar names of a bonded pair. Couples are not merely a prominent motif on Christmas cards but also, at least for part of the twentieth century, the chief participants in the Christmas card ritual. Couple-to-couple exchange antedates family-to-family exchange. And so couples are by no means insignificant.

In truth, most of the couples on the cards shown here are apparently visiting. They carry wreaths and packages and seem to be going somewhere. They pass from left to right or right to left. Walking or riding in a sleigh, they move through imaginary landscapes—or no landscape at all. A few are static and simply gaze out at us, but most are on the move, traveling through Christmas together and, one assumes, traveling through life together as well. Some of the depicted travel takes place by the light of day, but a significant number of the cards show the couple passing together through the darkness of night, another reference perhaps intended to be meaningful on more than one level. In one particularly arresting card, the couple exits upper left, leaving behind a dark and uninviting winter landscape.

1892 The popular song "Daisy Bell," composed by Harry Dacre, includes the line "a bicycle built for two."

1901 Carrie Jacobs-Bond of Janesville, Wisconsin, publishes seven songs, among them the immensely successful "I Love You Truly," sung in Frank Capra's 1946 film *It's a Wonderful Life* and at weddings beyond number.

1920 August 18. The Nineteenth Amendment is ratified, ending the disenfranchisement of women.

1921 In New York City, Margaret Sanger founds the American Birth Control League.

1925 "Tea for Two" is a tune included in the musical *No, No, Nanette*, written by Vincent Youmans and Irving Caesar.

1930 Iowa artist Grant Wood paints *American Gothic*, now in the Art Institute of Chicago.

1935 Fred Astaire sings Irving Berlin's "Cheek to Cheek" in *Top Hat*.

1936 December 10. Edward VIII writes a formal note of abdication as he leaves the British throne to marry American Wallis Simpson.

1938 January 22. Princeton, New Jersey. Premier performance of Thornton Wilder's three-act play *Our Town*, set in a fictional small town in New Hampshire.

1939 Clark Gable and Vivien Leigh star in the Hollywood film version of Margaret Mitchell's 1936 novel, *Gone with the Wind*.

In the predictable manner of Christmas cards, these images are normative in the extreme. Our couples all consist of one male and one female of a certain age, neither too young nor too old. Although no children are present or even suggested, our couples are of child-bearing and child-rearing age. All are white, healthy, energetic, and in good spirits. He is always taller than she. They are always apparently affluent and well-dressed. Much dressed too, for that matter, although in the mode of what era is rarely quite clear. Perhaps the nineteenth century or maybe even the eighteenth. Some couples appear more sophisticated or worldlier than others, but most share the generally positive outlook that pervades Christmas cards. There are no evident conflicts, no simmering disagreements, no suggestion of arguments about politics, religion, or having to eat Christmas dinner yet again with obnoxious in-laws.

The attraction of the theme of the couple is perhaps obvious in a society dedicated to the notion of romantic love, celebrated in an endless series of novels, songs, and films. Not all of these cards were sent by couples, however, and presumably not all went to couples. Furthermore, the representation of couples is not constant. By the 1940s they begin to take on a decidedly cute cast as they decline in number, a pattern congruent with the broader trend of juvenilizing the American Christmas.

1942 Margaret Sanger's American Birth Control League becomes part of the Planned Parenthood Federation of America.

1947 December 3. Tennessee Williams' play *A Streetcar Named Desire* opens on Broadway.

1948 Alfred Charles Kinsey publishes *Sexual Behavior in the Human Male*, followed in 1953 by *Sexual Behavior in the Human Female*.

1949 April 17. Metropolitan Opera basso Ezio Pinza sings "Some Enchanted Evening" for the first time for a New York theater audience at the opening of Rogers and Hammerstein's *South Pacific*.

1950 November 24. *Guys and Dolls*, a musical based on stories by Damon Runyon, opens on Broadway.

1953 The popular advice column "Can This Marriage Be Saved?" appears in *Ladies' Home Journal*.

1956 Grace Metalious publishes her sensational novel *Peyton Place*, which takes place in a fictional small town in New Hampshire.

1960 June 23. The U.S. Food and Drug Administration approves the sale of Enovid (the birth-control pill) for contraceptive use.

1963 February 19. Betty Friedan publishes *The Feminine Mystique*.

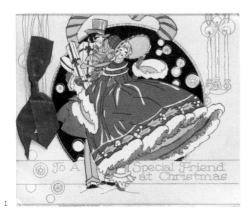

1

2

3

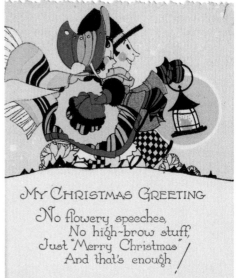

4

5

6

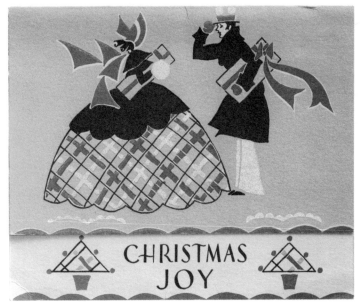

CHRISTMAS
JOY

7

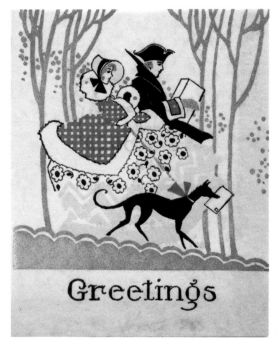

Greetings

8

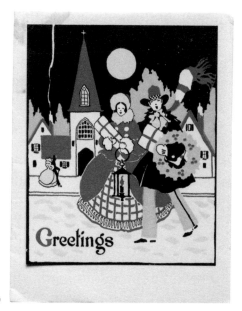

9

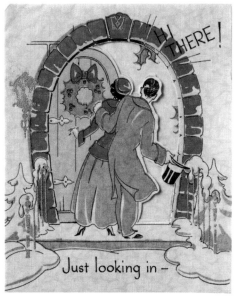

10

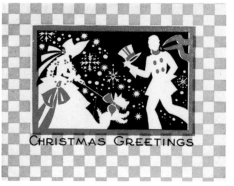

11

12

13

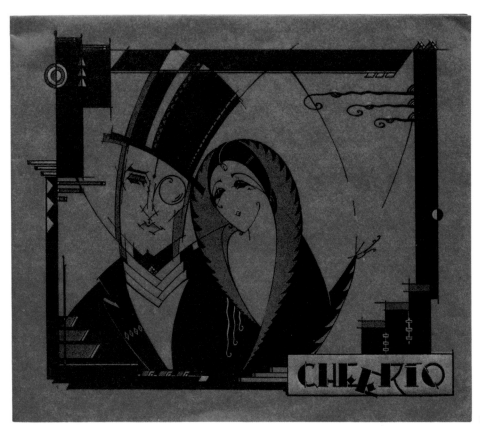

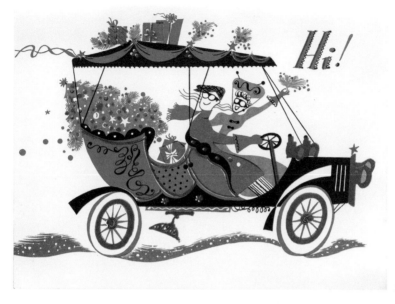

15

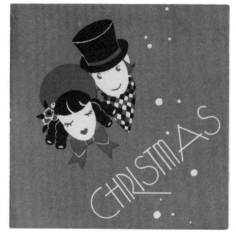

16

VISITING

The act of traveling to someone's home, or visiting, is a common motif on Christmas cards ranging from the early 1920s through the 1940s. Cards that feature the act of visiting can be broken down into a few distinct groups. Some show couples or families approaching a house or a door, having yet to meet the people they are visiting. Others show people greeting one another at a house's front door. Often the people approaching the house are holding presents, though not always. The visitors are usually walking, often through snow, but are sometimes shown using other modes of transportation, such as sleighs. There is no indication that people are coming to stay—no one carries luggage, for instance—but the impression is that these people have come from nearby and are engaged in a ritual of Christmas Day visitation.

The cards almost always depict the scene from outside the house, which allows viewers of the card to travel with the visitors. In this sense, the recipient of the card participates in the visit. On the cards that show visitors approaching the closed door of a home, the viewer can sense the anticipation of the visit; on cards that show the meeting the viewer can read the joy of the Christmas Day greeting.

The text of these cards often refers to "an old-fashioned" Christmas, implying that the act of visiting on Christmas Day is of some antiquity. The figures on greeting cards almost always wear pseudo-Victorian clothing; indeed, the scene itself is often equally pseudo-historic. The houses on the cards tend to be either individual fairy-tale–like cottages or parts of imaginary quaint and cozy villages. These scenes to do not offer realistic images but instead depict a sort of hazy Victorian world, almost predominantly rural, set in snowy New England. The sense is of village life and close community.

There may be some connection here to a real nineteenth-century tradition. In the nineteenth-century, New Yorkers (and some others) spent New Year's Day visiting their friends and

1870 The U.S. Congress and President Ulysses S. Grant designate Christmas Day a national holiday.

1918 Appearance of Booth Tarkington's *The Magnificent Ambersons*, a story of declining fortunes.

1920 Sinclair Lewis publishes *Main Street*, describing life in Gopher Prairie, Minnesota.

1923 Bessie Smith popularizes the Jimmy Cox tune "Nobody Knows You When You're Down and Out."

1929 Sociologists Robert and Helen Lynd examine small-city life in *Middletown: A Study in Modern American Culture.*

1929 Sammy Fain, Irving Kahal, and Willie Raskin publish the song "Wedding Bells Are Breaking Up That Old Gang of Mine."

1931 Irma S. Rombauer and Marion Rombauer Becker issue *The Joy of Cooking*, in which recipes for cookies associated with Christmas are marked with a star.

1932 U. S. first-class postage rises to three cents and remains at that rate until 1958.

1939 October 16. The George S. Kaufman and Moss Hart comedy *The Man Who Came to Dinner* opens at the Music Box Theatre in New York City.

family, an activity possibly based on an older Dutch tradition. Certainly, the acts of calling and visiting were parts of the larger Victorian social etiquette that spread far beyond the holiday season.

Visiting cards frequently include the word "greeting" somewhere in the text, which suggests that the cards may stand in for a physical meeting that cannot take place. One card includes the text "If to your door I cannot come / your voice I cannot hear / My thoughts are with you just the same / Merry Christmas and a Happy New Year." Such a message emphasizes the idea that the greeting card is a substitute for the holiday visit. If the sender and recipient cannot meet in person, they can send tokens evocative of a visit. As such, there is often a message of longing in the cards that depict visiting. One card sums up that feeling quite aptly in the image and accompanying text. A woman stands alone by a window, gazing out. The text reads: "Too far for a handclasp / a smile or a call / but not for this greeting / Merry Christmas to all!"

We can perhaps read the retrospective images and sentiments of these cards as reactions to a society that was becoming increasingly mobile, with family members moving farther and farther away from home. Although the cards often depict gift-giving, it is the action of greeting that is emphasized; presents are less the point than reunion. This theme of coming together is reiterated in Christmas songs such as "Have Yourself a Merry Little Christmas" from the 1944 film *Meet Me in St. Louis*: "Here we are as in olden days / Happy golden days of yore / Faithful friends who are dear to us / Gather near to us once more." As in the song, these cards suggest that Christmas is about being together, that no matter where life has taken you, you will be reunited with those you love for the holiday. It is poignant then, that these cards seem to stand in place of actual visits, displaying merriment and joy that will not be realized.

1943 Bing Crosby records "I'll Be Home for Christmas."

1944 Judy Garland sings "Have Yourself a Merry Little Christmas" in the musical film *Meet Me in St. Louis*.

1951 Singer Rosemary Clooney has a hit with "C'mon-a My House," a tune written by William Saroyan and Ross Bagdasarian.

1951 Meredith Willson writes "It's Beginning to Look a Lot Like Christmas," which becomes at hit for Perry Como and the Fontane Sisters and later Johnny Mathis.

1954 Perry Como records "There's No Place Like Home for the Holidays," written by Robert Allen and Al Stillman.

1955 December 1. Rosa Parks refuses to give up her seat on a bus in Montgomery, Alabama.

1958 The high-water mark of the Christmas card phenomenon in the U.S.; the average family mails one hundred cards.

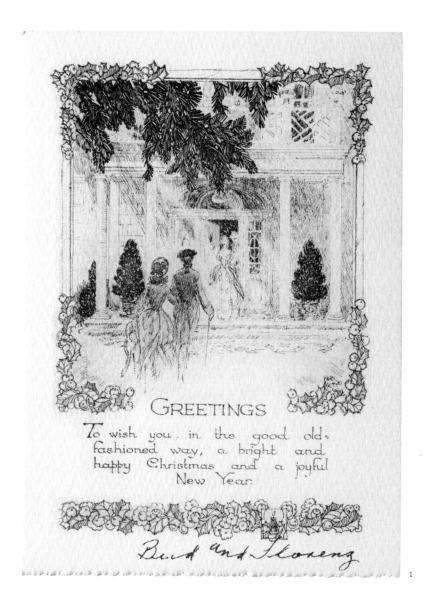

GREETINGS

To wish you, in the good old-
fashioned way, a bright and
happy Christmas and a joyful
New Year.

Buck and Florenz

1

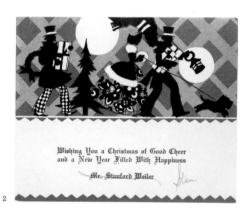

2

Wishing You a Christmas of Good Cheer
and a New Year Filled With Happiness

Mr. Stanford Weiler

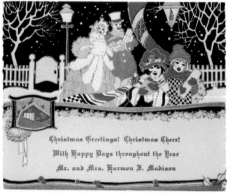

3

Christmas Greetings! Christmas Cheer!

With Happy Days throughout the Year

Mr. and Mrs. Harmon J. Madison

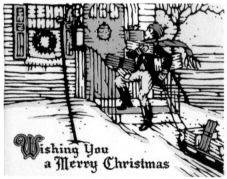

4

Wishing You
a Merry Christmas

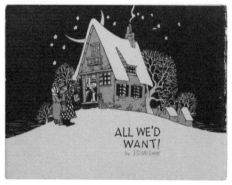

5

ALL WE'D
WANT!
by J. P. McEvoy

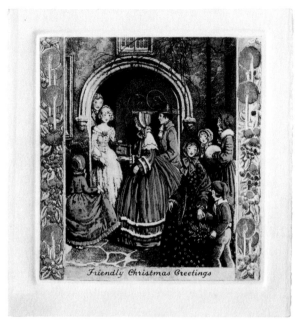

6

7

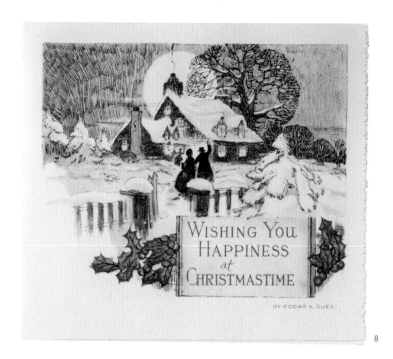

WISHING You HAPPINESS *at* CHRISTMASTIME

BY EDGAR A. GUEST

8

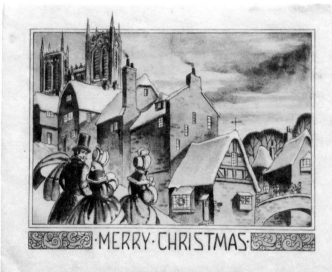

·MERRY·CHRISTMAS·

9

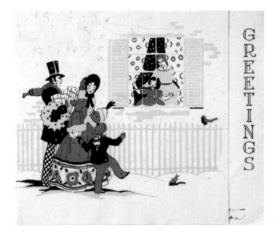

10

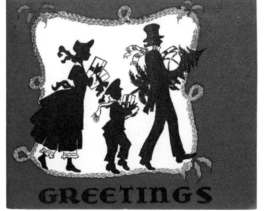

11

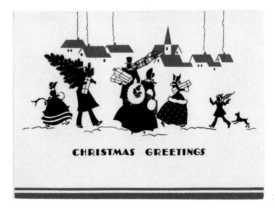

12

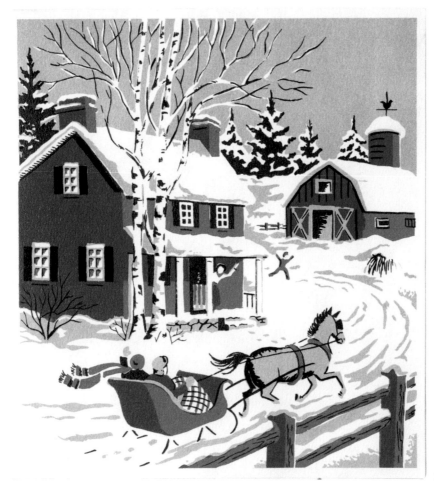

13

14

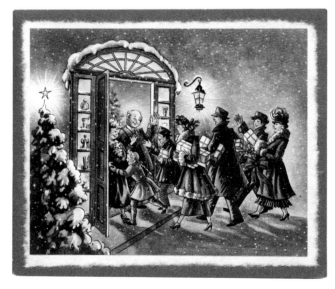

15

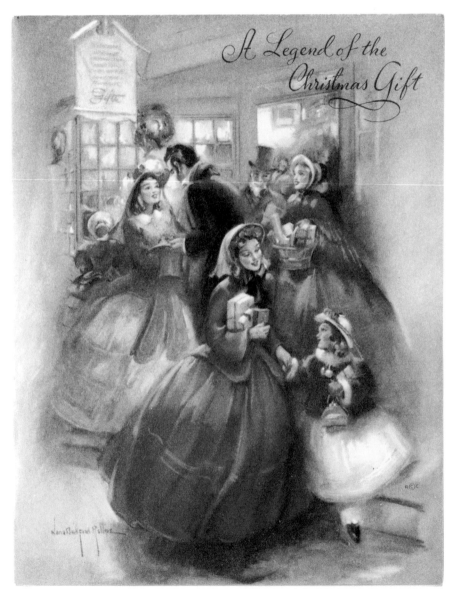

A Legend of the Christmas Gift

SANTA AND THE CHILDREN

Santa Claus is a New Yorker. Like many other New Yorkers, he is of mixed European ancestry, although the details of his lineage are somewhat vague and contradictory. What is clear is that evidence of Santa's presence begins to appear in and around New York City after the American Revolution, a product of the emerging interest in the city's early Dutch history. The writings of John Pintard and Washington Irving played some part in promoting Santa Claus, but the greatest early boost came from the Clement C. Moore poem "A Visit from St. Nicholas," first published in 1823 in Troy, New York. Later, cartoonist Thomas Nast's many evocations of Santa for *Harper's Weekly* gradually elaborated on the details of Moore's account and gave the figure of Santa a distinctive amplitude reminiscent of a Bacchus by the Flemish painter Peter Paul Rubens. In the twentieth century, Macy's got into the Santa act with its annual Thanksgiving Day Parade, celebrated in the film *Miracle on 34th Street*. Needless to say, all of this took place in New York City.

And so it is not inappropriate to point out that Santa Claus has become America's patron saint of materialism. For Dickens, Christmas was about benevolence and generosity, about giving and sharing. For the modern American child, Christmas is about things, about receiving and getting. Once upon a time, Santa was an authoritarian figure whose gifts were based on a child's good behavior, but over the years he evolved into a forgiving and generous friend. His newfound generosity further legitimized the indulgence of children's wishes, thus linking commercialization to his persona. Good or bad, now all shall have presents, for there is no sale in punishment.

1809 Washington Irving publishes *A History of New York from the Beginning of the World to the End of the Dutch Dynasty, by Diedrich Knickerbocker,* wherein fact, fantasy, and St. Nicholas commingle.

1823 December 23. A poem entitled "A Visit from St. Nicholas" appears in the Troy, New York, *Sentinel*; later known as "'Twas the Night before Christmas"; authorship is generally attributed to Clement Clarke Moore of Manhattan.

1837 February 21. Robert Weir, history and portrait painter and instructor at West Point, writes to a friend that he has just completed a painting of St. Nicholas; several copies exist.

1856 A small town in Spencer County, Indiana, officially takes the name Santa Claus.

1863 January 3. *Harper's Weekly* publishes the first in a series of images of Santa Claus created by cartoonist Thomas Nast.

1873 New York publisher Scribner's introduces *St. Nicholas Magazine* for children; the first editor is Mary Mapes Dodge, author of the bestselling novel *Hans Brinker, or the Silver Skates* (1865).

1889 Katherine Lee Bates popularizes a Mrs. Claus in her poem "Goody Santa Claus on a Sleigh Ride."

1890 Jacob Riis's *How the Other Half Lives* documents the widespread existence of child labor and of homeless children in New York's Lower East Side.

1891 In San Francisco, Captain Joseph McFee introduces the Salvation Army's annual Christmas Kettle.

1897 September 21. "Yes, Virginia, there is a Santa Claus," writes Francis P. Church in a *New York Sun* editorial responding to Virginia O'Hanlon's question.

1902 L. Frank Baum publishes the children's book *The Life and Adventures of Santa Claus.*

Some Christmas cards bearing images of Santa Claus were obviously made for children, but a fair number were circulated among adults. The sample here includes scenes of children in various states of anticipation of a visit from Saint Nick, often with the prescripted stockings hung by the chimney with care. Other cards offer ironic commentary on the Santa mythology or tweak it in some way. Santa drives a luxury automobile or travels by plane. He is a messenger boy, a railroad engineer, or a business executive. Santa shills for Coca-Cola, but no one appears to find this offensive or unseemly. Santa might just be a happy tippler—or even a swizzle stick. And in later years, he tends to become cute, like so much other imagery connected with Christmas. But whatever the incarnation, the whole Santa Claus phenomenon is really pretty strange, to put it mildly. Winter is real. So are candles, poinsettias, fireplaces, and decorated evergreens. Santa Claus is not. Furthermore, this fictional character has been fabricated over the years in broad daylight, so to speak, with every innovative step in the process fully documented. Talk about invented tradition.

So no, Virginia, you silly thing, there is no Santa Claus. But that being the case, one does wonder why American parents feel the need to perpetuate the falsehood. Is it really good to lie to little children? Does it keep alive their sense of wonder and belief in miracles or does it warp them for life? Does it prolong their childhood innocence or make them perpetually gullible? Opinions differ widely on these matters. Without Santa Claus and Christmas shopping, however, the retail trade in this country would look very different indeed, and about that there is little disagreement. Let us keep our priorities straight and not ask troublesome questions.

1903 June 17. The Victor Herbert operetta *Babes in Toyland* opens at the Chicago Grand Opera House.

1924 The first rendition of what is now known as the Macy's Thanksgiving Day Parade, which ends with the arrival of Santa Claus.

1931 Illustrator Haddon Sutton creates the first Santa Claus advertisement for Coca Cola.

1934 November 22. "Santa Claus Is Coming to Town," written by John Frederick Coots and Haven Gillespie, is heard for the first time on Eddie Cantor's radio show.

1939 First appearance of "Rudolph the Red-nosed Reindeer," written by Robert L. May for retailer Montgomery Ward.

1947 Twentieth Century Fox releases the award-winning film *Miracle on 34th Street*, written by Valentine Davies and directed by George Seaton; the cast includes a very young Natalie Wood.

1947 Cowboy singer Gene Autry popularizes the song "Here Comes Santa Claus," written in collaboration with Oakley Haldeman.

1949 Santa's Workshop, an early theme park designed by Arto

Monaco, opens in North Pole, New York, in the Adirondacks.

1952 Jimmy Boyd records "I Saw Mommy Kissing Santa Claus," a song written by Tommie Connors to promote Nieman Marcus's Christmas card for the year.

1953 Normand and Cecile Dubois open Santa's Village amusement park in Jefferson, New Hampshire.

1953 October 6. Singer Eartha Kitt, with Henri René and his orchestra, records "Santa Baby," written by Joan Javits and Philip Springer.

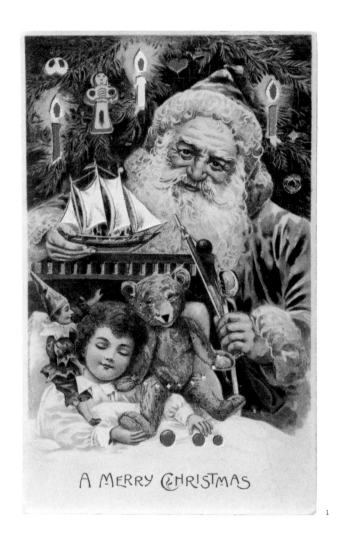

A MERRY CHRISTMAS

1

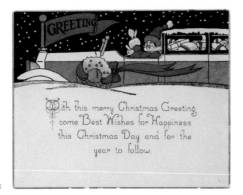

2

With this merry Christmas Greeting
come Best Wishes for Happiness
this Christmas Day and for the
year to follow.

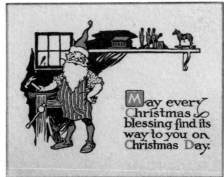

May every
Christmas
blessing find its
way to you on
Christmas Day.

3

MERRY CHRISTMAS

May Santa leave
at your address
Lots and lots of
happiness,
Enough of health, enough of cheer,
To last you through the whole
NEW YEAR.

Wm & Mrs Huston.

4

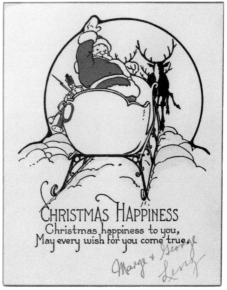

CHRISTMAS HAPPINESS
Christmas happiness to you,
May every wish for you come true.

Marge & George
Lenz

5

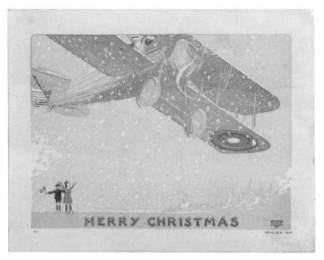

6

7

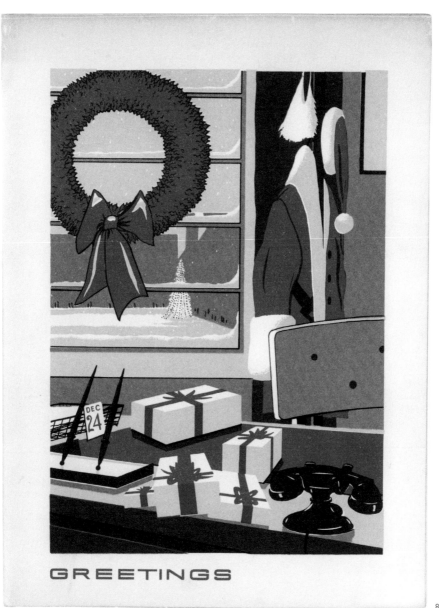

GREETINGS

8

Santa and the Children 169

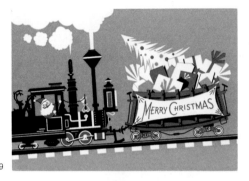

9

10

11

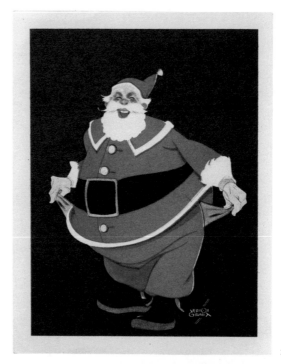

12

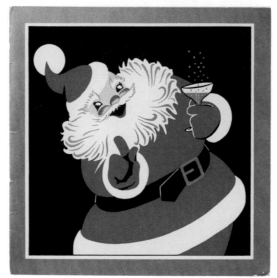

13

CHRISTMAS TREES

The important thing about evergreens is that they are forever green. An inconsequential truth during the warm months, perhaps, but significant when evergreens are the only oases of green in otherwise bleak brown or white landscapes. By the nineteenth century, the custom of decorating for the holiday with evergreen trees reached the United States, owing largely to an influx of German immigrants who brought the practice with them. The transformation of a common tree by adding ornaments into what historian Penne Restad calls an "exotic and fanciful vision of delight that lightened the gloom of winter" had a dimension of the magical for many Americans. Christmas trees began appearing in the houses of prominent residents in cities nationwide by the 1830s and 1840s.

The Christmas tree was a central component of the modern American Christmas by the turn of the century. Not surprisingly, representations of Christmas trees on Christmas cards are both abundant and varied. The trees may be treated as isolated and more or less abstracted design motifs or they may be situated within social contexts, which include bringing the tree home, whether from the forest or an urban vendor; decorating the tree; or simply enjoying its enchanting presence. Children figure more prominently in Christmas tree scenes than in some others, underlining the child-centered aspect of this particular Christmas component. Although a fair percentage of Christmas card images are set in one or another imagined past, many more decidedly depict the present. Other images are outside of time altogether, suggesting that the magical effects of the tree are more important than its presumed antiquity. Such images bear some affinity to those of candles and poinsettias, where narrative is only implied and rarely depicted.

Many cities began erecting public trees, increasingly a seasonal staple, in the early years of the twentieth century, although not without raising eyebrows and questions about separation

1824 Leipzig organist Ernst Anschutz writes the familiar carol "O Tannenbaum (O Christmas Tree)," drawing on a Tannenbaum tradition dating to the sixteenth century or earlier.

1848 December. A woodcut showing the British royal family's Christmas tree at Windsor Castle appears in the *Illustrated London News*.

1850 December. An edited version of the same woodcut is published in *Godey's Lady's Book*, becoming the first widely circulated picture of a decorated tree to appear in the U.S.

1851 Christmas trees are for sale in New York City.

1856 President Franklin Pierce may (or may not) be the first to set up a Christmas tree at the White House.

1880 F. W. Woolworth starts importing glass Christmas tree ornaments from Lauscha, Germany.

1882 December 22. In New York City, Edward H. Johnson, an associate of Thomas Edison, lights a Christmas tree with tiny incandescent bulbs.

1895 During the presidency of Grover Cleveland, the first electrically illuminated Christmas tree is set up in the White House.

of church and state. The first true "community" tree was the seventy-five-foot "Tree of Light" displayed in Madison Square Garden in New York City in 1912. Decorated with 1,200 multicolored Edison Company bulbs and toys for children, it sparkled in the eyes of the 25,000 people who turned out in a snowstorm to see it illuminated. Other prominent public trees followed suit, including a National Christmas Tree in Washington, D.C., and, in 1933, the famous Rockefeller Center tree, which appears on a card included here.

The decorated and lighted Christmas tree is what anthropologist Robert Plant Armstrong has called an affecting presence. It is no exaggeration to say that its effects are magical and that it enchants. No belief is necessary to appreciate its sensory powers. The illustrators of Christmas cards have done their best over the years to capture the peculiar attractions of these trees, but, as with candles, their efforts typically fall somewhat short. The image can allude to the thing, but the thing itself is larger, fuller, three-dimensional, and aromatic, and its ability to transform an interior is extraordinary. Sidestepping any impulse to offer invitations to meditate on the metaphysics of killing a tree that represents life, illustrators have often taken the option of representing an isolated, stylized, decorated tree. The depiction evokes while simultaneously acknowledging the limitations of image-making.

Many features of the twentieth-century American Christmas, the Christmas tree among them, are grist for the mills of anthropologists (and psychologists). It still functions as a focal point of the holiday, suggesting values associated with the American Christmas, among them family, home, community, generosity, and perhaps not quite extinguished vestiges of ancient tree worship. In the end as at the beginning, the important thing about evergreens is that they are ever green.

1901 A Christmas tree farm is established near Trenton, New Jersey, and planted with Norway spruces.

1901 December. General Electric advertises electric Christmas tree lights in *Ladies' Home Journal*.

1923 December 24. In Washington, D.C., President Calvin Coolidge lights the first National Christmas Tree, a 48-foot fir from Vermont decorated with 2,500 electric bulbs.

1926 National Outfit Manufacturers Association incorporates and begins selling Noma brand electric light sets for Christmas trees.

1933 The Rockefeller Center Christmas tree tradition begins.

1940 Corning Glass Works becomes a major manufacturer of glass Christmas tree ornaments, many retailed under the brand name Shiny Brite.

1958 At the age of 13, Brenda Lee records the Johnny Marks tune "Rockin' Around the Christmas Tree."

1959 The Aluminum Specialty Co. of Manitowoc, Wisconsin, manufactures aluminum Christmas trees.

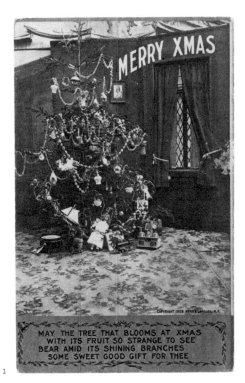

MERRY XMAS

MAY THE TREE THAT BLOOMS AT XMAS
WITH ITS FRUIT SO STRANGE TO SEE
BEAR AMID ITS SHINING BRANCHES
SOME SWEET GOOD GIFT FOR THEE

1

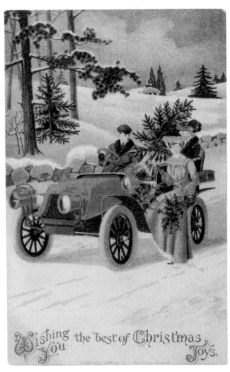

Wishing the best of Christmas
You Joys.

2

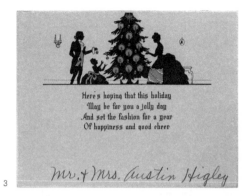

Here's hoping that this holiday
May be for you a jolly day
And set the fashion for a year
Of happiness and good cheer

Mr. & Mrs. Austin Higley

3

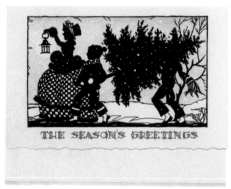

THE SEASON'S GREETINGS

4

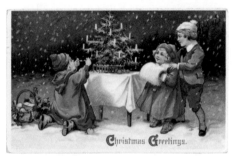

Christmas Greetings.

5

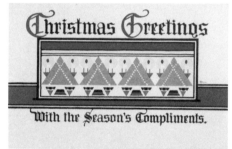

Christmas Greetings

With the Season's Compliments.

6

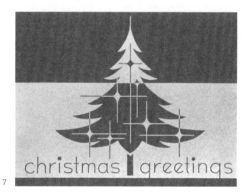

christmas greetings

7

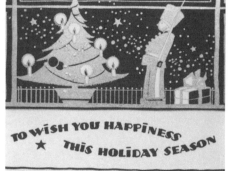

TO WISH YOU HAPPINESS
★ THIS HOLIDAY SEASON

8

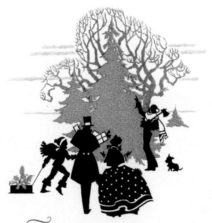

To WISH YOU CHRISTMAS JOY AND

ALL HAPPINESS IN THE NEW YEAR

9

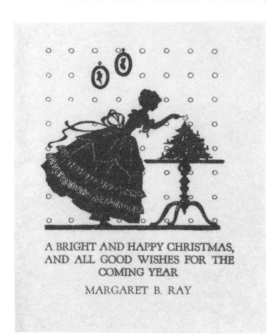

A BRIGHT AND HAPPY CHRISTMAS,
AND ALL GOOD WISHES FOR THE
COMING YEAR

MARGARET B. RAY

10

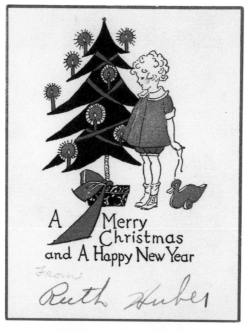

11

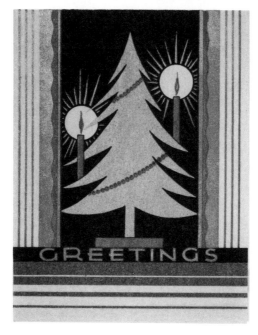

12

13

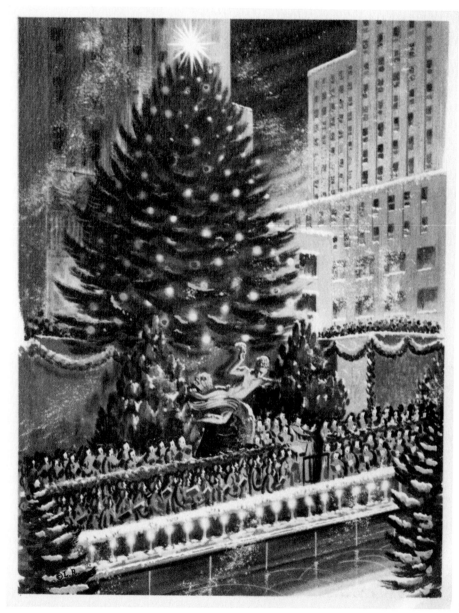

14

CHRISTIAN CHRISTMAS

With the exception of representations of the three kings and of churches and cathedrals, Christian religious imagery is present on what might seem to today's viewers a surprisingly small proportion of American Christmas cards before 1960. In fact, explicitly Christian references appear in negligible numbers before the advent of the Cold War. The reasons for this are numerous, complicated, and nuanced but may be boiled down to a few key points. First, the rise of the modern Christmas in the late nineteenth and early twentieth centuries was far more dependent on the development of the modern industrial economy and the concurrent rise of a consumerist cultural ethos than on increased religious sentiment. Second, the heirs of the Puritan tradition tended to look askance at overtly religious imagery outside ecclesiastical settings; some groups even preferred to minimize its presence there. Many viewed the visual language of Catholicism—the religion espoused by large groups of poor immigrants from Ireland and Italy, for example—as un-American and decidedly lower class, a perception that continued well into the twentieth century. Furthermore, some Americans of Protestant persuasion were not particularly amused to witness the increased presence of Catholicism in America when escape from that religion had on occasion prompted the emigration of their own ancestors from Western Europe. And there were those who simply had no use for religion in any form. In short, religion was a divisive subject.

After World War II, however, fears of the spread of Communism, fanned by the political right, permeated American society, and "the American way of life" came to include religious affiliation. Over the course of two decades, from 1940 to 1960, church membership rose from 50 to 63 percent of the population. But if this emphasis on religious participation, promoted at the highest levels of government in direct violation of the First Amendment, led to a greater volume of religious Christmas cards, the imagery was by no means coherent.

1844 May 6. Anti-Catholic riots erupt in Philadelphia.

1859 November 24. London publisher John Murray offers the first edition of Charles Darwin's *On the Origin of Species by Means of Natural Selection, or the Preservation of Favoured Species in the Struggle for Life*, price fifteen shillings.

1864 "In God We Trust" appears for the first time on U.S. currency (the two-cent coin).

1878 American atheist Robert G. Ingersoll publishes *The Ghosts and Other Lectures*.

1882 In New Haven, Connecticut, Irish-American priest Michael J. McGivney founds the Knights of Columbus, a Catholic fraternal order.

1891 Outfielder Billy Sunday turns down a lucrative baseball contract to begin training for the Christian ministry; champions temperance.

1918 Irving Berlin writes "God Bless America," later to become Kate Smith's signature song.

1924 Aimee Semple McPherson, a celebrity evangelist, begins broadcasting sermons on the Los Angeles radio station KFSG, owned by her Foursquare Gospel Church.

1925 The Scopes trial begins in Dayton, Tennessee, challenging a state law that makes teaching evolution illegal.

1927 Sinclair Lewis publishes *Elmer Gantry*, a scathing satirical novel about an evangelist; one character is based on Aimee Semple McPherson.

1928 May 26. First day of issue of the two-cent Valley Forge commemorative stamp, which depicts George Washington kneeling in prayer and bears the motto "In God We Trust."

1930 Fulton J. Sheen, later Archbishop of New York, begins radio broadcasts of *The Catholic Hour*.

Two categories of Christian imagery seem to predominate—some variation on the theme of the Nativity or the Adoration of the Shepherds, on one hand, and images of the Madonna and Child on the other. Cards of the first group borrow wholesale many of the visual tropes already familiar from cards depicting the three kings, including the guiding star, even though the Gospel of Luke specifies that the shepherds were abiding in a field and that the birth of Jesus was announced to them by an angel and a multitude of the heavenly host. Indeed, for some of these cards, it appears that the artist just replaced the camels of the three kings with sheep and tossed in a couple of shepherd's crooks. The meaning of the various instances of free variation on nativity imagery we leave to others to interpret.

In contrast, some of the cards depicting Madonna and Child were especially faithful to their sources, which were often paintings by various Italian and other "Old Masters." Many of these were printed on paper of reasonable quality and were meant to project an air of cultural sophistication and connoisseurship. Indeed, it is debatable whether these cards were meant to be read as religion or as art. Other cards did not strive for this educated effect. In many from the 1940s and 1950s, not even the Christ Child or the angels escape the prevailing fashion for cuteness (see Cute).

The text accompanying these images was not particularly consistent either. Many cards with Christian imagery contain entirely generic printed greetings, whereas others display the verses of popular carols. Cards with Bible verses did not necessarily quote Luke or Matthew, the only two evangelists to say anything about the birth of Jesus, but chose something else entirely—Philippians, for example. Many card writers elected to forgo biblical quotations entirely in favor of their own verses—"So 'neath the stars of Christmastide, that gem the sky's vast blue ..."—a decision that could be considered, at best, aesthetically and intellectually dubious.

1935 Establishment of The Family, a fusion of the political right and Christian fundamentalism devoted to promoting an authoritarian theocracy.

1948 The Supreme Court hears McCollum v. Board of Education Dist. 71 and rules that religious instruction in public schools is unconstitutional.

1951 *A Man Called Peter*, a biography of Peter Marshall, chaplain of the U.S. Senate, is published by his widow, Catherine Marshall.

1952 The Supreme Court hears Burstyn v. Wilson and determines that government may not censor motion pictures because they are offensive to religious beliefs.

1952 The U.S. Congress authorizes a National Day of Prayer.

1953 January 22. At the Martin Beck Theater in New York City, the first performance of Arthur Miller's play *The Crucible*, based on the Salem Witch Trials of 1692–93.

1953 Hollywood film *The Robe*, starring Richard Burton as the Roman soldier who wins Jesus's robe in a dice game, is released and subsequently wins several Oscars.

1954 The words "Under God" are inserted into the Pledge of Allegiance; legal challenges follow.

1954 January 10. *Inherit the Wind*, a play written by Jerome Lawrence and Robert Edwin Lee fictionalizing the 1925 Scopes trial, opens on Broadway.

1956 "In God We Trust" is adopted as the official motto of the United States of America.

1963 Columbia University professor of history Richard Hofstadter publishes *Anti-Intellectualism in American Life*.

1

Sistine Madonna Raphael

2

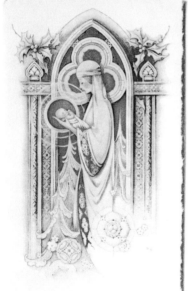

CHRISTMAS GREETINGS

3

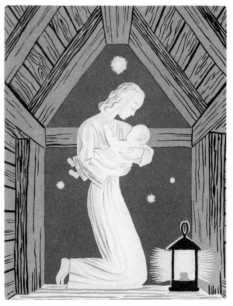

4

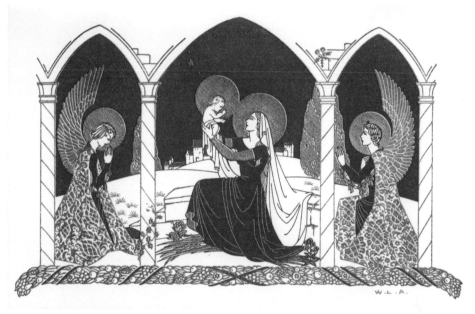

W·L·A·

5

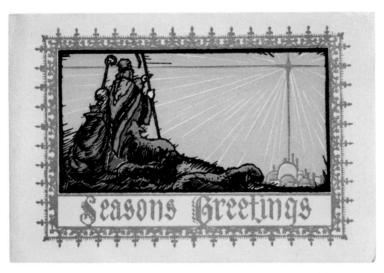

6

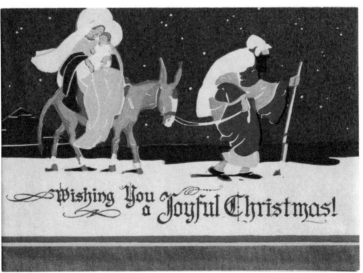

7

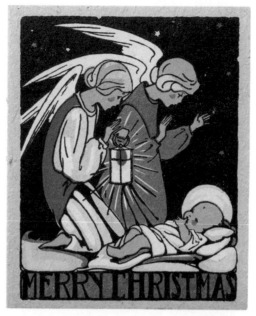

8

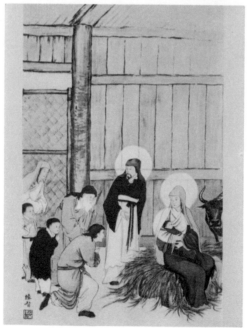

9

10

11

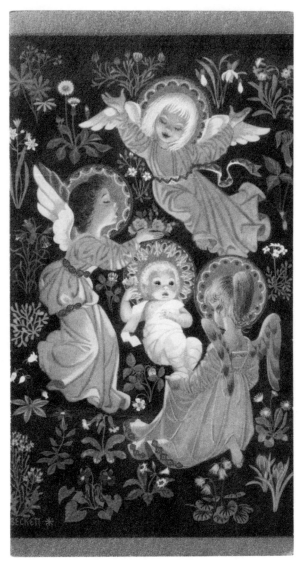

12

CHURCHES

The largely secular nature of the American Christmas card industry, as of the American Christmas itself, means that cards depicting Christian churches were less varied than some other visual themes. That churches appear at all is presumably because they are side effects of Christianity (or perhaps major manifestations thereof) and the sites of religious ceremonies. After houses, churches are the most common building type represented on American Christmas cards. Like houses, they are more often depicted from the outside than from within. In the earlier decades of the century, churches are occasionally shown as isolated architectural monuments, but by the middle of the century they typically appear as integral parts or centers of communities.

Early cards differ from later examples in at least one notable way. The emphasis on status and formality seen, for instance, in calling cards is mirrored during the same years in representations of grand cathedrals, usually in the Gothic manner, both American and European. Among the latter, French cathedrals seem particularly favored, Reims in particular, perhaps because it was nearly destroyed during World War I. As with some other Christmas cards bearing religious imagery, it is not always clear whether religion outranks art here or vice versa. Independent of its religious significance and its role in French history, Reims is also a major European architectural achievement, widely considered one of the glories of the French Gothic. Images of Reims or some other imposing European ecclesiastical monument, along with the expensive printing processes and materials with which they are rendered, signal cosmopolitan senders of taste, status, and affluence.

Major ecclesiastical monuments occasionally appear at later dates as well. One particularly poignant example on a 1942 card depicts St. Paul's Cathedral in London. The building had survived weeks of nearly nightly German bombing during 1940, although many neighboring

1831 French author and social activist Victor Hugo publishes *Nôtre-Dame de Paris*, which is swiftly translated into other European languages.

1857 William S. Pitts writes the song "The Church in the Wildwood," later associated with "the little brown church in the vale" of Bradford, Iowa.

1858 August 15. Cornerstone laid for St. Patrick's Cathedral on Fifth Avenue in New York City, James Renwick Jr., architect.

1872 Copley Square, Boston. Construction begins on the new home of Trinity Church, designed in a neo-Romanesque style by local architect H. H. Richardson.

1880 Harvard professor of art history Charles Eliot Norton publishes *Historical Studies of Church-Building in the Middle Ages: Venice, Siena, Florence.*

1892 Construction begins on the enormous neo-Gothic Cathedral Church of Saint John the Divine on Manhattan's Upper West Side,

designed by Ralph Adams Cram and others.

1904 *Mont-Saint-Michel and Chartres* appears, privately printed by its author, Henry Adams.

1905 American Impressionist Childe Hassam paints *The Church at Old Lyme* (Connecticut), now in the Albright-Knox Art Gallery in Buffalo, New York.

1907 September 23. In Washington, D.C., construction begins on the Cathedral Church of St. Peter and

structures—and some 20,000 neighboring residents—did not. American war correspondent Ernie Pyle, who was in London at the time, recorded the impact of seeing "the gigantic dome of St. Paul's Cathedral" surrounded by fire and smoke, miraculously still rising up over the city after an attack. The vision was captured by *Daily Mail* photographer Herbert Mason in what has since become an iconic image of blitz-era London.

Bursts of church imagery on less expensive cards appear in the postwar period. At that time, in concert with the development of suburbia and urban flight, came increases in church membership, church attendance, and church building. According to some reports, 69 percent of Americans claimed a church affiliation at the end of the 1950s; 50 percent said they attended weekly services, and more than $1 billion went toward church construction in 1960 alone. Churches appear frequently on Christmas cards of this period, most of them denominationally ambiguous, generic, and apparently Protestant churches in more or less colonial or early nineteenth-century styles. Differentiated from other buildings primarily by the presence of a tall steeple, these churches may either be part of a larger town or village (but rarely city) landscape or they may stand solitary within a snowy winter landscape.

When people appear, they are frequently depicted walking toward the church rather than away from it, perhaps to suggest the drawing power of the faith. When no people appear, churches may be represented as emblems of peace, conveyed through the addition of words such as "Silent Night" or "'Twas the Night before Christmas." Throughout cards of this later era, churches are generally depicted as dignified but unpretentious and approachable structures integrated into the both the natural world and American social and cultural life. Whatever religious controversies and conflicts may exist in the body politic are not represented here.

St. Paul (Washington National Cathedral), designed by English Anglican church architect Frederick Bodley.

1908 In Oak Park, Illinois, Frank Lloyd Wright's Unity Temple, built for the local Unitarian Universalist congregation, is completed.

1914 September 20. German shelling destroys significant portions of Reims Cathedral in northern France. Restoration begins in 1919, funded in part by the Rockefeller family.

1926 The Philadelphia publishing house of Lippincott issues *Old Churches and Meeting Houses in and around Philadelphia*, written by John Thomson Faris.

1930 Henry Irving Brock publishes *Colonial Churches in Virginia.*

1935 June 15. The Chapter House of Canterbury Cathedral is the venue for the first performance of T.S. Eliot's verse drama *Murder in the Cathedral.*

1940 September 7. The London Blitz begins. The Nazis bomb

the city nightly for many weeks, causing heavy casualties and vast destruction, but Westminster Abbey and St. Paul's Cathedral sustain only minor damage.

1953 The Baltimore R&B group, The Orioles, record "Crying in the Chapel."

1955 Le Corbusier's concrete chapel of Nôtre Dame du Haut is completed at Ronchamp, France, replacing an ancient structure destroyed in World War II.

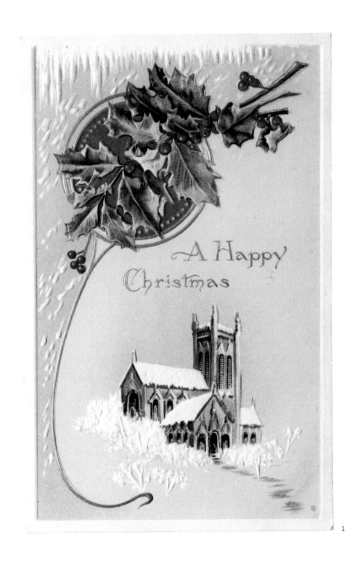

A Happy Christmas

2

Rheims Cathedral Neal Quhrey

St. Paul's Cathedral from Fleet Street.

3

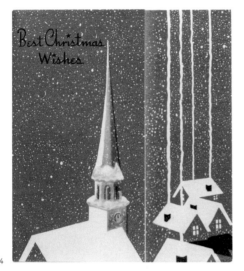

4

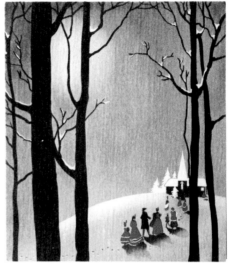

5

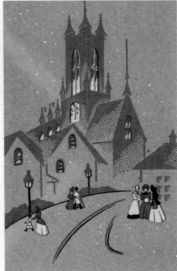

6

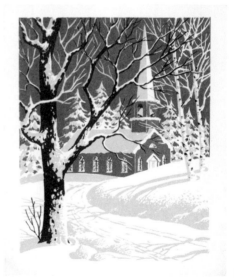

7

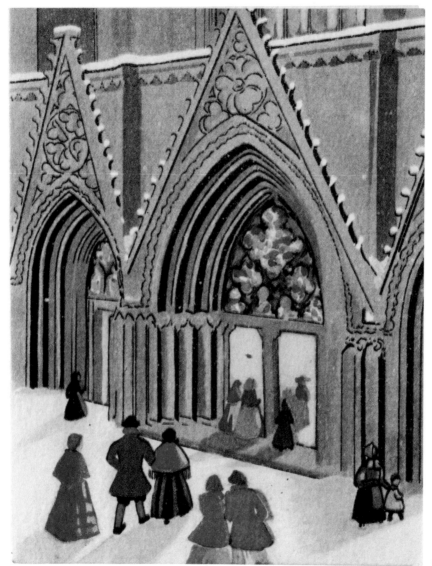

8

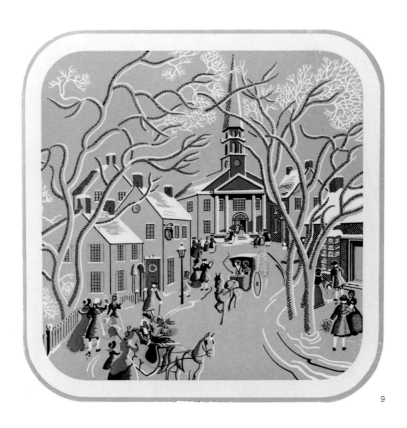

9

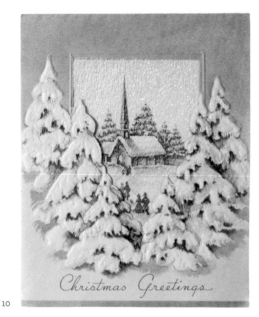

Christmas Greetings

10

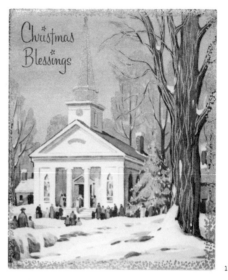

Christmas Blessings

11

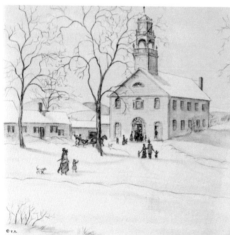

12

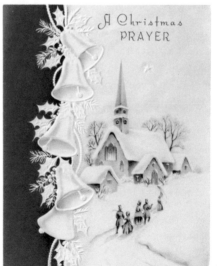

A Christmas PRAYER

13

FAMILY PHOTOGRAPHS

Remember all those vivacious young couples, happy, in love, and apparently without a care in the world? The cards in this section show that it couldn't go on forever. Biology has had its way; the earth is being peopled. We have the photographs to prove it.

Photographic processes were often involved in the industrial production of Christmas cards, but the undisguised photograph on a card is a relative seasonal rarity. Although both chromolithography and photography are nineteenth-century achievements, their development and patterns of use followed different paths. Chromolithography and related processes were favored for inventing images, whereas photography was deemed valuable for its ability to record images. Historically, the Christmas card has depended on invented imagery.

Photographic cards, then, stand apart from the general mass of Christmas cards in at least three distinctive ways. First and not insignificantly, they are usually monochromatic. A considerable part of the appeal of conventional cards is their often brilliant and sometimes startling use of color. In this sense, the card's nineteenth-century origins in chromolithography and its cultural meanings are sustained and honored. Before the middle of the twentieth century, however, most photographic cards remained a single hue.

Second, because photography records what is before the lens, photographic cards are specific in the extreme. Although darkroom magic is possible and some images have obviously been artfully arranged and printed, an equal number seem to have captured a fleeting moment and not always artfully. Seen by themselves or in the context of familiar family photography of the same period, many of the photographs are unremarkable, not so different from the hundreds of thousands of such photos that still survive. They are pictures of people, once meaningful to those who knew them, but strangers to us. In the context of Christmas cards, where generalization is the dominant principle, these cards take the opposite tack and insist on specifying particular people at particular moments and often in quite particular places. The conventional-

1839 In France, Louis Daguerre introduces the Daguerreotype, which becomes the first widely available form of photography.

1841 William Henry Harrison becomes the first U.S. President to be photographed while in office.

1850 American photographer Mathew Brady publishes *The Gallery of Illustrious Americans*, a collection of portraits of prominent figures.

1892 In Rochester, New York, George Eastman establishes Eastman Kodak Co., with the intention of manufacturing photographic supplies for the mass market.

1900 Eastman Kodak introduces the popular Brownie, an inexpensive box camera that takes snapshots.

1905 January. *National Geographic* publishes its first full-page photographs, taken in Tibet.

1907 Emily Bissell of Wilmington, Delaware, introduces the Christmas Seal to the U.S.; proceeds from sales fund the study and treatment of tuberculosis.

1919 America's first tabloid, *The New York Daily News* ("New York's Picture Newspaper"), comes on the market, making prominent use of pictures and pictorial features.

1925 Siberian immigrant Anatol Josepho patents an automatic, coin-operated instant photo booth, which

ized imagery of the typical Christmas card invites engagement but is not insistent. It observes a certain social distance and balance, a kind of artifactual decorum. Photographs, on the other hand, are explicit in content and make more intense demands on attention and response. They represent an alternative communication strategy that, it could be argued, elevates the sender over the recipient.

Third, with a few exceptions, photographic cards depict children, sometimes by themselves and sometimes with parents. Photographs of adults alone are a distinct minority. People who live far apart have exchanged photographs since paper prints became available in the nineteenth century. But why privilege children in these images? Why merge the photograph with the Christmas card at all? Some of these cards are clearly expensive, so it cannot have been a matter of economics. There is much here to ponder.

The photographs are by no means the same. Some are evidently the work of professionals, whereas others are probably snapshots taken by a parent. Some are literally photographic prints, but others have been industrially reproduced, possibly in substantial numbers. The repeated emphasis on children, however, supports the argument that these cards are meant as emblems of idealized family identity. The images have been fashioned and selected with the intention of conveying a positive impression of the family. Aside from the biologically encoded appeal that young children have for adults, photographs of children suggest family pride in their offspring and security in the knowledge that these children represent the next generation and continuation of the family bloodline.

That photographs are powerfully evocative is not in question here. Nor is the claim that they are exceptions to the conventions of American Christmas card imagery. People who decided to send photographically illustrated cards were in the minority. We wonder who thought that cards of this sort were appropriate seasonal gestures and why.

swiftly becomes a Times Square and boardwalk attraction.

1935 Eastman Kodak introduces Kodachrome color-reversal film for color prints and transparencies; the film remains in production until 2009.

1936 Henry Luce buys *Life* and transforms it into America's first and most successful photographic news magazine.

1938 President Franklin D. Roosevelt establishes the March of Dimes to fund polio research.

1939 Harold Edgerton and James R. Killian Jr. publish *Flash! Seeing the Unseen by Ultra High-Speed Photography.*

1942 The Pulitzer Prize for Photography is awarded for the first time to Milton Brooks of the *Detroit News* for *Ford Strikers Riot.*

1945 Joe Rosenthal's iconic *Raising the Flag on Iwo Jima* wins the Pulitzer Prize for Photography.

1948 Polaroid Corporation introduces instant cameras with self-developing film.

1953 December. The first issue of Hugh Hefner's *Playboy* appears, with Marilyn Monroe as the centerfold.

1954 Alfred Hitchcock directs James Stewart and Grace Kelly in the film *Rear Window.*

1955 January 24. *The Family of Man,* a photographic exhibition curated by Edward Steichen, opens at New York's Museum of Modern Art.

1955 April 12. Jonas Salk announces the development of a successful polio vaccine.

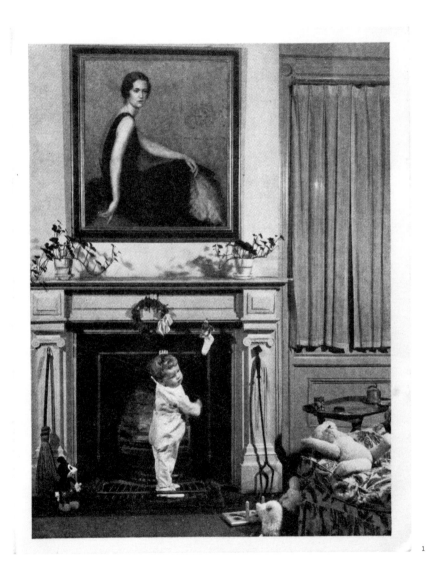

1

2

THE SEASON'S
BEST WISHES

To Greet You Right Heartily
at this good season and to
wish you happiness in
the New Year

3

Season's Greetings

4

Holiday Greetings
from
The Eliots

Christmas 1924

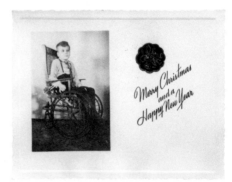

5

Merry Christmas
and a
Happy New Year

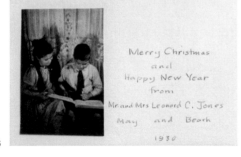

6

Merry Christmas
and
Happy New Year
from
Mr. and Mrs Leonard C. Jones
May and Beach
1930

7

WE'RE STANDING ON OUR HEADS FOR JOY,
'CAUSE CHRISTMAS IS HERE!

With the
Season's
Greetings

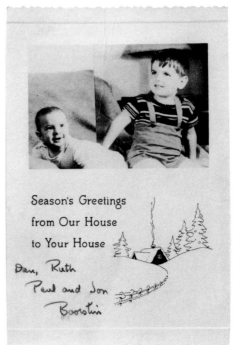

Season's Greetings
from Our House
to Your House

Dan, Ruth
Paul and Jon
Boorstin

8

9

Best wishes for a

Merry Christmas

from
The Holdens

10

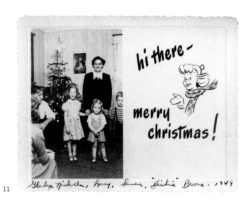

Gladys Nicholson, Mary, Susan, "Dickie" Boone. 1949

11

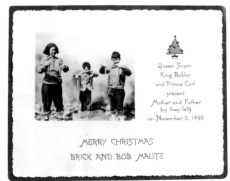

Queen Susan
King Bobby
and Prince Carl
present
Mother and Father
(as they felt)
on November 3, 1948

MERRY CHRISTMAS
BRICK AND BOB MAUTZ

12

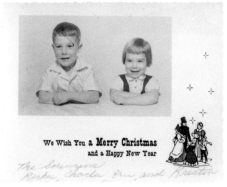

We Wish You a **Merry Christmas**
and a Happy New Year

The Sorensens
Ricky, Charles, Eric, and Kristen

13

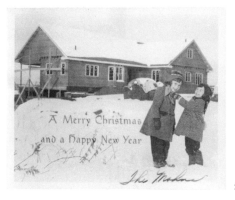

A Merry Christmas
and a Happy New Year

The Madsens

14

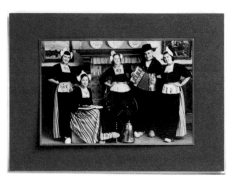

15

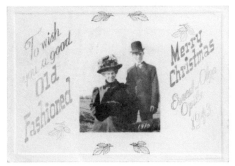

To wish
you a good
Old
Fashioned

Merry
Christmas
Eugene, Ore.
1948

16

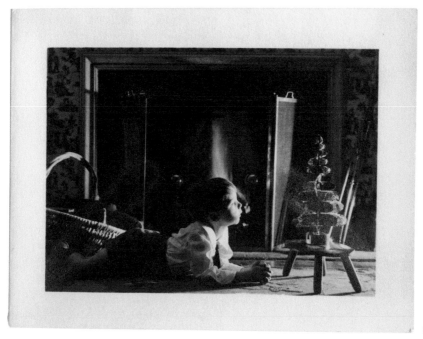

17

WARM PLACES

Commingled with images of winter travel, evergreens, snug houses, and toasty fireplaces are occasional Christmas cards bearing pictures of something else, from somewhere else—rows of palm trees, orange groves, yuccas blooming in a desert landscape, or views of Yosemite or a Spanish mission. With these cards, we are clearly not in New England anymore, or New York, Pennsylvania, or Minnesota. Nor is most of the population, for that matter. The stereotypical American Christmas is a cultural artifact of the wintry northland, but the American population has been increasingly drawn to the country's southlands over the course of the twentieth century, and indeed well before that. Tracking the continually shifting mean center of national population gives some idea of this process. Back in 1790, when such calculations were first made, the mean center was in Kent County on Maryland's eastern shore. By 1900 the center had moved south and west to Bartholomew County in southeastern Indiana; in 1960, the center was one state further west and a few miles south, near Centralia, Illinois. And the shift continues.

Migrants have not settled evenly across the continent. As the cards reveal, Florida and California have been two of the principal beneficiaries of this movement. Population in Florida in 1900 was a little over half a million; by 1960 it had grown to nearly five million. But that is small potatoes compared to growth in California. In 1900 population there was about a million and a half, but by 1960 it had soared to well over fifteen million. Admittedly, not all of California is balmy, but these figures document that an increasing number of Americans were living where winters were warmer and greener than they are up north.

1776 November 1. In southern California, Spanish Franciscans found the Mission San Juan Capistrano, named after a priest from the Abruzzo region of Italy.

1848 January 24. James W. Marshall discovers gold at Sutter's Mill in Coloma, California, setting off the California gold rush.

1858 Hungarian-born Agoston Haraszthy, owner of a vineyard near Sonoma, publishes his *Report on Grapes and Wine in California.*

1888 January 10. The 540-room Spanish-style Ponce de Leon Hotel is completed in St. Augustine, Florida, designed by New York architects Carrère and Hastings for developer Henry Flagler.

1888 February. The immense wooden beachfront Hotel del Coronado, built largely by immigrant Chinese laborers, opens in Coronado, California, across the bay from San Diego.

1890 U.S. Congress authorizes Yosemite National Park, which later comes under the jurisdiction of the National Park Service, founded in 1912.

1891 Near Palo Alto, California, railroad magnate and politico Leland Stanford founds a university named in memory of his son, a victim of typhoid at age 15.

1906 April 18 at 5:12 a.m. A major earthquake strikes San Francisco, California; estimated death toll exceeds 3,000.

1908 In Pasadena, California, architects Charles Sumner Greene and Henry Mather Greene build one of their "ultimate bungalows" for the Gamble family.

1912 The Overseas Railroad extends Henry Flagler's Florida East Coast Railway from the mainland to Key West.

Many who live in warm places send traditional cards, with all the usual wintry imagery, but some people chose the cards included here, and one wonders what prompted them to do so. The images are not all the same; perhaps the intentions were not either. Some cards suggest pride of place, depicting bridges or urban scenes indicative of contemporary vigor and accomplishment. Others show venerable cultural artifacts, Spanish missions in particular, perhaps intended to indicate historical depth in a part of the country that otherwise seems so emphatically new, or evidence of Christian continuity in spite of geographic distance and difference. A number of cards appear to celebrate the non-wintry climate and flora; some even flaunt it and taunt the folks who live in less hospitable environments. And some of the cards—or perhaps many—may well be strategies for dealing with cognitive dissonance. For those who have grown up in Florida or an eternally comfortable part of California (or Arizona or Hawaii), a warm December may be unproblematic. But for those who spent their formative years elsewhere, those old folks who came down from Maine or Minnesota to settle near Fort Lauderdale or some other beckoning frost-free spot, nostalgia for the old winter may still linger.

Christmas is not the same in warm places as it is in cold. These cards acknowledge and wrestle with that truth. Just as photographic cards fuse two otherwise separate genres, in that case the Christmas card and the family photo, so these cards from warm places merge the Christmas card with the picture postcard and produce cognitively complex results in the process.

1915 Architect Bernard Maybeck's grandiose Palace of Fine Arts rises in San Francisco as a prominent feature of the Panama-Pacific International Exposition.

1921 Al Jolson sings "California, Here I Come" in the Broadway musical *Bombo*, written by Buddy DeSylva and Joseph Mayer.

1923 The iconic Hollywood sign is erected in the hills above Los Angeles.

1926 June 1. Norma Jeane Mortenson, later known as Marilyn Monroe, is born in Los Angeles.

1926 A category 4 hurricane devastates Miami, ending the Florida land boom ofthe 1920s.

1932 Los Angeles hosts the Summer Olympics.

1937 May 28. The Golden Gate Bridge is completed, linking San Francisco and Marin County; it is painted orange from the start.

1938 June 23. South of St. Augustine, Marine Studios, later Marineland of Florida, opens and attracts 20,000 to see a bottlenose dolphin.

1942 Marjorie Kinnan Rawlings

publishes *Cross Creek*, an account of her life in the Florida back country.

1945 John Steinbeck's novel *Cannery Row* is set in Monterey, California, during the Great Depression.

1947 December 6. President Harry Truman formally dedicates the Everglades National Park.

1954 George Cory and Douglass Cross write "I left My Heart in San Francisco," which later becomes Tony Bennett's signature song.

1955 Disneyland opens in Anaheim, California.

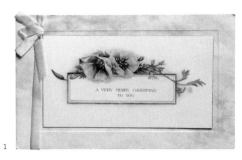

1

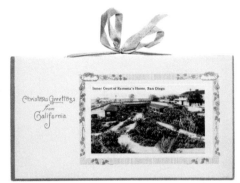

Christmas Greetings from California

Inner Court of Ramona's Home, San Diego

2

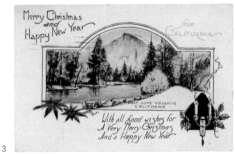

Merry Christmas and Happy New Year

from CALIFORNIA

HALF DOME YOSEMITE CALIFORNIA

With all good wishes for A Very Merry Christmas And a Happy New Year

3

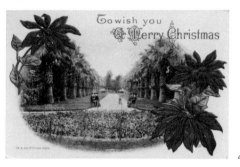

To wish you A Merry Christmas

IN A CALIFORNIA PARK

4

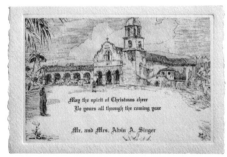

May the spirit of Christmas cheer
Be yours all through the coming year

Mr. and Mrs. Alvin A. Singer

5

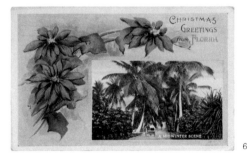

CHRISTMAS GREETINGS from FLORIDA

A MIDWINTER SCENE

6

CHRISTMAS GREETINGS FROM FLORIDA

From palm-lined ways and sunlit bays
Where lakes like jewels glimmer blue
Where flowers rare perfume the air
And golden fruit adds fragrance too

Mr. & Mrs. H. B. Clark

7

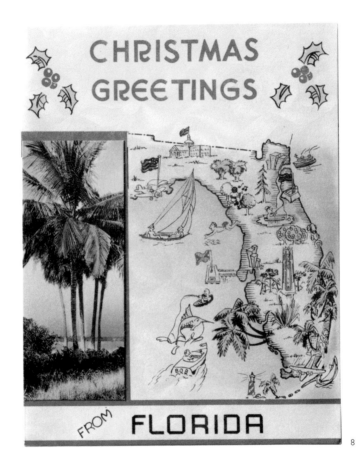

CHRISTMAS GREETINGS FROM FLORIDA

8

9

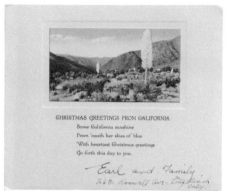

CHRISTMAS GREETINGS FROM CALIFORNIA
Some California sunshine
From 'neath her skies of blue
With heartiest Christmas greetings
Go forth this day to you.

Earl and Family
26B Roswell Ave – Long Beach
Calif.

10

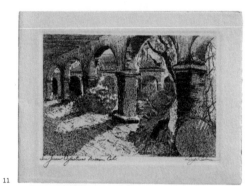

11

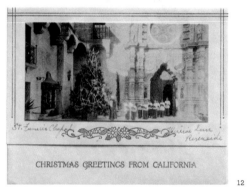

CHRISTMAS GREETINGS FROM CALIFORNIA

12

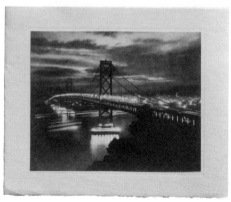

13

14

Seasons Greetings

15

16

17

CUTE

Although Christmas cards have long featured images of small animals and children, a notable number of cards from the 1940s and 1950s display a very specific "cute" aesthetic. Early twentieth-century cards featured more realistic-looking subjects: the figures are identifiably cute but still relatively lifelike. By the early 1940s, cute cards bear figures that are cartoonish and fantastic. On these cards, subjects such as animals, angels, children, and snowmen are all rendered with the same distinctive attributes: they have squat, chubby bodies; round cheeks; and small features. The images are almost wholly secular. Although images of little angels are nominally religious, they are less evocative of piety than of the simple, mundane sweetness that permeates all of these cards. Even baby Jesus in his manger is depicted as a cute, chubby baby bathed in the light of equally cute angels.

It is helpful to consider these cards in their contemporary context of the cultural and political climate of the 1940s and 1950s. Perhaps fear and anxiety related to World War II and the imagined Communist threat in the 1950s drove some people to choose cards that were unequivocally cheerful and pleasant. Perhaps adult reality had proven itself too difficult to bear. With their sugary-sweet images, cute cards serve as a form of visual junk food that requires little thought to enjoy. Even cards with overtly political messages could be given a cute cast. In one card, a blond angel marches with an American flag. In another, two Scottie dogs improbably talk to each other on the phone; the whole scene is printed in nationalistic red, white, and blue.

The iconography of these cards can easily be connected to concurrent images in popular culture. The twentieth century saw a rise of cute visual culture, from toys to cartoons to film. Several cards seem to make explicit references to *Bambi*. The angel cards clearly recall the illustrations from Charles Tazewell's popular 1946 book *The Littlest Angel*. Snowman cards call to mind the song "Frosty the Snowman."

1902 English author and illustrator Beatrix Potter publishes *The Tale of Peter Rabbit*.

1904 Philadelphia artist Grace Drayton creates the Campbell Kids, for many years prominent in advertisements for the Campbell Soup Co. of nearby Camden, New Jersey.

1908 Kenneth Grahame's classic children's book *The Wind in the Willows* is published in London and New York.

1909 In the Christmas issue of *Ladies' Home Journal*, Rose O'Neill's Kewpies make their first appearance and go on to become international phenomena.

1921 Child performer Jackie Coogan begins his acting career as Charlie Chaplin's young sidekick in *The Kid*.

1926 Winnie-the-Pooh makes his debut in A. A. Milne's eponymous book, engagingly illustrated by E. H. Shepard.

1934 Child actress Shirley Temple sings "On the Good Ship Lollipop" in the Hollywood film *Bright Eyes*.

1935 Goebel Porzellanfabrik near Oeslauby, Germany, produces its first Hummel figurines.

1940 July 27. The fully developed Bugs Bunny character appears in the cartoon *The Wild Hare*.

It is likely that at least some of these cards were intended for children, but we should not assume that all of them were. One of the *Bambi*-esque cards bears the greeting "A Loving Christmas Wish for My Wife." Other cute cards are printed with the family name on the inside, suggesting that they sent such cards to everyone on their list.

Many of these cards employ puns and baby talk. A kitten hanging in a stocking is labeled with a tag that reads "just a little somepin' for your Christmas." On another card a puppy sits in a chair reading a magazine under the text "Season's Greetings. Here's sumpin' that you ought to read." This type of babyish language lends itself to the cute cards, emphasizing the easygoing sweetness of the message. Likewise, many cards show various animals and snowmen engaged in human activities, adding a degree of absurdity to the cute.

Cute cards are neither nostalgic nor futuristic. Many of the cards show figures without a setting; we simply see the cute object with no context. These cards send their inoffensive meanings only through their design features. Easy cuteness is the message. Cute cards are Christmas pablum, easy to look at and easy to swallow. They are rarely religious, although even the occasional card with religious overtones employs the same sort of cutesy physical shorthand. We can view these cards, which reached their apex during World War II and the postwar era, as a sort of sugary respite from otherwise grim realities. Perhaps they are only blandly appealing and inoffensive fantasies. Or perhaps they are not quite as cute in their intentions as in they are in their imagery.

1942 December 7. In Amsterdam, Anne Frank records that Bep and Miep gave her a Kewpie doll for St. Nicholas Day, which her family had never celebrated.

1949 The Milton Bradley Co. introduces the board game Candyland, designed in 1945 by Eleanor Abbott.

1950 October 2. Charles M. Schulz's daily syndicated comic strip *Peanuts* premiers in eight newspapers.

1950 Gene Autry makes the first recording of "Frosty the Snowman," written by Jack Rollins and Steve Nelson.

1951 March 12. Hank Ketcham's daily syndicated comic strip *Dennis the Menace* appears in sixteen newspapers.

1952 E. B. White's book for children about a pig and a spider, *Charlotte's Web*, is published with illustrations by Garth Williams.

1958 Alvin and the Chipmunks, created by Ross Bagdassarian Sr., record "The Chipmunk Song (Christmas Don't Be Late)" to great acclaim.

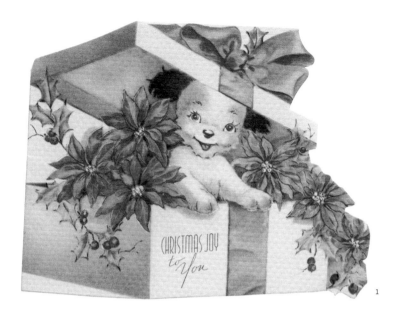

1

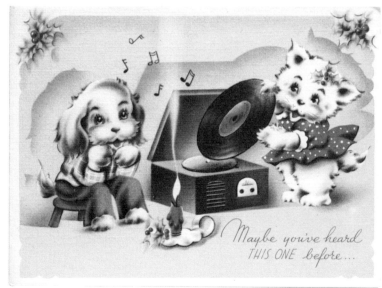

2

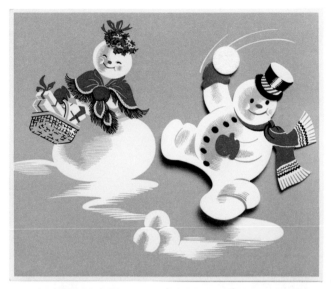

3

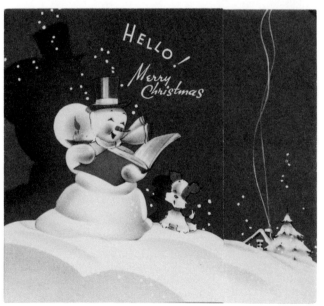

4

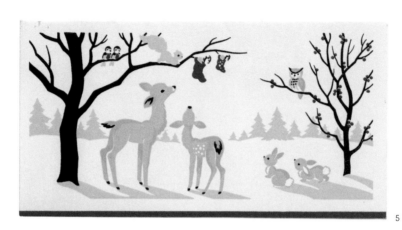

5

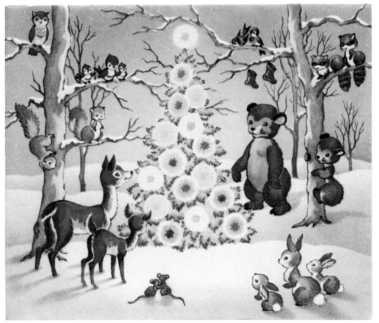

6

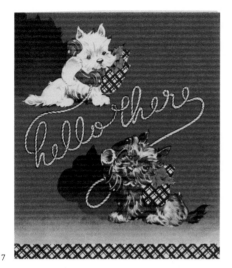

7

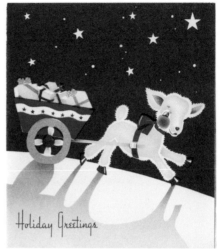

8

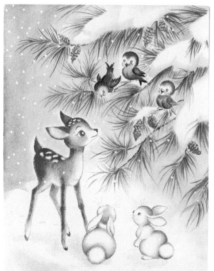

9

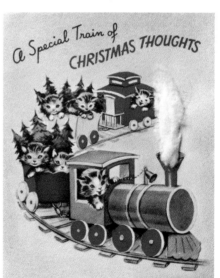

10

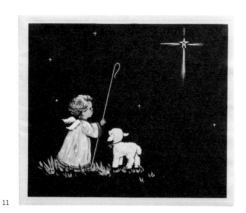

11

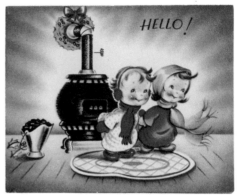

12

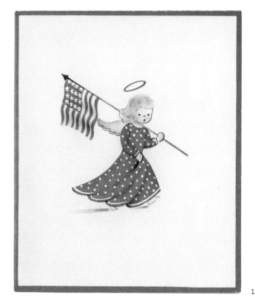

13

14

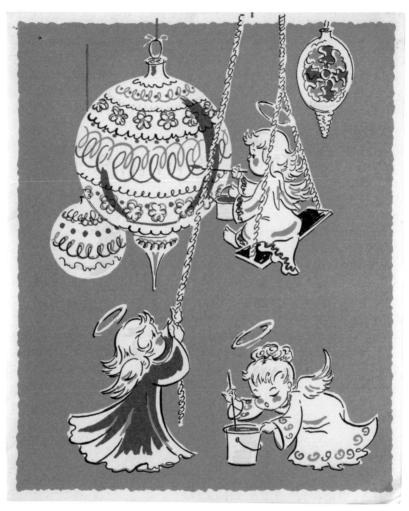

15

HUMOR

The emergence of comical Christmas cards coincided with the development of a new type of humor in America. Whereas publications of the early nineteenth century espoused a genteel point of view, magazines such as *Life*, *Puck*, and *Judge* founded in the 1880s and 1890s targeted an expanding middle-class reader base. With popularization of the comic strip at the turn of the century, a new vein of accessible humor grew into a widespread facet of American culture. In the 1920s, a new type of "gag strip" originated, relying on verbal-visual interdependence and quickness of comprehension. This moved away from the paragraphs of explanatory text formerly accompanying illustrations. Simultaneously, sociopolitical concerns no longer dominated subject matter, yielding to the idea of humor for humor's sake. Our earliest humorous Christmas cards epitomize these novel, single-panel visual puns.

As the 1920s progressed, strains of sophisticated urban humor materialized, typified by the founding of *The New Yorker* magazine. Simultaneously, less effete varieties of humor continued to thrive in magazines, newspapers, and elsewhere. Silent movie comedies, such as those starring Charlie Chaplin and Buster Keaton, opened to great acclaim, and Walt Disney Productions introduced *Steamboat Willie*. Sexual liberation, which surfaced during the "Roaring Twenties" also found an outlet in the comics, exemplified by Betty Boop's debut in 1930 and similarly revealed in the "cute sexy" themes of several of our cards. The same year saw the film debut of the Three Stooges, as well as the release of the first Warner Brothers cartoon. The various manifestations of the humor industry prospered during the Depression, both as cheap entertainment and as a means of relieving tension and transcending disheartening circumstances. Newspapers (and the funnies) came to millions who could not afford movie tickets and were

1876 *The Harvard Lampoon* is founded in Cambridge, Massachusetts.

1907 Cartoonist Bud Fisher introduces *Mutt and Jeff*, considered the first daily comic strip.

1913 George Herriman's cartoon strip *Krazy Kat* makes its appearance in William Randolph Hearst's *New York Evening Journal*.

1917 Comic actor Buster Keaton makes his silent film debut in *The Butcher Boy*.

1919 Robert Benchley begins writing for *Vanity Fair*.

1920 September 20. *Winnie Winkle the Breadwinner* comic strip premieres, created by Martin Branner.

1927 James Thurber joins the editorial staff at *The New Yorker*, recently founded by Harold Ross.

1928 March 19. The *Amos 'n Andy* radio show begins, a situation comedy broadcast from station WMAQ in Chicago.

1928 November 19. Walt Disney's animated short film *Steamboat Willie*, featuring Mickey Mouse, premieres at B. S. Moss's Colony Theatre in New York City.

1930 September 8. Chic Young's comic strip *Blondie* first appears, distributed by King Features Syndicate; Dagwood Bumstead is resident clown.

1930 The Three Stooges appear in their first Hollywood film, *Soup to Nuts*.

not among the 10 percent of Americans with electricity and radios. Numerous cards shown here slyly refer to tight funds, many visually referencing the stereotypical thrifty Scotsman.

The magazine *Ballyhoo* revolutionized an even sexier brand of humor, which was perpetuated as college humor magazines began to reach the general public. The continued popularity of films is itself referenced on Christmas cards, while the advent of national radio networks and the rise of comedy programming strengthened humor's hold on the national consciousness. In the 1940s, comic books diversified to appeal to younger audiences by presenting wholesome strips often featuring animals, and they attracted older readers with crime and sexy women. Christmas cards from this period reflect both family fare and this new aggressively adult humor.

The audience for comics enlarged considerably during wartime, as did representations of related themes in the comics. During this period *Captain America* was born, along with *Military Comics*, which featured a multiethnic team of adventurers fighting Germany and other Axis powers. Christmas cards sent by members of wartime armed forces sometimes used comic-book-style illustration.

Over the decades represented in this volume, the evolution of the humorous Christmas card corresponded closely with contemporaneous developments in numerous mass media, providing an effective lens for investigating American culture and self-representation.

1932 *The Jack Benny Program*, a weekly radio show, begins its run on NBC.

1932 February 15. George Burns and Gracie Allen become regulars on the *Guy Lombardo Show*, broadcast on CBS radio.

1932 Comedy duo Stan Laurel and Oliver Hardy appear in the award-winning film short *The Music Box*.

1935 Clarence Day Jr. publishes the book version of *Life with Father*.

1935 Abbott and Costello perform together for the first time at the Eltinge Burlesque Theater on 42nd Street in New York City.

1935 The Marx Brothers appear in the zany MGM film *A Night at the Opera*.

1936 Premiere of Charlie Chaplin's *Modern Times*, which satirizes factory work and other developments of the modern era.

1937 Bob Hope makes his network radio debut on NBC's *Woodbury Soap Hour*.

1946 Bob Elliott and Ray Goulding perform as Bob and Ray on their radio show on WHDH in Boston.

1951 October 5. Jackie Gleason and colleagues introduce the television situation comedy *The Honeymooners*, set in Brooklyn, New York.

1951 October 15. *I Love Lucy* is launched and swiftly becomes the most-watched television show in America.

1952 Harvey Kurtzman and William Gaines launch *Mad* magazine, immortalizing Alfred E. Neuman.

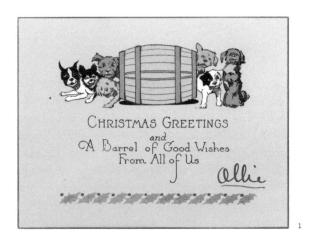

CHRISTMAS GREETINGS
and
A Barrel of Good Wishes
From All of Us

Ollie

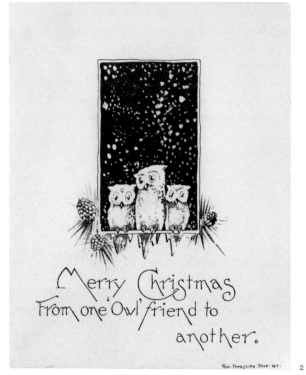

Merry Christmas
From one 'Owl' friend to
another.

The Treasure Shop N.Y.

2

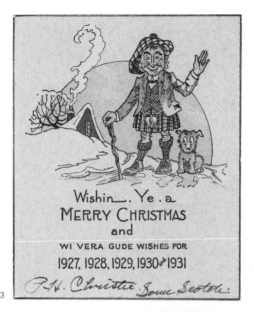

3

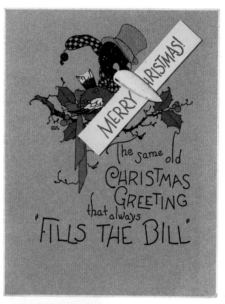

4

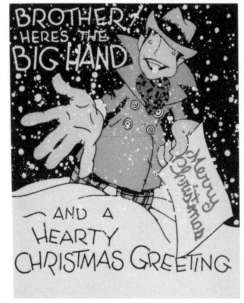

5

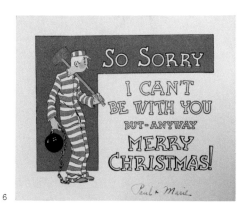

6

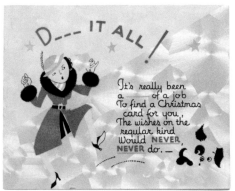

7

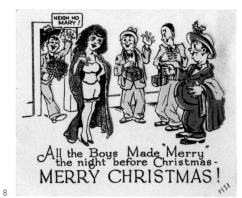

8

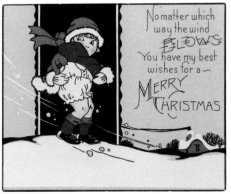

9

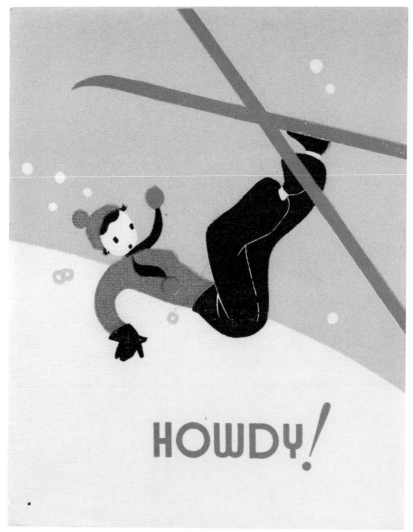

10

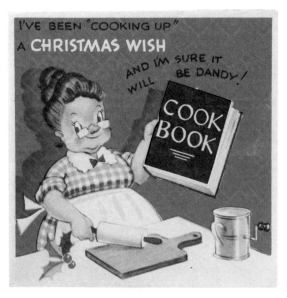

11

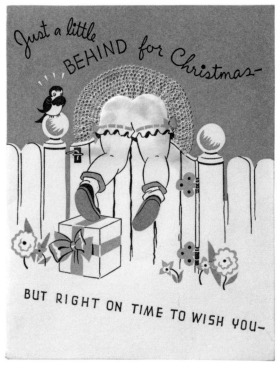

12

13

14

BUSINESS

Unlike other categories of cards examined here, business cards are defined by their senders, not by the subject matter of their imagery. The reason that businesses send Christmas cards at all is suggested in Marcel Mauss's classic study *The Gift*, in which he observed that some forms of gift exchange serve to maintain "a profitable alliance." There is mutual benefit in businesses exchanging Christmas cards, for they combine offerings of festive holiday greetings with thanks for patronage past and hopes for more in the future. A fair number of cards reiterate the idea that business is based not only on commercial exchange but on friendship as well. Although business card imagery often replicates or parallels that seen on conventional social cards, certain differences distinguish business cards from those sent from household to household.

First, business Christmas cards, particularly in the eras studied here, were sent by men to men, for the business world was a man's world. It is likely that female clerical employees played some role in preparing cards for mailing, but their involvement typically remains invisible. Thus the imagery of business cards was stereotypically masculine, as the era understood that construct, weighted toward formal and relatively impersonal subjects. Humor was acceptable, as were occasional bits of playfulness, but cuteness and sweetness and depictions of loving couples and happy families were usually avoided. On the other hand, occasional scenes of male bonding, whether drinking, feasting, sitting before a fire, or even hunting, were apparently appropriate.

Second, business cards typically circulated beyond senders' social circles into their business circles. Once upon a time, when American commerce was relatively homogeneous, these may have been nearly the same, but with the country's increasing social complexity came the greater likelihood that some important business contacts were of different origins and cultural backgrounds. And so here there might be cause for tactful caution. What to do if some impor-

1889 July 8, Dow Jones & Co. initiates publication of the *Wall Street Journal.*

1891 American Express introduces Traveler's Checks, facilitating travel abroad and giving AmEx an international presence.

1896 William Jennings Bryan delivers his famous "Cross of Gold" speech at the Democratic National Convention.

1901 J. P. Morgan and Elbert H. Gary found U. S. Steel, the world's first billion-dollar corporation and at one time the largest corporation in the world.

1903 April 22. The current New York Stock Exchange building at 18 Broad Street in lower Manhattan opens for trading.

1904 The book version of Ida M. Tarbell's uncomplimentary account *The History of the Standard Oil Company* appears and sells well.

1906 Upton Sinclair publishes *The Jungle,* exposing the U.S. meat-packing industry.

1906 The Pure Food and Drug Act requires accurate labeling of contents of drugs.

tant business partners are not like us, whatever that might mean? Or if we are not like them? It is good business to acknowledge another person's holidays. Acknowledging does not mean sharing, however, and does not require repudiation of personal beliefs or behaviors. It is probably also good business not to stand so far apart from prevailing cultural practice that others interpret distance as rebuke.

Enter the "Season's Greetings" card. Although under-represented in the sampling of business cards shown here, "Season's Greetings" and variations on it may constitute the most prevalent form of business Christmas card, particularly by the middle of the twentieth century. Such cards are judiciously understated but sufficient for their purpose. They neither presume nor proselytize, yet they bow graciously to prevailing cultural practice. Messages within such cards often thank the recipient for business past and hope for good things in the coming year, in other words, for the continuation of a profitable alliance.

The third factor that sets business cards apart from the mainstream of social cards is that they can sometimes be much more expensive. Karl Marx is helpful here, noting that "a conventional degree of prodigality" can become a business necessity "as an exhibition of wealth and consequently as a source of credit." This means distinguished design, quality materials, and outstanding workmanship. In the period studied here, it was obviously considered good business to send Christmas cards. Whereas smaller operations sometimes purchased stock cards and simply had the company name printed on them, larger firms often sent custom-made cards. These took a variety of forms, ranging from very large, imposing, and obviously costly sheets and booklets to reproductions of notable paintings and even original prints. As symbols of the company sending them, these cards were sometimes self-referential. The Reynolds Metals Company, for example, made sure that the bright metallic finish on their cards was in keeping

1914 Charles E. Merrill and Edmund C. Lynch enter the investment business.

1922 Start of the Teapot Dome Scandal, which involves no-bid contracts and kickbacks and eventually leads to the imprisonment of Secretary of the Interior Albert B. Fall.

1925 January 25. President Calvin Coolidge tells newspaper editors, "After all, the chief business of the American people is business."

1926 U. S. Foil of Louisville, Kentucky, later Reynolds Metals Company, starts producing aluminum foil for packaging.

1928 Presidential candidate Herbert Hoover promises "a chicken in every pot."

1929 October 24. Black Friday on the New York Stock Exchange and the start of the Great Depression.

1931 James Truslow Adams publishes *The Epic of America*, in which he coins the phrase "the American Dream."

1931 E. Y. Harburg and Jay Gorney write "Brother, Can You Spare a Dime?," which becomes an anthem of the Great Depression.

1940 Woody Guthrie pens "This Land Is Your Land" and records the song in 1944.

with their products. A card sent by the Ridge Tool Company depicts an army of toy soldiers carrying wrenches rather than rifles. In this way, at least some business Christmas cards not only broadcast the financial soundness of the company but promoted sales of its products as well.

Business cards also appear in other sections of this book. Identifying a business card may involve some guesswork if the card does not bear the name of a firm or if the envelope has been lost. Senior figures in sales and purchasing and other managers often dealt with contacts outside their own firm on a first-name basis. Cards with a business demeanor, so to speak, bearing the printed name or signature of a single (usually) male sender, are likely to be business cards as well.

1

1941 Release of the film *Citizen Kane*, directed by and starring Orson Welles.

1946 American economist Milton Friedman begins teaching at the University of Chicago.

1949 February 10. Opening performance of Arthur Miller's award-winning play *Death of a Salesman* at New York's Morosco Theatre.

1950 Diner's Club Card developed after Frank McNamara forgets his wallet while dining at New York's Major's Cabin Grill.

1951 New York's Franklin National Bank issues the first bank credit card.

1956 The film version of *The Man in the Gray Flannel Suit*, based on the novel by Sloan Wilson, is released,

with Gregory Peck in the leading male role.

1961 January 17. In his farewell speech, departing President Dwight Eisenhower warns of the increasing influence of the military-industrial complex.

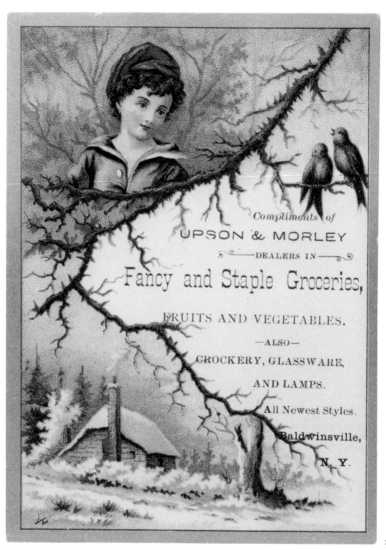

Compliments of
UPSON & MORLEY
—DEALERS IN—
Fancy and Staple Groceries,
FRUITS AND VEGETABLES.
—ALSO—
CROCKERY, GLASSWARE,
AND LAMPS.
All Newest Styles.
Baldwinsville,
N. Y.

2

3

4

5

6

7

8

APPRECIATION

YOUR Good Will the past year is warmly appreciated, and equally warm and sincere is our Wish that the Coming Year will be one of Progress and Prosperity.

THE J. McCRAKEN CO.
Portland, Oregon

9

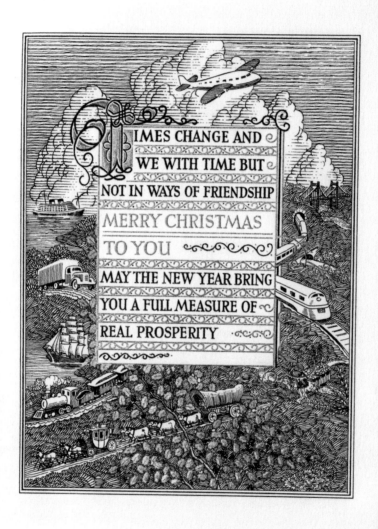

TIMES CHANGE AND
WE WITH TIME BUT
NOT IN WAYS OF FRIENDSHIP
MERRY CHRISTMAS
TO YOU
MAY THE NEW YEAR BRING
YOU A FULL MEASURE OF
REAL PROSPERITY

10

11

12

13

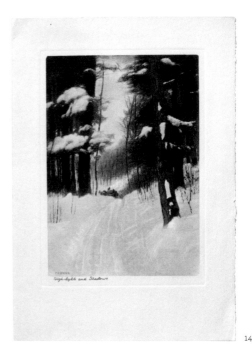

14

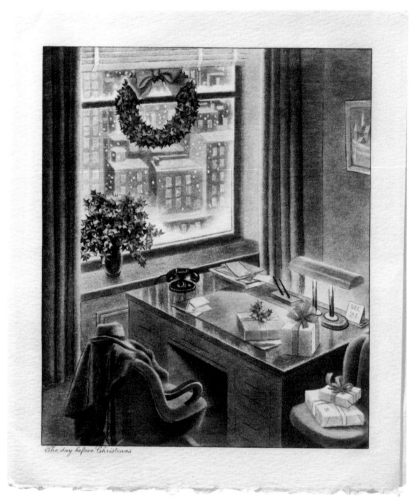

The day before Christmas

15

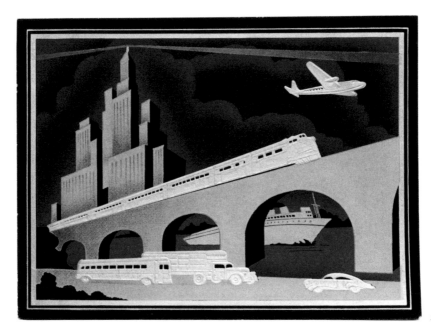

16

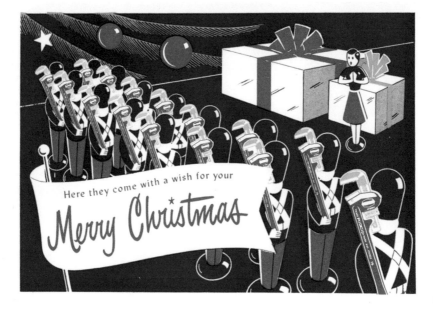

17

18

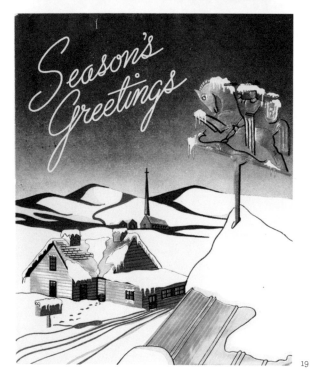

19

French-fold card
5⅝ x 4⅜ inches
Red silkscreen printing on white paper, white border
ca. 1950

AFTERWORD

No, Virginia, there really is no Santa Claus. Nor is there peace on earth or good will toward men, not to mention women. Christmas cards have not changed the world. But who ever thought that they would? Christmas cards are small gestures made to brighten the season and perhaps, more generally, to offer some slight alternative to and compensation for the narrow routines of everyday life, which are especially confining in winter. Christmas cards are little oases of good cheer in an otherwise drab and colorless landscape. They were never meant to be transformative.

But that does not mean that they were inconsequential or that they do not illuminate larger cultural issues. Let us return, one more time, to the images that have been the focus of this inquiry. It is well worth noting what has been obvious throughout: Christmas card imagery is either mimetic or representational on the one hand, or stylized on the other. In either case, and this is important, whatever is represented is recognizable. What Christmas card imagery is not, however, is abstract. The entire abstract-art enterprise that crested at the mid-century is nearly invisible in the American Christmas card tradition. There are probably several reasons for this, but the most important may be the simplest: abstract art has—by definition—no content. It means whatever we want it to mean or whatever we are told it means or, more likely, it means nothing at all. Christmas cards communicate, always, and there is little purpose in communicating nothing at all.

Christmas cards, then, can be understood as a traditional art form with the manifest function of communication. We may speak of them as a form of artful seasonal communication, for while their artfulness necessarily varies, their intention to communicate does not. What is conveyed or at least suggested ranges from simple greeting to more complicated or extended narratives and clusters of associations embedded in elaborated imagery. The power of images resides in the fact that potential meanings are invited, enabled, or prompted but never limited or constrained. Interpretation of images is open-ended

and personal. People make of them what they will.

Christmas cards are not only communicative but also communal. They are an art form that, if not widely produced, is at least widely circulated and in that sense broadly shared. Unlike most museum pieces, Christmas cards are available throughout the larger society. There is little that is exclusive or inaccessible about them, economically or intellectually. Furthermore, the social work they perform involves the reification of communities. Each household in its cache of cards of the season holds a tangible manifestation of its own social circle, its personal community, no one exactly like any other. This pattern of reified social circles is repeated and varied in each successive household, an artifactual evocation of social lives and interconnection.

Christmas cards may also be considered a democratic art. They are evidently desirable, obviously available, and—perhaps particularly important where art and vast amounts of money are so often thought inseparable—decidedly affordable. Within recent months a Warhol painting sold at auction for something like $10 million, and another brought about $15 million, give or take a million or two; the exact figure doesn't matter. This data by itself is worth pondering, since it is difficult to see what socially positive ends such expenditures might serve. But pass beyond such thinking to note that a mere $1 million would buy three, four, or even more millions of old Christmas cards. Even when new, even when the cards included in this book were first purchased, Christmas cards were affordable fare. The whole point of producing images as multiples is to increase their number while decreasing their cost. A democratic art is about inclusivity rather than exclusivity, about what is accessible to the many rather than to the few. We may have been remiss in not providing data about period cost of cards converted to present-day dollars, but all evidence indicates that most cards cost a few pennies in the past, equivalent to a couple of dollars today. It would be instructive if assessments of the artistic achievement of a given society were based not on rare and costly monuments but on objects available to the majority of the population at modest

price. Looking at Christmas cards rather than Warhols, for instance, might lead to different comprehensions and insights about American society and culture.

Readers will have noticed the distance between some of the events that appear in the timelines and the nature of the images on the cards. The occasional references to the miseries inflicted by some members of the species on others remind us that what American philosopher Mary Daly called the foreground is always with us. Some people are predatory and never rest in their efforts to repress or exploit others. Read any newspaper or check the Internet. Wars, bombs, repression, riots, fraud, corruption, and all the rest. Always. Oblique or overt references to wars, nationalism, politics, and ideology do appear here and there on American Christmas cards, but these are far outnumbered by the prevailing references to the background. It is probably not accurate to say that Christmas cards embody a philosophy, but they do celebrate the positive attributes of lives centered on community, communion, sharing, and benevolence, free from the forces of malevolence.

And so, for one last time, there is no Santa Claus. But Frank Church was right when he wrote to little Virginia O'Hanlon that love and generosity are real. And so are kindness, compassion, and concern for others. The world is not as most people would have it; it is possible to imagine something better. Perhaps Christmas cards are vehicles for that imagining, depicting people as they would have themselves be. Call Christmas cards benevolent fantasies or fantasies of benevolence, as you prefer. Whatever the case, there is far more positive than negative in the purposes and aesthetics of commonplace American Christmas cards of the past. As we said before, they are worth a second look.

IMAGE CAPTIONS

Cards of the
Nineteenth Century

1. Flat card
6¾ x 5⅝ inches
Chromolithography
with gold on cardstock
1881
Louis Prang & Co.,
Boston, Massachusetts

2. Flat card
3⁷⁄₁₆ x 4⁵⁄₁₆ inches
Chromolithography on
cardstock
ca. 1870
OB (Obpacher Bothers,
Munich)

3. Flat card
4 x 5¼ inches
Chromolithography on
cardstock, gold border
ca. 1870
MB (Meissner & Buch,
Leipzig)

4. Flat card
3⅜ x 5⁷⁄₁₆ inches
Chromolithography on
cardstock
ca. 1870
H & F (Hildesheimer &
Faulkner, London)

5. Flat card
6 x 2¾ inches
Chromolithography
and embossing on thin
cardstock
ca. 1875

6. Flat card
2¾ x 5⁹⁄₁₆ inches
Chromolithography on
cardstock
ca. 1875

7. Flat card
4⅝ x 3⅛ inches
Chromolithography with
gold on cardstock
ca. 1875

8. Flat card
4¹¹⁄₁₆ x 3³⁄₁₆ inches
Chromolithography on
cardstock, gold border

ca. 1875
Raphael Tuck & Sons,
London

9. Augmented flat card
(two-sided card)
4¼ x 3 inches (fringe
excluded)
Chromolithography on
two cardstock sheets,
mounted back to back,
light pink silk fringe
ca. 1880

10. Flat card
6 x 4¼ inches
Chromolithography on
cardstock
ca. 1885

11. Augmented flat card
(two-sided card)
2¾ x 4 inches (fringe
excluded)
Chromolithography on
two cardstock sheets,
mounted back to back,
light blue silk fringe
ca. 1885

12. Flat card
6¼ x 4⅜ inches
Chromolithography
with silver on pebbled
cardstock
ca. 1885
OB (Obpacher Brothers,
Munich)

13. Flat card
6⅛ x 4¹¹⁄₁₆ inches
Chromolithography with
gold on cardstock
ca. 1880

14. Flat card
3¾ x 4⅞ inches
Chromolithography on
cardstock
1883
Louis Prang & Co.,
Boston, Massachusetts

15. Flat card
5¾ x 3³⁄₁₆ inches
Chromolithography on
cardstock
ca. 1885

Christmas Postcards

1. Postcard
Chromolithography with
gold and embossing on
cardstock
Sent 1911 from New
Portland to Kent's Hill,
Maine
Printed in Germany
Design copyrighted 1910
by Edw. Lowey

2. Postcard
Chromolithography with
gold and embossing on
cardstock
Sent 1910 (?) from Burnt
Hills, New York, to same
NAF Co. (?)

3. Postcard
Chromolithography with
gold and embossing on
cardstock
ca. 1910
Raphael Tuck & Sons,
London, Art Publishers to
Their Majesties the King
and Queen
Printed in Saxony
*Hoar Frost and Winter
Snows* series of Christmas
postcards, no. 510

4. Postcard
Chromolithography with
gold and embossing on
cardstock
Sent 1911 from Auburn to
Brooklyn, New York
Design copyright 1910 by
H. Wessler

5. Postcard
Chromolithography with
gold and embossing on
varnished cardstock
Sent 1912 from Syracuse to
Schenectady, New York
SB (or BS)
Printed in Germany

6. Postcard
Chromolithography with
gold and embossing on
cardstock
Sent 1911 from Willimantic

to Mansfield Center,
Connecticut
International Art
Publishing Co., New York
and Berlin
Printed in Germany

7. Postcard
Chromolithography with
silver and embossing on
cardstock
Sent 1908 from
Hensonville, New York,
to same

8. Postcard
Chromolithography with
gold and embossing on
cardstock
Sent 1913 from Brooklyn
to Schenectady, New York
P. S. Dresden
Printed in Germany
Design copyright 1911 by
A. Horwitz, New York

9. Postcard
Chromolithography with
gold and embossing on
cardstock
Sent 1909 from
Schenectady to Burnt
Hills, New York
PFB (Paul Finkenrath,
Berlin)
Printed in Germany

10. Postcard
Chromolithography with
gold and embossing on
cardstock
ca. 1910
Davidson Brothers,
London and New York
Printed in Germany

11. Postcard
Chromolithography with
gold and embossing on
cardstock
ca. 1910
Printed in Germany

12. Postcard
Chromolithography with
gold and embossing on
cardstock
Sent 1910 from New

Britain to Colchester, Connecticut
Davidson Brothers, London & New York
Printed in Germany

13. Postcard
Chromolithography with gold and embossing on cardstock
1911
Printed in Germany
Design copyrighted 1911 by John Winsch, New York

14. Postcard
Chromolithography with gold and silver and embossing on cardstock
1912
Printed in Germany
Design copyrighted 1912 by John Winsch, New York

15. Postcard
Color lithography on cardstock
ca. 1915
Robert H. Lord, Boston, "Good Post Cards"
Text by R. H. L. (Robert H. Lord)

16. Postcard
Chromolithography with gold and embossing on cardstock
Sent 1911 from Vallejo, California, to same
Raphael Tuck & Sons, London, Art Publishers to Their Majesties the King and Queen
Printed in Bavaria
Yuletide series of Christmas postcards, no. 104

Calling Cards

1. Single-fold card
2¼ x 4⅝ inches
Gold engraving on cardstock, gold bevel edge
ca. 1920
Engraved greeting and senders' names inside

2. Calling card
2⅞ x 4⅜ inches
Black and color engraving

on cardstock, debossed (sunk) panel
ca. 1920

3. Calling card
4½ x 5½ inches
Black and color engraving with gold on cardstock, gold border
ca. 1930
Made in U.S.A.

4. Calling card
2½ x 5¼ inches
Engraving on cardstock, debossed panel, red border and edge
ca. 1920

5. Calling card
2⅞ x 4¼ inches
Black and color engraving on cardstock, debossed panel
Sent 1920

6. Calling card
3⅛ x 4 inches
Black engraving with gold on cardstock
Sent 1923

7. Calling card
3¼ x 5¾ inches
Black and color engraving and other printing with gold on cardstock, partial imitation deckle edge
ca. 1925

8. Single-fold card
3⅛ x 4⅛ inches
Color engraving with gold on cardstock, debossed panel, gilded bevel edge, red ribbon
ca. 1920
Engraved calling card inside

9. Calling card
3 x 5 inches
Black engraving with gold on cardstock, debossed panel
ca. 1925

10. Calling card
4 x 5⅜ inches
Black and color engraving with gold on very heavy cardstock, debossed

(sunk) panel
ca. 1920

11. Calling card
3⅜ x 5⅜ inches
Black and color engraving on cardstock, debossing, tinted imitation partial deckle edge
ca. 1925

12. Calling card
3⁷⁄₁₆ x 5⁷⁄₁₆ inches
Black and color engraving on cardstock, debossed panel
ca. 1920

13. Calling card
4 x 6 inches
Black and color engraving with gold on cardstock, debossed panel
ca. 1925

14. Calling card
3⅞ x 5 inches
Black engraving with hand-coloring on embossed cardstock, gold border
ca. 1930
A.M. Davis, Boston, Massachusetts

15. Calling card
4 x 5 inches
Black and white engraving on cardstock, debossed panel, red border
ca. 1925

16. Calling card
2½ x 5¼ inches
Black and color engraving on cardstock, debossed panel
ca. 1920

Shrines

1. Flat card
3½ x 5⅛ inches
Color lithography with gold on linen-finish cardstock, red border
1912
Sandford Card Co., Dansville, New York
Designer M. C. R. Weld (?); the same design also appears as a postcard.

2. Postcard
Chromolithography with gold and embossing on cardstock
Sent 1910 from Ballston Spa to Burnt Hills, New York
International Art Publishing Co., New York and Berlin
Printed in Germany

3. Postcard
Black and color lithography with gold on heavy, textured cardstock
Sent 1910 from Boston, Massachusetts, to Clayton, New York
The A. M. Davis Co., Quality Cards, Boston, Massachusetts

4. Flat card
4⅛ x 5⅜ inches
Black and color engraving on cardstock, debossed panel, white border
ca. 1925

5. Flat card
3½ x 4½ inches
Black and color engraving on cardstock
ca. 1925

6. Flat card
4 x 5 inches
Black and color engraving on heavy cardstock, debossed panel, tinted bevel edge
ca. 1920

7. Flat card
4⅛ x 6½ inches
Black engraving and color printing on cardstock
ca. 1925

8. Single-fold card
3¼ x 5⅛ inches
Black and color engraving with gold on cardstock, debossed panel
1919
Thompson-Smith Co., Fifth Ave., New York

9. Flat card
4⅛ x 5⅜ inches
Black and color engraving

on cardstock, white border
and edge
ca. 1925

10. Flat card
3¼ x 6¼ inches
Black and color
lithography with gold on
cardstock, blue border
ca. 1925

11. Flat card
5 x 6 inches
Black and color engraving
with gold on cardstock,
applied panel of black
and color engraving on
pearlescent paper, white
border
ca. 1930
Made in U.S.A.

12. Modified flat card
4½ x 5¼ inches
Black engraving and color
printing with gold on
cardstock, die-cut contour
ca. 1930

13. Flat card
4½ x 6¾ inches
Black and color engraving
on cardstock, red border
Sent 1949

14. Booklet
5 x 7 inches
Black and gold engraving
with colors and metallic
inks on cardstock, die-cut
lower contour, bound with
green ribbon
ca. 1925
Made in U.S.A.

15. Flat card
4¹¹⁄₁₆ x 6 inches
Black and color engraving
and printing with gold on
cardstock
ca. 1925

16. Booklet
4 x 5¼ inches
Black and color engraving
on cardstock, white border,
bound with red ribbon
ca. 1920
Made in U.S.A.

17. Single-fold card
4⅝ x 6¼ inches

Black and green letterpress
printing on heavy paper,
partial deckle edge
ca. 1935

Winter

1. French-fold card
Color lithography on
canvas-textured paper
ca. 1940
Created by Paramount,
Pawtucket, Rhode Island
Made in U.S.A.

2. French-fold card
6 x 4¾ inches
Hand-colored etching
on laid paper, impressed
plate mark
ca. 1930
The same image also
appears as a flat card.

3. Single-fold card
4⁹⁄₁₆ x 5⁹⁄₁₆ inches
Four-color process
lithography on cardstock
Sent 1961
Gibson, Cincinnati, Ohio
Reproduction of *New
England Winter Scene* by
George Durrie (1820–1863),
a hand-colored lithograph
published by Currier &
Ives, New York, 1861

4. French-fold card
4⅛ x 5⅜ inches
Four-color process
lithography on paper
ca. 1950
Hallmark, Kansas City,
Missouri
Reproduction of *The Old
Snow Roller* by Grandma
Moses (Anna Mary
Robertson Moses, 1860–
1961), copyright Galerie
St. Etienne, New York

5. Augmented single-fold
card (extra sheet inside)
5½ x 6½ inches
Black and color
lithography on glossy
cardstock
ca. 1955
Henri Fayette, Chicago,
Illinois

6. Augmented French-fold
card (cover image tipped
onto conventional French
fold)
6 x 7½ inches
Four-color process
lithography on paper,
applied to paper with
printed borders and
deckle edge
ca. 1955
Designers and Illustrators
Card no. 25718
Printed in U.S.A
Image by Doris Spiegel
(1907–?)

7. Single-fold card
6¼ x 7¾ inches
Half-tone lithography on
heavy paper with deckle
edge
ca. 1935

8. French-fold card
7 x 5 inches
Black and color engraving
and other color printing
with metallic accents on
mottled and textured paper
with pinked edge
ca. 1925

9. Flat card
3¾ x 5⅝ inches
Black engraving and color
lithography with metallic
accents on cardstock
ca. 1925
Made in U.S.A.

10. Modified
single-fold card
3⅞ x 4¾ inches
Black and color
lithography with gold on
cardstock, die-cut contour
ca. 1935
Made in U.S.A.

11. French-fold card
4½ x 5½ inches
Four-color process
lithography on paper
Sent 1951
Made in U.S.A.

12. Flat card
4¼ x 5½ inches
Black and color lithogra-
phy with gold on cardstock
ca. 1925

Designer ERH
(unidentified)

13. French-fold card
4 x 5 inches
Red and gray litho-
graphy on paper, partial
deckle edge
ca. 1950
Image by Jean Lamont

14. French-fold card
3⅝ x 5⅝ inches
Black engraving with hand
coloring on imitation
parchment
ca. 1930

15. French-fold card
4½ x 6¼ inches
Black, red, and silver
letterpress printing (?) on
imitation parchment
ca. 1935

16. Single-fold card
5½ x 4¼ inches
Color lithography on
cardstock
ca. 1955
Irene Dash Greeting Card
Co., Inc., New York
Printed in U.S.A.
Image by Eyvind Earle
(1916–2000), no. 10E 22

Candles

1. Flat card
3¼ x 5⅛ inches
Black and gold
engraving on cardstock
ca. 1925

2. Single-fold card
5 x 4 inches
Red and black engraving
on cardstock, red border
and edge on three sides
ca. 1930

3. Augmented
single-fold card
6⅞ x 3¾ inches
Black and color
engraving and
lithography with gold
accents on heavy
cardstock, debossed
panel, green-edged
ribbon

1917
P. F. Volland & Co.,
Chicago, Illinois

4. Flat card
4¼ x 2¾ inches
Red and black lithography
on cardstock
ca. 1925

5. Flat card
4¼ x 5½ inches
Black and color
lithography with gold on
cardstock
ca. 1930

6. Flat card
4 x 5 inches
Black and color
lithography with light
embossing on cardstock
ca. 1930

7. Flat card
4 x 4¾ inches
Black and color
lithography with gold
accents on cardstock, gold
border
ca. 1925
Made in U.S.A.

8. French-fold card
4¹⁵⁄₁₆ x 4¹⁄₁₆ inches
Red, black, and silver
lithography on heavily
textured paper
ca. 1935
Logo of Allied Printing
Trades Council, Chicago,
Illinois
Made in U.S.A.

9. Modified French-fold
card
5⅛ x 3⅝ inches
Green, black, and gold
lithography on lightweight
imitation parchment, short
fold at bottom
ca. 1935

10. French-fold card
5¾ x 4⅝ inches
Color lithography with
hand-coloring and gold
on paper
Sent 1948 from Modesto,
California
McNicol, Boston,
Massachusetts

11. Augmented
French-fold card
6 x 4½ inches
Brown and gold
lithography with
embossing on embossed
paper over metallic gold,
both applied to lightly
textured paper
ca. 1955
Harry Doehla Co., Nashua,
New Hampshire
Made in U.S.A.

12. Modified French-fold
card
5⅞ x 4¼ inches
Red and silver lithography
on lightweight paper, short
fold at right
Sent 1933

13. Modified
and augmented
French-fold card
6½ x 4¹¹⁄₁₆ inches
Black and color
lithography with light
embossing and metallic
glitter on lightly textured
paper, short fold at right
ca. 1955

14. French-fold card
4¼ x 4¼ inches
Blue and red lithography
on paper
ca. 1940
W & W (White and
Wyckoff, Holyoke,
Massachusetts?)

Poinsettias

1. Postcard
Color lithography
with gold accents and
embossing on cardstock
Sent 1914 from Springfield,
Massachusetts, to
Ellington, Connecticut
Whitney Made, Worcester,
Massachusetts

2. Postcard
Chromolithography with
gold and embossing on
cardstock
Sent 1911 from Waterford
to East Killingly,
Connecticut

Raphael Tuck & Sons,
London, Art Publishers to
Their Majesties the King
and Queen
Printed in Saxony
The Poinsettia series of
Christmas postcards,
no. 518

3. Calling card
3¼ x 4¾ inches
Black and color engraving
on cardstock, debossed
panel
ca. 1925

4. Booklet
2¹³⁄₁₆ x 4¹⁄₁₆ inches, bound
by red ribbon
Color engraving with gold
on cardstock
Sent 1916

5. Flat card
3⅝ x 4½ inches
Black and color
lithography with gold
thermography on
cardstock, partial imitation
deckle edge
Sent 1935

6. Modified
French-fold card
3¹⁵⁄₁₆ x 4⅞ inches
Red, silver, and black
letterpress printing on
textured paper, short fold
at right
Sent 1934

7. French-fold card
4¼ x 4¼ inches
Black and color
lithography on paper
ca. 1940
Whitney, Worcester
Massachusetts

8. Modified
and augmented
French-fold card
5⅝ x 5⅝ inches
Black and color
lithography on lightweight
embossed paper over
textured metallic gold
paper, over inset textured
paper window, die-cut
contour, red ribbon
1938
A Hallmark Card, Hall

Brothers, Inc., Kansas City,
Missouri

9. French-fold card
4¼ x 4¼ inches
Black, red, and silver
lithography on textured
paper
ca. 1938

10. Modified
and augmented
French-fold card
5½ x 5 inches
Black and color
lithography on
lightweight, embossed
paper, layered over
textured, metallic gold
paper, die-cut front panel
ca. 1940
Made in U.S.A.

11. Augmented
French-fold card
6¹³⁄₁₆ x 5¼ inches
Color lithography with
gold embossing and
flocking on lightweight
paper, insert of
metallic gold paper over
lightweight blue paper
1941
National Printing Co.
Made in U.S.A.

12. French-fold card
5¹⁵⁄₁₆ x 4¹³⁄₁₆ inches
Flocking and gold on
lightweight black paper
ca. 1950

13. Modified
and augmented
French-fold card
5¹³⁄₁₆ x 4¾ inches
Four-color process
lithographed folding
flowers applied to color-
printed paper with die-cut
contour
ca. 1950
Made in U.S.A.
Christmas Petals (?)

14. Modified
French-fold card
5¹¹⁄₁₆ x 4¾ inches
Black and color process
lithography on paper,
front panel die-cut and
folded back

ca. 1950
An Artistic Card
Made in U.S.A.

15. Augmented French
fold card
5¾ x 4¾ inches
Die-cut and embossed
flower applied to paper
with color lithography,
embossing, and glitter
Sent 1952
"A Doehla Fine Arts Card,"
Harry Doehla, Nashua,
New Hampshire
Made in U.S.A.

16. French-fold card
5⅞ x 4¾ inches
Four-color process
lithography and
embossing on paper
Sent 1948 from Walnut
to Sterling, Illinois
Made in U.S.A.

Three Kings

1. Single-fold card
3⅞ x 4⅞ inches
Etching with hand-
coloring on cardstock,
impressed plate mark,
partial deckle edge
ca. 1930

2. Single-fold card
5½ x 7¼ inches
Black lithography
with hand-coloring on
cardstock, debossed
panel, partial imitation
deckle edge
ca. 1930
Decoratone

3. Flat card
3⅜ x 4⁵⁄₁₆ inches
Black and color
lithography on textured
cardstock
ca. 1920
A. M. Davis, Boston,
Massachusetts

4. Flat card
3⅝ x 4⅝ inches
Black and color
lithography with
gold on cardstock,
gold border

ca. 1930
Made in U.S.A.

5. Flat card
4⅜ x 5⅝ inches
Black engraving and black
and color lithography on
cardstock, gold border,
imitation deckle edge
ca. 1930

6. French-fold card
3⅜ x 4½ inches
Black and color
lithography with gold on
imitation parchment
Sent 1930

7. Modified and
augmented French-fold
card
6 x 4½ inches
Lithographed and gold
paper panel die-cut to
reveal lithographed paper
insert
ca. 1940
National Printing Co.
Made in U.S.A.

8. Flat card
3⅜ x 4⅞ inches
Black engraving with black
and gold lithography on
cardstock
Sent 1931

9. Flat card
4¼ x 6⅝ inches
Black engraving and color
lithography with gold on
cardstock, gold border
ca. 1930

10. French-fold card
7⅝ x 5¾ inches
Black lithography with
hand-coloring (?), gold,
and embossing on paper
ca. 1935
Keating, Philadelphia,
Pennsylvania

11. Flat card
4¼ x 3⅛ inches
Black engraving with
hand-coloring on
cardstock
ca. 1930

12. Flat card
5⅜ x 3⅞ inches

Black engraving and color
lithography with gold on
cardstock, gold border
ca. 1930
Made in U.S.A.

13. Flat card
4½ x 3½ inches
Black and color
lithography with gold on
cardstock
ca. 1925
Rust Craft, Boston,
Massachusetts

14. French-fold card
4 x 5 inches
Blue lithography with
silver on lightly embossed
paper
Sent 1938
Union Made in U.S.A.

15. French-fold card
4⅞ x 5¼ inches
Black and color
lithography with silver
on lightweight embossed
paper
ca. 1938
Made in U.S.A.

16. French-fold card
5⅜ x 4⅜ inches
Four-color process
lithography on paper
Sent 1953
Hawthorne-Sommerfield
Made in U.S.A.

Travel by Coach

1. French-fold card
5¼ x 7¼ inches
Black intaglio print on
very lightweight paper,
impressed plate mark
Image dated 1924, sent
1927
Designed and signed by
Maurice Day (1892–1983)

2. Single-fold card
3⅛ x 6⅛ inches
Color lithography on paper
1925
Signed by Morton Hanson
(1865–1949)

3. Single-fold card
11 x 8½ inches

Black and color engraving
and lithography with hand-
coloring on paper
Sent 1949

4. Flat card
3¾ x 4¾ inches
Black and color litho-
graphy with gold ther-
mography on cardstock
Sent 1930

5. French-fold card
4¹⁄₁₆ x 5¼ inches
Black lithography with
imitation hand-coloring on
embossed paper
ca. 1935
Rust Craft, Boston,
Massachusetts

6. Single-fold card
4½ x 5⅜ inches
Black lithography with
imitation hand-coloring
on cardstock, partial
deckle edge
ca. 1925

7. Single-fold card
4 x 5 inches
Black engraving and
color lithography with
gold on cardstock,
debossed panel, partial
imitation deckle edge
Sent 1930, Dixon to
Sterling, Illinois

8. Flat card
5 x 6¾ inches
Black engraving and color
lithography with gold on
cardstock
Sent 1931

9. Flat card
3⁷⁄₁₆ x 4½ inches
Black and color
lithography on cardstock
ca. 1930

10. Flat card
4⅛ x 5⅜ inches
Black lithography with
hand-coloring on very
heavy cardstock, white
border
ca. 1925

11. Single-fold card
5¾ x 4¾ inches

Black lithography with imitation hand-coloring and gold on very heavy, textured cardstock, debossed panel, partial deckle edge
Sent 1926, New York to Schenectady, New York
Image initialed NC

12. Modified French-fold card
3⁵⁄₁₆ x 5¼ inches
Black and red lithography on very lightweight, pearlescent paper, short fold at bottom
Sent 1933
Made in U.S.A.

13. Modified French-fold card
4⅜ x 5⅜ inches
Black, red, and silver lithography on paper, short fold at bottom
ca. 1935

14. French-fold card
4⅝ x 5⅝ inches
Color lithography on paper
ca. 1950

15. French-fold card
4⅜ x 5¼ inches
Color lithography on textured paper
ca. 1950
Rust Craft, Boston, Massachusetts

Ships

1. Postcard
Chromolithography with silver and embossing on cardstock
Sent 1907 from Hancock, Massachusetts, to East Chatham, New York

2. Modified flat card
4⁷⁄₁₆ x 5⅜ inches
Black and color lithography with gold on embossed cardstock, die-cut upper contour
ca. 1925
Made in U.S.A.

3. Flat card
4 x 5⅛ inches
Black and color lithography and letterpress printing with gold on cardstock
ca. 1925

4. Flat card
4¼ x 5½ inches
Black and color lithography with gold on cardstock
Sent 1926 (?)

5. Flat card
4⅛ x 5⅛ inches
Green and black lithography with silver thermography on cardstock
ca. 1930

6. Flat card
4⅛ x 6½ inches
Black and color engraving and lithography with embossing on cardstock
ca. 1925

7. Calling card
3 x 5 inches
Engraving on cardstock, debossed panel
ca. 1920

8. Flat card
4⅜ x 5¾ inches
Brown/black lithography with hand-coloring on cardstock
ca. 1930

9. French-fold card
4½ x 6¹⁄₁₆ inches
Black and color lithography with gold on imitation parchment
ca. 1926

10. Flat card
4⅜ x 5½ inches
Black and gold lithography with engraving and embossing on cardstock
ca. 1925

11. Flat card
5⅜ x 6½ inches
Black and color lithography with engraving, hand-coloring,

and gold on cardstock
ca. 1925

12. Augmented French-fold card
4⅞ x 5⅞ inches
Black lithography with hand coloring on imitation parchment, red ribbon
ca. 1930

13. Augmented French-fold card
6⅜ x 8 inches
"Steel engraved from a Signed Original Lithograph" on imitation parchment, sheet of silver foil inserted between top and second sheets, partial deckle edge, glassine oversheet with information about the artist (removed for photograph)
Sent ca. 1950 by Schermerhorn Bros. Co.
Reproduction of *Saucy Brig* by Gordon Grant (1875–1962)

14. Flat card
5½ x 4¼ inches
Black and color engraving with gold on cardstock
ca. 1930

15. French-fold card
6¼ x 5³⁄₁₆ inches
Black and color lithography with gold thermography on imitation parchment
ca. 1930

16. Augmented French-fold card
6 x 7⁹⁄₁₆ inches
Color lithographed top panel applied to lithographed paper
ca. 1950
American Artists Group, New York
Printed in U.S.A.
Reproduction of *Sails in the Sunset* by Rockwell Kent (1882–1971)

17. French-fold card
5½ x 4½ inches
Color lithography on lightweight paper

ca. 1938
Made in U.S.A.

Medieval Revels

1. French-fold card
6¼ x 5³⁄₁₆ inches
Black and color engraving with gold accents on paper, partial deckle edge
Sent 1948

2. Single-fold card
6¼ x 6¼ inches
Black etching on heavy paper, slight impressed plate mark, partial deckle edge
ca. 1930

3. Modified single-fold card
5½ x 4½ inches
Lithography on cardstock, debossed panel, short fold at bottom, partial deckle edge
ca. 1930

4. Modified French-fold card
4¼ x 6 inches
Black and color lithography with gold on paper, short fold at right
ca. 1935
Made in U.S.A.

5. French-fold card
4¼ x 5¾ inches
Black and color lithography on paper, partial deckle edge
ca. 1930
Unidentified artist's monogram

6. Flat card
4½ x 5¾ inches
Black lithography with hand-coloring on cardstock
ca. 1925

7. Flat card
4¼ x 5⅜ inches
Black and gold thermography with imitation hand coloring on cardstock, pinked edge
ca. 1925

8. Single-fold card
3⅞ x 4⅞ inches
Letterpress black printing
with imitation hand
coloring on cardstock
ca. 1925
Unidentified artist's
monogram

9. Modified
double-fold card
4 x 5 inches
Black engraving on
printed marbleized paper;
front panel opens left,
second panel opens right,
short fold at right
ca. 1930

10. Modified
single-fold card
5¼ x 6¼ inches
Black and color
lithography and
engraving with silver
on heavy cardstock,
short fold at right
Sent ca. 1935 by
Consolidated Ribbon
and Carbon Company,
Chicago, Illinois
Image signed by Wheeler

11. Flat card
4⅛ x 6½ inches
Black and color
lithography with
engraving on cardstock
ca. 1925

12. Flat card
4⅛ x 7⅛ inches
Black and color
lithography with
engraving and gold
on cardstock
1928
N. O. N.

13. French-fold card
3 x 5 inches
Black lithography with
hand coloring (?) and gold
on imitation parchment
ca. 1926

14. Single-fold card
5¼ x 7 inches
Black and color lithogra-
phy with gold on paper
ca. 1935 (?)
Tiffany & Co., New York (?)

Design by Winifred E.
Lefferts (1902–1990)

Houses and Homes

1. Flat card
3⅞ x 6 inches
Black letterpress printing
on cardstock, deckle edge
1927

2. Flat card
3¹³⁄₁₆ x 5⁷⁄₁₆ inches
Color lithography with
engraving and gold
accents on cardstock,
debossed panel, gold
border
ca. 1925
Made in U.S.A.

3. Modified
single-fold card
3⅞ x 4⅞ inches
Black and color lithogra-
phy with engraving and
gold on cardstock; die-cut
front panel folds down
ca. 1930

4. Calling card
4¼ x 5⁷⁄₁₆ inches
Black and color engraving
with gold and embossing
on cardstock, black and
gold borders, gilded
imitation deckle edge
Sent 1928

5. Flat card
4 x 5 inches
Blue and white engraving
with gold on cardstock
ca. 1930

6. Flat card
4 x 4⅞ inches
Black lithography
with hand coloring on
marbleized cardstock
This card appears in the
1930 Christmas card
catalogue of the Little Art
Shop, Washington, D.C.

7. Augmented
single-fold card
6⁷⁄₁₆ x 7⁷⁄₁₆ inches
Black and color
lithographed top panel
with blue border applied to

heavy gold-printed,
cardstock, white ribbon
ca. 1930

8. Single-fold card
5 x 6½ inches
Blue-black aquatint with
etching on cardstock,
impressed plate mark,
partial deckle edge
Sent 1929 from Wall Street
Station, New York, to
Schenectady, New York

9. French-fold card
6¼ x 7¹³⁄₁₆ inches
Black lithography on
heavy paper, debossed
panel
ca. 1950
Printed by Brown
& Bigelow, St. Paul,
Minnesota
"'Home, Sweet Home' East
Hampton, Long Island"
Image by Reinhold H.
Palenske (1884–1954)

10. Flat card with addition
10⅛ x 8 inches
Brown and color
lithography on cardstock,
debossed panel, partial
deckle edge, separate
attached card
Sent 1932

11. French-fold card
4⅞ x 3¹⁵⁄₁₆ inches
Black and color
lithography on paper
ca. 1935
A Rytex Creation, Peru,
Indiana

12. French-fold card
6¾ x 5⅜ inches
Black and color
lithography with
embossing on paper
ca. 1950
Gartner and Bender,
Chicago
Made in U.S.A.
Lithographed in Mirrotone

13. French-fold card
5½ x 4¼ inches
Black and color
lithography on paper
ca. 1940
Made in U.S.A.

14. Modified
French-fold card
5¾ x 4⅜ inches
Black and color
lithography on paper,
center of front panel
die-cut to fold open
ca. 1950
"A Doehla Fine Arts Card,"
Harry Doehla, Nashua,
New Hampshire
Made in U.S.A.

15. French-fold card
5⁷⁄₁₆ x 4³⁄₁₆ inches
Black and red lithography
with silver on paper
ca. 1935
Made in U.S.A.

16. Modified
French-fold card
4⅝ x 6½ inches
Color lithography with
letterpress printing on
paper, front panel with
die-cut openings
ca. 1950

Hearths

1. Calling card
3½ x 4½ inches
Black and color engraving
with gold on cardstock
ca. 1920

2. Flat card
4½ x 5½ inches
Black engraving with
hand-coloring on card-
stock, debossed panel
ca. 1925

3. Flat card
4½ x 5½ inches
Brown lithography
with hand-coloring and
engraving on cardstock,
debossed panel, deckle
edge at bottom
ca. 1925

4. Flat card
4½ x 5½ inches
Black lithography with
imitation hand-coloring
and embossing on
cardstock, debossed panel
ca. 1925
Made in U. S. A.

5. Flat card
4 x 2¾ inches
Black lithography
with hand-coloring
on cardstock
ca. 1920
Illegible initials,
Providence, Rhode Island

6. Flat card
4½ x 3½ inches
Black lithography with
imitation hand-coloring on
cardstock
ca. 1920

7. Flat card
4 x 5 inches
Black and color
lithography with
engraving on cardstock
ca. 1925

8. Single-fold card
3 x 4¼ inches
Black and color
lithography on imitation
parchment
ca. 1930
Rust Craft, Boston,
Massachusetts

9. Single-fold card
3¼ x 4⅝ inches
Black and color
lithography with gold
accents on heavy
cardstock, die-cut slot
(for calling card?) inside
ca. 1930
Rust Craft, Boston,
Massachusetts

10. French-fold card
4⅛ x 5 inches
Black and color
lithography with gold on
imitation parchment
ca. 1930

11. French-fold card
3½ x 4½ inches
Black and color
lithography with gold
on lightweight imitation
parchment
ca. 1935

12. French-fold card
4¼ x 4¼ inches
Red and black lithography
on paper

ca. 1940
Made in U.S.A.

13. French-fold card
4¼ x 5 inches
Color lithography
on lightweight
embossed paper
Sent 1939

14. French-fold card
5½ x 4½ inches
Color lithography and
embossing on lightweight
paper
ca. 1950

Music

1. Postcard
Chromolithography
with gold accents and
embossing on cardstock
Sent 1910 from Amsterdam
to Huntersland, New York
Raphael Tuck & Sons,
London, Art Publishers to
Their Majesties the King
and Queen
Printed in Saxony
Christmas Hymns series
of postcards, no. 514

2. Flat card
3⁵⁄₁₆ x 4⅜ inches
Black lithography with
white hand-coloring on red
cardstock, white border
ca. 1920
A. M. Davis, Boston,
Massachusetts

3. Flat card
4⁹⁄₁₆ x 5½ inches
Black and color
lithography with gold
thermography and
engraving on cardstock
ca. 1930

4. Flat card
4 x 5 inches
Black and color
lithography with gold on
cardstock
Sent 1929

5. Flat card
4⅜ x 5⅞ inches
Black and color
lithography with gold

accents and engraving
on cardstock
ca. 1925
Made in U.S.A.

6. Modified
single-fold card
4⅜ x 5⅜ inches
Black lithography with
silver and engraving on
heavy cardstock, short
fold at bottom, partial
deckle edge
ca. 1925

7. Modified
single-fold card
4⅜ x 5⅜ inches
Black engraving with
gold on cardstock, short
fold at bottom
ca. 1930
Made in U.S.A.

8. Single-fold card
4¹⁄₁₆ x 6¼ inches
Imitation colored
engraving on cardstock,
debossed panel
ca. 1930
Illegible artist's signature

9. Flat card
5⅜ x 4³⁄₁₆ inches
Black and color
lithography with gold and
engraving on cardstock,
gold border
ca. 1930

10. French fold card
4¹⁄₁₆ x 5 inches
Red lithography on
lightweight paper
ca. 1935
Made in U.S.A.

11. Modified
French-fold card
5¹¹⁄₁₆ x 4¹¹⁄₁₆ inches
Black and color
lithography and
embossing on paper,
front panel with die-cut
scalloped edge on
two sides
ca. 1950
Made in U.S.A.

12. Augmented
French-fold card
4⅜ x 6 inches

Black and color
lithographed panel with
gold border applied
to lithographed and
embossed paper
Sent 1941
Made in U.S.A.

13. Flat card
4 x 5 inches
Black and color
lithography with gold and
embossing on cardstock
ca. 1930

14. Modified
French-fold card
6 x 5 inches
Black and color
lithography with gold on
glossy paper, front panel
die-cut to reveal words
inside
ca. 1950
WB (Wallace Brown?),
union logo for Allied
Printing Trades Council,
New York
Made in U.S.A.

Couples

1. Booklet
5⅜ x 6½ inches
Black and color lithogra-
phy with hand-coloring
and gold thermography
on cardstock, bound
with red ribbon
ca. 1930
Rust Craft, Boston,
Massachusetts

2. French-fold card
3⅜ x 5¾ inches
Black and color
lithography with gold on
imitation parchment
ca. 1930

3. Flat card
3⁷⁄₁₆ x 5¹³⁄₁₆ inches
Black and red engraving
on cardstock
ca. 1930

4. Flat card
4⅝ x 3⅝ inches
Black and color
lithography on cardstock,
imitation deckle edge top

and bottom
ca. 1925

5. Flat card
5¹¹⁄₁₆ x 4⅜ inches
Black and color
lithography with
engraving on cardstock,
red border
ca. 1925
Clark, New York

6. Single-fold card
4⅝ x 5¾ inches
Black and color
lithography with
gold and embossing
on paper, imitation
deckle edge
ca. 1930

7. Modified
single-fold card
4¹⁄₁₆ x 4⅞ inches
Black and color lithography
with silver on cardstock,
short fold at bottom
ca. 1935
Made in U.S.A.

8. Single-fold card
5 x 4 inches
Black and color
lithography with gold on
imitation parchment
ca. 1930

9. Augmented
French-fold card
4 x 3⅛ inches
Black and color
lithographed front
panel applied to paper
Sent 1936

10. Modified
French-fold card
5¼ x 4¼ inches
Black and color
lithography with
silver thermography
on lightweight imitation
parchment, center of
front panel die-cut to
reveal panel beneath
Sent 1934
Made in U.S.A.

11. French-fold card
3⅜ x 4⅜ inches
Blue and red
lithography with silver

on embossed paper
ca. 1938

12. French-fold card
4½ x 5¾ inches
Black, green, and red
lithography on glossy
paper
ca. 1935
Made in U.S.A.

13. Single-fold card
4⅝ x 6 inches
Blue/black mezzotint (?)
on heavy paper, impressed
plate mark, deckle edge
ca. 1930
Illegible artist's signature

14. French-fold card
5⅛ x 6 inches
Black lithography with
gold on lightweight red
paper
ca. 1935

15. Single-fold card
5¼ x 7 inches
Black and color
lithography on cardstock
Sent 1953
Turner & Porter (Buffalo,
New York?) U.S.A.

16. French-fold card
4¼ x 4¼ inches
Black, red, and blue
lithography on paper
ca. 1940

Visiting

1. Flat card
6¼ x 4½ inches
Color lithography with
imitation hand-coloring on
cardstock, partial imitation
deckle edge
ca. 1930

2. Flat card
4¼ x 5¼ inches
Black and red lithography
with gold on cardstock
ca. 1930

3. Flat card
4⅜ x 5⅜ inches
Black and color
lithography with gold
thermography, embossing,

and engraving on card-
stock, partial imitation
deckle edge
ca. 1925

4. Single-fold card
3⅜ x 4½ inches
Black and color lithogra-
phy on heavy paper
ca. 1930

5. Single-fold card
4¼ x 5⁹⁄₁₆ inches
Color lithography with
hand-coloring on heavy
cardstock, partial deckle
edge
ca. 1930
The Buzza Co.,
Minneapolis, Minnesota

6. Single-fold card
5 x 4¾ inches
Black engraving
with hand-coloring
and gold on heavy paper,
impressed plate mark,
partial deckle edge
ca. 1925

7. French-fold card
5⅞ x 4⅜ inches
Black and color
lithography with gold on
imitation parchment
ca. 1935

8. Single-fold card
4½ x 5 inches
Black and color
lithography with
gold accents and
engraving on
cardstock, partial
imitation deckle edge
1931
The Buzza Co., Craftacres,
Minneapolis, Minnesota

9. French-fold card
5⅛ x 6⅝ inches
Black lithography with
hand-coloring on imitation
parchment
ca. 1930

10. Modified
French-fold card
5 x 6 inches
Black, red, and gray
letterpress (?) printing
on embossed paper,

short fold at right
ca. 1935

11. French-fold card
4⅞ x 5¹³⁄₁₆ inches
Color lithography on paper
ca. 1935
Illegible publisher's logo
on back

12. French-fold card
3 x 4⅛ inches
Black and red
lithography on paper
ca. 1935
Carrington Co.,
Chicago, Illinois

13. French-fold card
5½ x 5 inches
Black, red, and gray
lithography on paper
ca. 1955
Green Tree, Boston,
Massachusetts

14. French-fold card
5¾ x 4¾ inches
Black lithography with
imitation hand-coloring
on paper
ca. 1950
Made in U.S.A.

15. Augmented
French-fold card
5⅜ x 6½ inches
Black and color
lithography on paper
over white, deckle-edge
paper, over red paper
ca. 1950
Unidentified artist's initials

16. French-fold card
6⅛ x 4¾ inches
Black and color
lithography on paper
ca. 1940
Rust Craft, Boston,
Massachusetts
Image signed Nana
Bickford Rollins
(1886–1959)

Santa and the Children

1. Augmented postcard
Chromolithographed
cardstock with die-cut
openings over paper

backing
Sent 1912 from
Schenectady, New York,
to same

2. Flat card
4 x 5 inches
Black and color lithog-
raphy with engraving
on cardstock, gold border
ca. 1935

3. Flat card
3¹⁄₁₆ x 3⅞ inches
Black and color
lithography on cardstock,
tinted border and edge
1913
The A. M. Davis Co.,
Quality Cards, Boston,
Massachusetts

4. Flat card
4¹⁄₁₆ x 3³⁄₁₆ inches
Black and color
lithography on cardstock,
red border and edge
ca. 1920

5. Flat card
5 x 4 inches
Black lithography
with hand-coloring on
cardstock
Sent 1934

6. Flat card
3³⁄₁₆ x 4⅝ inches
Color lithography on
cardstock
ca. 1935
YMCA Draeger Imp.

7. French-fold card
6¼ x 4¼ inches
Black and color letterpress
printing with gold on
lightweight, imitation
wood-grain paper
ca. 1935

8. Single-fold card
5¾ x 7¾ inches
Black and color
lithography on cardstock
ca. 1930

9. Single-fold card
4½ x 6½ inches
Black, blue, and red
lithography on glossy
cardstock

ca. 1950
Henri Fayette,
Chicago, Illinois

10. Modified and
augmented flat card
4⅞ x 5⅞ inches
Black and color lithogra-
phy on cardstock, white
border; die-cut slots for in-
serted letterpress greeting
ca. 1950
Chryson's, Hollywood,
California

11. Double-fold card
6 x 3½ inches
Blue and red lithography
on heavy cardstock, die-cut
to reveal image beneath;
fold at both left and right
ca. 1950
Henri Fayette, Chicago,
Illinois

12. Single-fold card
6½ x 5 inches
Black and color
lithography on cardstock
ca. 1950
Designers and Illustrators
Card, no. 15909
Image by Vernon Grant
(1902–1990)

13. Single-fold card
5⅛ x 5⅛ inches
Black and color
lithography with gold on
glossy cardstock
ca. 1950
Henri Fayette, Chicago,
Illinois

Christmas Trees

1. Postcard
Sepia photolithography on
cardstock
1909
Roth & Langley, New York

2. Postcard
Chromolithography and
gold on cardstock
1906
H. I. Robbins, Boston,
Massachusetts
The Metropolitan News
Co., Boston, Massachusetts,
and Germany

3. Flat card
3½ x 4½ inches
Black and orange
engraving with gold
accents on cardstock,
gold border
Sent 1930 from Savanna
to Sterling, Illinois

4. Modified
single-fold card
4¼ x 5¼ inches
Black lithography with
silver and engraving on
cardstock, debossed panel,
short fold at bottom
ca. 1930

5. Postcard
Chromolithography and
embossing on cardstock
Sent 1912 from Hudson to
Schenectady, New York
G (Gibson Art Co.,
Cincinnati, Ohio)
Printed in Germany
Christmas series postcard,
no. 204

6. Postcard
Black and color
lithography on cardstock
ca. 1925
P. F. Volland Co., Chicago,
Illinois
Printed in U.S.A.

7. French-fold card
3½ x 4¾ inches
Silver lithography over
green on lightweight paper
ca. 1935
Buzza Cardozo, Hollywood,
California

8. Flat card
4 x 5 inches
Red and silver lithography
on cardstock
ca. 1930

9. Flat card
5½ x 4⅝ inches
Black and color
lithography with
engraving on cardstock
ca. 1935
Carrington Co., Chicago,
Illinois

10. Single-fold card
4¾ x 4 inches

Red letterpress (?) printing
on imitation parchment
ca. 1935

11. Flat card
4½ x 3½ inches
Red and black lithography
with gold on cardstock, red
border and edge
ca. 1930

12. French-fold card
4⁹⁄₁₆ x 3½ inches
Black and color
lithography on imitation
parchment
ca. 1935
Made in U.S.A.

13. Single-fold card
5 x 6⅝ inches
Color lithography on
glossy paper
Sent 1955 by Otto J.
Wilson Co. (Salem,
Oregon?)
Reproduction of a painting
of a 1955 Buick by J. Crabb

14. Single-fold card
6½ x 5 inches
Color lithography on
heavy, textured paper
ca. 1950
Designers and Illustrators,
New York, card no. 15921
Printed in U.S.A.
Designed by Leo Rackow
(1901–1988)

Christian Christmas

1. French-fold card
5½ x 4⅛ inches
Color lithography on paper
ca. 1950
Barton-Cotton, Inc.,
Baltimore, Maryland
Made in U.S.A.
Reproduction of *Holy
Night* by Carlo Maratti
(1625–1713)

2. French-fold card
4¹¹⁄₁₆ x 3¹¹⁄₁₆ inches
Brown/black
photolithography on
paper, partial gold border
ca. 1935

3. Modified
and augmented
French-fold card
7 x 5⅞ inches
Lithography with imitation
hand-coloring and gold,
short fold at right, partial
deckle edge, green foil
insert
ca. 1950

4. Single-fold card
6⅜ x 5 inches
Black and color
lithography on heavy
paper
Sent 1953
A. A. G. (American Artists
Group, New York?)
Printed in U.S.A.

5. Single-fold card
4½ x 6¹⁵⁄₁₆ inches
Red and gold engraving on
heavy cardstock
ca. 1955
Tiffany & Co., New York
Design by Winifred E.
Lefferts Arms (1903–1995)

6. French-fold card
4⅛ x 6¼ inches
Color lithography with
gold on paper
ca. 1930

7. French-fold card
4½ x 6¼ inches
Color lithography
with gold on imitation
parchment
Sent 1930

8. Single-fold card
5½ x 4½ inches
Black and color
lithography on fibrous
cardstock
ca. 1940
"Brownie"

9. Single-fold card
5⅞ x 4½ inches
Black and color
lithography on paper
Sent 1947
United Service to China
(formerly United China
Relief), 1790 Broadway,
New York
Reproduction of
The Manger from

the Collection at
University at Peiping

10. Single-fold card
6 x 5½ inches
Black and color
lithography on heavy
paper
Sent 1952
Irene Dash Greeting Card
Co., New York
Printed in U.S.A.
Design copyright Tasha
Tudor (1915–2008)

11. Augmented
French-fold card
4⅜ x 5⅞ inches
Black and color
lithographed booklet
set into die-cut slot
on black and color
lithographed paper
Sent 1949
Made in U.S.A.

12. Single-fold card
7½ x 4 inches
Black and color
lithography with gold on
heavy paper
Sent 1954
Designers and Illustrators,
New York, card no. E432-
11 L
Design by Sheilah Beckett
(1913–?)

Churches

1. Postcard
Chromolithography
with gold accents and
embossing on cardstock
1910
A. S. Meeker, New York
Christmas series, no. 506

2. Single-fold card
7⅞ x 6⅜ inches
"Steel etching" with
imitation (?) hand-coloring
on heavy paper, debossed
panel, partial deckle edge
ca. 1930
Illegible artist's signature

3. French-fold card
6⅛ x 4¾ inches
Color lithography on
textured paper

1942
Rust Craft, Boston,
Massachusetts
View of St. Paul's
Cathedral from
Fleet Street

4. Modified
French-fold card
4½ x 4⅛ inches
Red and black lithography
on lightweight paper, short
fold on right
ca. 1935
Quality Made in U.S.A.

5. French-fold card
5 x 4¼ inches
Black and red lithography
on paper
ca. 1935
Rynart, union logo Allied
Printing Trades Council,
Chicago, Illinois
Made in U.S.A.

6. French-fold card
5¾ x 4½ inches
Color lithography with
gold on paper
ca. 1935

7. Single-fold card
6¼ x 5¼ inches
Color lithography on
heavy, textured paper
Sent 1954
A Sunshine Card
Made in U.S.A.

8. Single-fold card
4½ x 3½ inches
Color lithography on
paper
ca. 1950
"Brownie"

9. Single-fold card
6 x 6 inches
Color lithography with
gold accents on glossy
cardstock
ca. 1950
Henri Fayette, Chicago,
Illinois

10. Augmented
French-fold card
5¾ x 4⅝ inches
Color lithography and
embossing on paper, front
panel die-cut to reveal

inserted transparent and
printed sheets
Sent 1951

11. French-fold card
5½ x 4½ inches
Color lithography with
gold accents on paper
ca. 1950
Colortype Created
Made in U.S.A.

12. Single-fold card
6 x 5½ inches
Color lithography on
heavy paper
Sent 1947
Irene Dash Greeting Card
Co., New York
Printed in U.S.A.
Image by Tasha Tudor
(1915–2008)

13. French-fold card
5⅝ x 4⁹⁄₁₆ inches
Black and color
lithography and
embossing on paper
Sent 1956
Paper Craft
Made in U.S.A.

Family Photographs

1. Single-fold card
6¼ x 4⅞ inches
Black photolithography on
heavy paper
Sent 1935 from New
York, New York, to Lynn,
Massachusetts

2. Flat card
4 x 6 inches
Sepia-colored
photographic print
and lithography on
photographic paper
Sent 1930
Young Photo Service,
Albany, New York

3. Flat card
4¼ x 5½ inches
Brown/black photographic
print with lithography
on photographic paper,
debossed panel
Sent 1934

4. Augmented
single-fold card
5 x 6½ inches
Black photolithograph on
paper applied to cardstock
with black thermography
Sent 1924

5. Augmented flat card
4¼ x 5½ inches
Brown/black photographic
print with black
lithography and applied
ornament, debossed panel,
imitation deckle edge
ca. 1945

6. Augmented flat card
3¼ x 5⅛ inches
Black photographic
print and handwritten
greeting on linen-textured
cardstock
Sent 1930

7. Augmented
French-fold card
3¹³⁄₁₆ x 5⅞ inches
Sepia-colored
photographic print fitted
into embossed paper with
black engraving, partial
deckle edge
ca. 1930

8. Flat card
5½ x 3¹¹⁄₁₆ inches
Brown/black photographic
print with lithography
and hand-coloring on
photographic paper,
debossed panel
Sent 1935

9. Flat card
5½ x 3¾ inches
Brown/black photographic
print and lithography on
photographic paper, partial
imitation deckle edge
Sent 1946

10. Flat card
5½ x 4¼ inches
Black photographic print
with black lithography
on photographic paper,
imitation deckle edge
ca. 1950

11. Flat card
4¼ x 5½ inches

Black photographic print
and black lithography
on photographic paper,
debossed panel, imitation
deckle edge
Sent 1949

12. Augmented flat card
4¼ x 5½ inches
Black photographic
print with letterpress (?)
printing and hand-coloring
on photographic paper,
imitation deckle edge,
applied to red cardstock
Sent 1948

13. Flat card
4¼ x 5⅜ inches
Black photographic
print and lithography
on photographic paper,
imitation deckle edge
Sent 1956

14. Flat card
4 x 5 inches
Black photographic
print with greeting on
photographic paper
ca. 1960

15. Augmented
single-fold card
5 x 7 inches
Black photolithography
on cardstock with gold
border applied to red-
surfaced cardstock over
heavy white cardstock
Sent ca. 1955
Henri Fayette, Chicago,
Illinois

16. Flat card
3⁷⁄₁₆ x 5 inches
Brown/black photographic
(?) print on photographic
paper, debossed panel
Sent 1943

17. Single-fold card
4¼ x 5½ inches
Brown/black
photographic print
on heavy photographic
paper
ca. 1940

Warm Places

1. Augmented booklet
4 x 6¾ inches
Panel of light brown
lithography with hand
coloring, gold, and tinted
edge applied to
marbleized cardstock,
debossed panel, bound
with variegated ribbon
ca. 1925
Gibson Lines, Cincinnati
and New York

2. Augmented booklet
3⁵⁄₁₆ x 6 inches
Imitation hand-colored
photograph applied to
lithographed cardstock,
purple border on three
sides, bound with
chartreuse ribbon
ca. 1930

3. Postcard
Color lithography on
linen-textured cardstock
Sent 1926 from Los
Angeles, California, to
Norwichtown, Connecticut
Pacific Novelty Co.,
San Francisco and Los
Angeles, California

4. Postcard
Color lithography
with gold accents and
embossing on cardstock
Sent 1919 from Los
Angeles, California,
to Portland, Oregon

5. Flat card
3⅞ x 5⅞ inches
Black lithography with
imitation hand-coloring on
cardstock, debossed panel,
deckle edge at sides
ca. 1930

6. Postcard
Color lithography on
cardstock
Sent 1917 from Orlando,
Florida, to East Thompson,
Connecticut

7. Augmented flat card
4½ x 6¼ inches
Imitation hand-colored
photograph applied to

cardstock with black
lithographed text,
debossed panel
ca. 1930

8. Augmented
French-fold card
5½ x 4¼ inches
Imitation hand-colored
photograph applied
to black and color
lithographed lightweight,
embossed paper
ca. 1935
Sunny Scenes Inc.,
Winter Park, Florida

9. Single-fold card
4³⁄₁₆ x 5⁷⁄₁₆
Black engraving (?) on
heavy cardstock, debossed
panel, deckle edge at right
ca. 1930
Reproduction of an
etching by Harter

10. Augmented flat card
4¾ x 5¾ inches
Imitation hand-colored
photograph applied to
cardstock with black
lithographed text,
debossed panel
Sent ca. 1930 from Long
Beach, California, to
Portland, Oregon

11. Single-fold card
4⅝ x 6¼ inches
Brown lithography with
imitation hand-coloring on
heavy cardstock, debossed
panel, deckle edge at right
ca. 1930
Image by Lempi Ostman
(1899–?)

12. Modified
and augmented
French-fold card
4⅛ x 5¼ inches
Hand-colored photograph
applied to lithographed
and embossed paper, short
fold at bottom
Sent ca. 1930 from
Riverside, California

13. Augmented
French-fold card
5⅛ x 6¼ inches
Imitation hand-colored

photograph of Oakland Bay Bridge applied to paper, debossed panel, deckle edge at bottom
Sent ca. 1950 from San Francisco, California

14. French-fold card
6 x 7⁵⁄₁₆ inches
Black engraving on paper, impressed plate mark, deckle edge at bottom
ca. 1950
The Castle Co. Ltd.

15. Augmented French-fold card
6¼ x 4⅝ inches
Paper photographic print applied to textured paper with red letterpress (?) printing, deckle edge at bottom
ca. 1950

16. Augmented French-fold card
7½ x 5⅝ inches
Three-color lithograph (view of San Francisco Bay) over sheet of silver foil, applied to imitation parchment
ca. 1940
Image by Fred Pond (1900–1943)

17. Augmented French-fold card
5¾ x 4½ inches
Lithography and flocking on heavy glassine over color lithographed insert
ca. 1955

Cute

1. Modified French-fold card
4⅛ x 5⅜ inches
Black and color lithography on weave-textured paper, die-cut contour
Sent 1939
W W (White & Wyckoff, Holyoke, Massachusetts?)
Made in U.S.A.

2. French-fold card
4⅜ x 6 inches

Black and color lithography on weave-textured paper
ca. 1938
Made in U.S.A.

3. Augmented single-fold card
5½ x 6½ inches
Black and color lithography on heavy, glossy cardstock; figure on right attached by springs (jiggles and bounces), felt "snowball" in hand
ca. 1950
Henri Fayette, Chicago, Illinois

4. Modified French-fold card
4⅝ x 5 inches
Black, blue, and red lithography on paper, short fold at right
ca. 1940
J. P. (?)
Made in U.S.A.

5. French-fold card
3¼ x 6¼ inches
Black and color lithography on paper
Sent 1952

6. French-fold card
5 x 6 inches
Black and color lithography and embossing on paper
Sent 1953
WB (Wallace Brown, New York?), logo of Allied Printing Trades Council, New York
Made in U.S.A.

7. French-fold card
4⅞ x 4¼ inches
Black and color lithography on embossed paper
ca. 1940
Made in U.S.A.

8. French-fold card
4⅞ x 4¼ inches
Black and color lithography on paper
ca. 1940
Made in U.S.A.

9. Double-fold card
7½ x 5¾ inches
Color lithography on heavy paper
Sent 1950
Treasure Masters, Minneapolis, Minnesota
Patent applied for
(interior may have held a photograph, now missing)

10. Augmented French-fold card
5¼ x 4⅜ inches
Black and color lithography on pebbled paper, applied cotton "smoke"
1947
Rust Craft, Boston, Massachusetts

11. French-fold card
4¼ x 5 inches
Color lithography and embossing on paper
Sent 1948 from Rock Falls to Sterling, Illinois
Made in U.S.A.

12. French-fold card
4 x 5 inches
Black and color lithography on paper
ca. 1950
Made in U.S.A.

13. French-fold card
4¾ x 3¾ inches
Black and color lithography on paper
Sent 1942 (?)
Whit. (Whitman?)
Made in U.S.A.

14. French-fold card
5 x 4³⁄₁₆ inches
Black and color lithography on paper, red border
ca. 1950

15. French-fold card
6 x 5 inches
Black and color lithography on textured paper
Sent 1952
WB (Wallace Brown, New York?), logo of Allied Printing Trades Council, New York
Made in U.S.A.

Humor

1. Flat card
3⅜ x 4⁷⁄₁₆ inches
Black and color lithography with gold on cardstock, red border
ca. 1920

2. Flat card
5¹⁄₁₆ x 4 inches
Black lithography on cardstock
ca. 1925
The Treasure Shop, New York

3. Flat card
5½ x 4½ inches
Black and color lithography on cardstock, gold border
Sent 1927 (?)

4. Augmented flat card
5⁹⁄₁₆ x 4¼ inches
Black lithography with hand-coloring on cardstock, white border, die-cut opening in "beak" for insert
ca. 1925
A. M. Davis, Boston, Massachusetts

5. Flat card
4⅞ x 3⅞ inches
Black and color lithography with spattered white "snow" on cardstock
Sent 1928

6. Flat card
4½ x 5½ inches
Black and color lithography on cardstock
ca. 1930

7. French-fold card
3⅞ x 4⅞ inches
Black and color lithography on lightweight, embossed paper
ca. 1935
Rust Craft, Boston, Massachusetts

8. Flat card
4½ x 5½ inches
Black thermography and color lithography

on cardstock
Sent 1931

9. Flat card
4½ x 5½ inches
Black and color
lithography on cardstock,
maroon border
Sent 1931

10. French-fold card
5⁷⁄₁₆ x 4¼ inches
Color lithography
on paper
ca. 1950
Made in U.S.A.

11. Modified
and augmented
French-fold card
4⅞ x 4⅞ inches
Black and color
lithography on paper,
die-cut around book
with folding cover
Sent 1944
Made in U.S.A.

12. Augmented
French-fold card
5 x 4 inches
Black and color
lithography on paper,
die-cut for fabric
"petticoat" insert
ca. 1940
Rust Craft, Boston,
Massachusetts

13. Flat card
5 x 4 inches
Black thermography
and color lithography
on cardstock
ca. 1930

14. French-fold card
4¼ x 5½ inches
Black and color
lithography on paper
ca. 1950
Designers and Illustrators,
New York, card no. 10862
Printed in U.S.A.
Design by Eleanor Stewart

Business

1. French-fold card
3½ x 6 inches
Red lithography and

embossing on paper
ca. 1950

2. Flat card
4¹¹⁄₁₆ x 3⅜ inches
Chromolithography on
cardstock, light brown
border
ca. 1880

3. Flat card
3¼ x 4⅞ inches
Black and color
lithography on heavy
cardstock
ca. 1930

4. Flat card
4¼ x 5½ inches
Black and color engraving
with embossing on
cardstock
ca. 1925

5. Flat card
3½ x 5¹⁄₁₆ inches
Black and color engraving
and lithography on
cardstock
Sent 1931

6. Flat card
3⅜ x 5⅜ inches
Black and color lithogra-
phy with gold thermogra-
phy on cardstock
Sent 1938

7. Flat card
3⅝ x 5⅞ inches
Black and color engraving
on cardstock
Sent 1916

8. Flat card
4¹³⁄₁₆ x 7 inches
Black lithography on
cardstock
ca. 1950

9. Flat card
4⅞ x 4⅛ inches
Black and red lithography
with gold and embossing
on cardstock
ca. 1915

10. French-fold card
7 x 5½ inches
Black engraving with
gold on paper, partial
deckle edge

Sent 1949
Schmitt Steel Company,
Portland, Oregon

11. Single-fold card
6 x 8 inches
Black and color
lithography on paper,
debossed panel
ca. 1950
Image by Forrest W. Orr

12. Modified
French-fold card
5 x 6 inches
Brown/black and
red lithography with
engraving and gold on
cardstock, debossed panel,
short fold at right, partial
deckle edge
ca. 1950

13. Single-fold card
6⁷⁄₁₆ x 4½ inches
Black and color block print
(?) on paper, partial deckle
edge
ca. 1930
Image by (Jacob) Elshin
(1892–1976)

14. Single-fold card
8¾ x 6¼ inches
Black lithography with
imitation hand-coloring
on heavy paper, debossed
panel, partial
deckle edge
Sent 1930
Image by F. H. Brigden
(1871–1956)

15. French-fold card
6⁵⁄₁₆ x 5⁷⁄₁₆ inches
Black and color
lithography on paper,
partial deckle edge
ca. 1950

16. French fold card
5¼ x 7¼ inches
Color lithography with
silver and embossing
on lightweight, black-
surfaced paper
ca. 1950

17. French-fold card
4⅞ x 7 inches
Color lithography on
glossy paper

Sent 1949 by The Ridge
Tool Company, Elyria,
Ohio

18. Single-fold card
5 x 5 inches
Red and black lithography
on cardstock
ca. 1950
Chryson's, Hollywood,
California

19. French-fold card
5¾ x 4¾ inches
Color lithography and
embossing on aluminum-
foil-faced paper
ca. 1950
The Reynolds Metals
Company

BIBLIOGRAPHY

Ames, Kenneth L. "Colonial Images on Christmas Cards." *Antiques* 158, no. 6 (2000): 874–81.

Ames, Kenneth L., Barbara Franco, and L. Thomas Frye, eds. *Ideas and Images: Developing Interpretive History Exhibits.* Nashville: American Association for State and Local History, 1992.

Anderson, Christine, and Terry Tischer. *Poinsettias: The December Flower—Myth and Legend, History and Botanical Fact.* Tiburon CA: Waters Edge Press, 1998.

Anderson, Richard L. *American Muse: Anthropological Excursions into Art and Aesthetics.* Upper Saddle River NJ: Prentice Hall, 2000.

Appleton, Jay. *The Symbolism of Habitat: An Interpretation of Landscape in the Arts.* Seattle: University of Washington Press, 1990.

Archer, John. *Architecture and Suburbia: From English Villa to American Dream House, 1690–2000.* Minneapolis: University of Minnesota Press, 2005.

Armstrong, Neil. *Christmas in Nineteenth-Century England.* Manchester: Manchester University Press; New York: Palgrave Macmillan, 2010.

Armstrong, Robert Plant. *The Affecting Presence: An Essay in Humanistic Anthropology.* Urbana: University of Illinois Press, 1971.

Bachelard, Gaston. *The Poetics of Space.* Boston: Beacon Press, 1994.

____. *The Psychoanalysis of Fire.* Boston: Beacon Press, 1964.

Baigell, Matthew, and Milly Heyd, eds. *Complex Identities: Jewish Consciousness and Modern Art.* New Brunswick NJ: Rutgers University Press, 2001.

Belk, Russell W. "A Child's Christmas in America: Santa Claus as Deity." *Journal of American Culture* 10, no. 1 (1987): 87–100.

Berger, John. *Ways of Seeing.* London: British Broadcasting Corporation; Harmondsworth: Penguin, 1972.

Binkley, Sam. "Kitsch as a Repetitive System: A Problem for the Theory of Taste Hierarchy." *Journal of Material Culture* 5, no. 2 (2000): 131–52.

Blair, Arthur. *Christmas Cards for the Collector.* London: B. T. Batsford, 1986.

Bogart, Michele Helene. *Artists, Advertising, and the Borders of Art.* Chicago: University of Chicago Press, 1995.

Bourdieu, Pierre. *Distinction: A Social Critique of the Judgment of Taste.* Cambridge MA: Harvard University Press, 1984.

Brown, Donald E. *Human Universals.* Philadelphia: Temple University Press, 1991.

Buday, György. *The History of the Christmas Card.* London: Spring Book, 1954.

Chase, Ernest Dudley. *The Romance of Greeting Cards: An Historical Account of the Origin, Evolution and Development of Christmas Cards, Valentines and other Forms of Greeting Cards from the Earliest Days to the Present Time.* Dedham MA: Rust Craft, 1956.

Coffin, Tristram Potter. *The Book of Christmas Folklore.* New York: Seabury Press, 1973.

Collins, Ace. *Stories behind the Greatest Hits of Christmas.* Grand Rapids MI: Zondervan, 2010.

Cross, Gary S. *The Cute and the Cool: Wondrous Innocence and Modern American Children's Culture.* New York: Oxford University Press, 2004.

Daly, Mary. *Gyn/ecology: The Metaethics of Radical Feminism.* Boston: Beacon Press, 1978.

Davies, Valentine. *Miracle on 34th Street.* New York: Harcourt, Brace, and Co., 1947.

Davis, Paul. *The Lives and Times of Ebenezer Scrooge.* New Haven: Yale University Press, 1990.

Dickens, Charles. *A Christmas Carol, in Prose, Being a Ghost Story of Christmas.* London: Chapman & Hall, 1845 (1843).

____. *The Pickwick Papers.* New York: W. A. Townshend, 1861 (1836-37).

Dirda, Michael. *Classics for Pleasure.* Orlando: Harcourt, 2007.

Dissanayake, Ellen. *Homo Aestheticus: Where Art Comes from and Why.* Seattle: University of Washington Press, 1995.

____. *What Is Art For?* Seattle: University of Washington Press, 1988.

Dow, Arthur Wesley. *Composition: A Series of Exercises in Art Structure for the Use of Students and Teachers.* Berkeley: University of California Press, 1997 (1899).

Ecke, Paul. *The Ecke Poinsettia Manual.* Batavia IL: Ball Publishing, 2004.

Elias, Norbert. *The Civilizing Process.* Oxford: B. Blackwell, 1982.

Epstein, Greg M. *Good without God: What a Billion Nonreligious People Do Believe.* New York: William Morrow, 2009.

Fischer, David Hackett. *Historians' Fallacies: Toward a Logic of Historical Thought.* New York: Harper & Row, 1970.

Flynn, Tom. *The Trouble with Christmas.* Buffalo NY: Prometheus Books, 1993.

Freedberg, David. *The Power of Images: Studies in the History and Theory of Response.* Chicago: University of Chicago Press, 1989.

Gans, Herbert J. *Popular Culture and High Culture: An Analysis and Evaluation of Taste.* New York: Basic Books, 1974.

Geldzahler, Henry. *New York Painting and Sculpture: 1940–1970.* New York: E. P. Dutton, 1969.

Gilmore, Jann Haynes. *Greetings from Delaware and Other Artist Communities: The Jann Haynes Gilmore and B. Joyce Puckett Collection of Artist Greeting Cards.* Dover DE: Biggs Museum of American Art, 2007.

Golby, J. M. and A. W. Purdue. *The Making of the Modern Christmas.* Athens GA: University of Georgia Press, 1986.

Goody, Jack. *The Culture of Flowers.* Cambridge: Cambridge University Press, 1993.

Gordon, Beverly. "Intimacy and Objects: A Proxemic Analysis of Gender-Based Response to the Material World." In *The Material Culture of Gender, the Gender of Material Culture,* ed. Katherine A. Martinez and Kenneth L. Ames. Winterthur, DE: Winterthur Museum, 1997, 237–52.

Gowans, Alan. *The Comfortable House: North American Suburban Architecture, 1890–1930.* Cambridge MA: MIT Press, 1989.

____. *Learning to See: Historical Perspectives on Modern Popular/Commercial Arts.* Bowling Green OH: Bowling Green University Popular Press, 1981.

Hale, Jonathan. *The Old Way of Seeing.* Boston: Houghton Mifflin, 1994.

Halle, David. *Inside Culture: Art and Class in the American Home.* Chicago: University of Chicago Press, 1993.

Harris, Daniel. *Cute, Quaint, Hungry and Romantic: The Aesthetics of Consumerism.* New York: Basic Books, 2000.

Heller, Steven. *Artists' Christmas Cards.* New York: A&W Publishers, 1979.

Higonnet, Anne. *Pictures of Innocence: The History and Crisis of Ideal Childhood.* New York: Thames and Hudson, 1998.

Hillier, Bevis. *Greetings from Christmas Past.* London: Herbert Press; New York: Universe Books, 1982.

Hobsbawm, Eric and Terence Ranger, eds. *The Invention of Tradition.* Cambridge: Cambridge University Press, 1988.

Hoffman, Robert C. *Postcards from Santa Claus.* Garden City Park NY: Square One Publishers, 2002.

Hudson, Graham S. *The Design & Printing of Ephemera in Britain & America, 1720–1920.* London: British Library; New Castle DE: Oak Knoll Press, 2008.

Irving, Washington. *The Sketch-Book of Geoffrey Crayon, Gent.* Philadelphia: Carey & Lea, 1830 (1819–20).

Ivins, William M. *Prints and Visual Communication.* Cambridge MA: MIT Press, 1953.

Johnston, Patricia, ed. *Seeing High & Low: Representing Social Conflict in American Visual Culture.* Berkeley: University of California Press, 2006.

Jones, Charles Williams. *Saint Nicholas of Myra, Bari, and Manhattan: Biography of a Legend.* Chicago: University of Chicago Press, 1978.

Kammen, Michael G. *American Culture, American Tastes: Social Change and the 20th Century.* New York: Knopf, 1999.

Kaye, Harvey J. *The Powers of the Past: Reflections on the Crisis and the Promise of History.* Minneapolis: University of Minnesota Press, 1991.

Kent, Rockwell. *A Northern Christmas: Being the Story of a Peaceful Christmas in the Remote and Peaceful Wilderness of an Alaskan Island.* New York: American Artists Group, 1941.

Kery, Patricia Frantz. *Art Deco Graphics.* New York: Thames and Hudson, 2002.

Kleeblatt, Norman L. and Susan Chevlowe, eds. *Painting A Place in America: Jewish Artists in New York, 1900–1945: A Tribute to the Educational Alliance Art School.* New York: Jewish Museum; Bloomington: Indiana University Press, 1991.

Kouwenhoven, John Atlee. *Half a Truth Is Better Than None: Some Unsystematic Conjectures About Art, Disorder, and American Experience.* Chicago: University of Chicago Press, 1982.

Lavin, Maud. *The Business of Holidays.* New York: Monacelli Press, 2004.

Loewen, James W. *Lies My Teacher Told Me: Everything Your American History Textbook Got Wrong.* New York: New Press, 1995.

____. *Teaching What Really Happened: How to Avoid the Tyranny of Textbooks and Get Students Excited About Doing History.* New York: Teachers College, Columbia University, 2010.

Lowe, Scott C., ed. *Christmas: Philosophy for Everyone: Better Than a Lump of Coal.* Malden MA: Wiley-Blackwell, 2010.

Marling, Karal Ann. *Merry Christmas! Celebrating America's Greatest Holiday.* Cambridge MA: Harvard University Press, 2000.

Mashburn, J. L. *The Artist-Signed Postcard Price Guide: A Comprehensive Reference.* Enka NC: Colonial House, 2003.

Mauss, Marcel. *The Gift: Forms and Functions of Exchange in Archaic Societies.* New York: W. W. Norton, 1990 (1923).

May, Elaine Tyler. *Homeward Bound: American Families in the Cold War Era*. New York: Basic Books, 1999.

McCracken, Grant David. *Chief Culture Officer: How to Create a Living, Breathing Corporation*. New York: Basic Books, 2009.

____. *Culture and Consumption: New Approaches to the Symbolic Character of Consumer Goods and Activities*. Bloomington: Indiana University Press, 1988.

_____. *Culture and Consumption II: Markets, Meaning, and Brand Management*. Bloomington: Indiana University Press, 2005.

Merck, Robert M. *Deck the Halls*. New York: Abbeville, 1992.

Miller, Daniel, ed. *Material Cultures: Why Some Things Matter*. Chicago: University of Chicago Press, 1998.

____, ed. *Unwrapping Christmas*. Oxford: Clarendon Press; New York: Oxford University Press, 1993.

Moore, Thomas. *The Re-Enchantment of Everyday Life*. New York: HarperCollins, 1996.

Nast, William Glover, comp. *The Christmas Drawings of Thomas Nast*. New York: World Publishing, 1970 (1863).

New Yorker, The. *The Complete Book of Covers from the New Yorker, 1925-1989*. New York: Knopf, 1989.

Nissenbaum, Stephen. *The Battle for Christmas*. New York: Alfred A. Knopf, 1997.

O'Donnell, Anne Stewart. "A First Look at Arts and Crafts Greeting Cards." *Antiques* 164, no. 6 (Dec. 2003): 62–71.

____. "Greetings from the 20th Century: Or How the Arts & Crafts Movement Helped Launch a Billion-Dollar Worldwide Industry." *Style 1900* 16, no. 4 (Fall/Winter 2003): 48–55.

_____. "Very Collectible Volland." *Style 1900* 18, no. 4 (Fall/Winter 2005–6): 58–67.

Penniston, Benjamin H. *The Golden Age of Postcards: Early 1900s: Identification & Values*. Paducah KY: Collector Books, 2008.

Pieske, Christa. *Das ABC des Luxuspapiers: Herstellung, Verarbeitung und Gebrauch 1860-1930*. Berlin: Reimer, 1984.

Pugin, Augustus Welby Northmore. *Contrasts*. Leicester: Leicester University Press; New York: Humanities Press, 1969 (1841).

Purvis, Alston W., and Martijn F. Le Coultre. *Graphic Design 20th Century*. New York: Princeton Architectural Press, 2003.

Reed, Robert M. *Christmas Postcards*. Atglen PA: Schiffer Pub., 2007.

____. *Vintage Postcards for the Holidays: Identification & Value Guide*. Paducah KY: Collector Books, 2006.

Restad, Penne L. *Christmas in America: A History*. New York: Oxford University Press, 1995.

Rickards, Maurice. *Collecting Printed Ephemera*. New York: Abbeville, 1988.

Sandman, Larry, ed. *A Guide to Greeting Card Writing*. Cincinnati OH: Writer's Digest Books, 1980.

Schmidt, Leigh Eric. *Consumer Rites: The Buying and Selling of American Holidays*. Princeton: Princeton University Press, 1995.

Shank, Barry. *A Token of My Affection: Greeting Cards and American Business Culture*. New York: Columbia University Press, 2004.

Sloane, David E., ed. *American Humor Magazines and Comic Periodicals*. New York: Greenwood Press, 1987.

Spitz, Ellen Handler. *Inside Picture Books*. New Haven: Yale University Press, 1999.

Sprague, Elizabeth, and Curtiss Sprague. *How to Design Greeting Cards*. Pelham NY: Bridgman, 1944 (1926).

Susman, Warren. *Culture as History: The Transformation of American Society in the Twentieth Century*. New York: Pantheon Books, 1984.

Truettner, William and Roger Stein. *Picturing Old New England: Image and Memory*. Washington DC: National Museum of American Art, Smithsonian Institution; New Haven: Yale University Press, 1999.

Van Dyke, Henry. *The Spirit of Christmas*. New York: Charles Scribner's Sons, 1905.

Voltaire (François-Marie Arouet). *Candide*. New York: Literary Guild, 1929 (1759).

Waits, William Burnell. *The Modern Christmas in America: A Cultural History of Gift Giving*. New York: New York University Press, 1993.

White, Gleeson. *Christmas Cards & Their Chief Designers*. London: The Studio, 1895.

Wiggin, Kate Douglas. *The Romance of a Christmas Card*. Boston and New York: Houghton Mifflin, 1916.

Williams, Martin T. *Hidden in Plain Sight: An Examination of the American Arts*. New York: Oxford University Press, 1992.